Ships & Seamanship

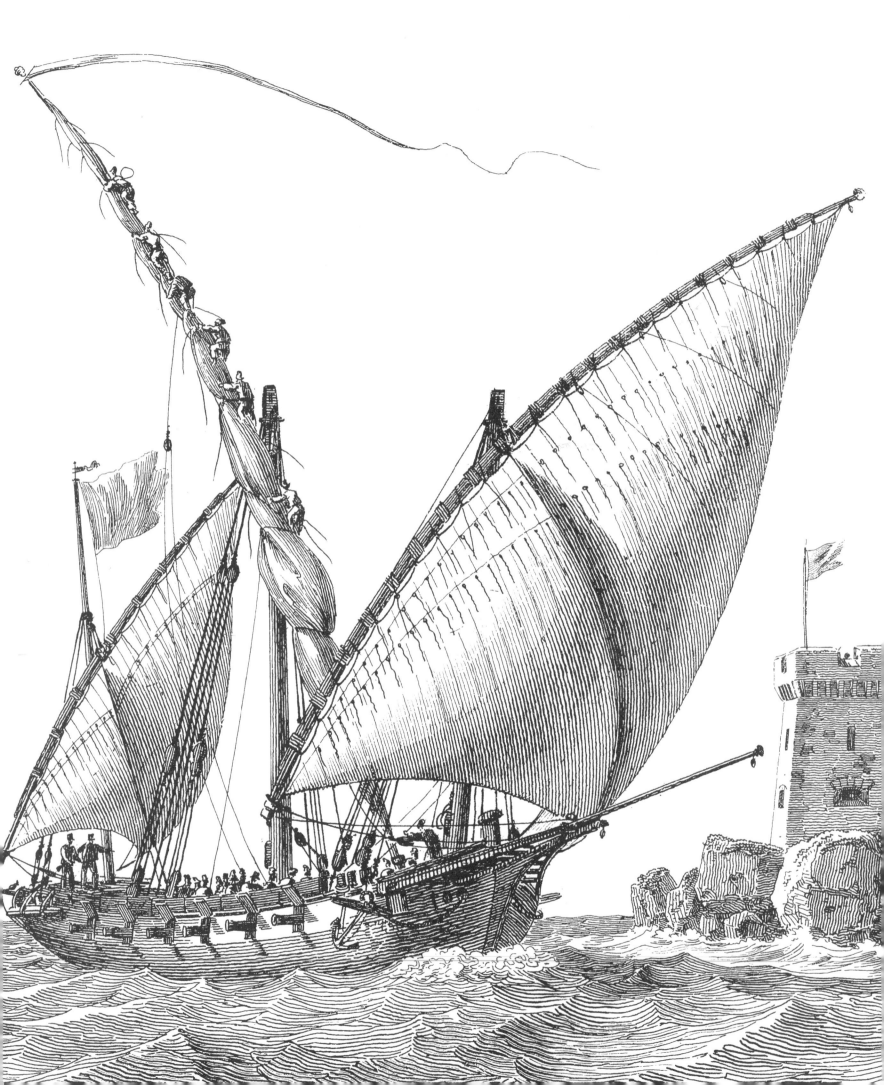

Ships & Seamanship

The Maritime Prints of J J Baugean

JOHN HARLAND

NAVAL INSTITUTE PRESS
Annapolis, Maryland

First published in Great Britain in 2000 by
Chatham Publishing,
61 Frith Street,
London W1V 5TA

Published and distributed in the United States of America
and Canada by the Naval Institute Press, 291 Wood Road,
Annapolis, Maryland 21402-5034

Library of Congress Catalog No. 00-108384

ISBN 1-55750-985-9

This edition is authorized for sale in the United States,
its territories and possessions, and Canada.

Manufactured in Great Britain.

Contents

INTRODUCTION

The artist .6

Accuracy of observation6

The warships of the period6

Rigs .7

Rigging .8

Anchoring .9

Dutch and Scandinavian craft9

Features of Mediterranean craft9

Polacre rig .10

Lateen rig .11

Seamanship of the lateen sail12

Quadrilateral fore-and-aft sails13

BIBLIOGRAPHY15

THE PLATES

WARSHIPS [Plates 1-62]

Ships of the line16

Frigates .30

Corvettes and brigs42

Schooners and minor vessels53

Ship's boats .72

MERCHANT VESSELS [Plates 63-119]

Three-masted square-riggers78

Brigs, schooners and sloops90

Mediterranean local types98

Baltic and North Sea vessels126

FISHING AND SMALL CRAFT [Plates 120-151]

The north coast of France136

Mediterranean fishing boats147

River craft .157

PORTS AND HARBOURS [Plates 152-192]

Shipbuilding and repair167

Port facilities .184

Port activities .190

Seakeeping .206

CONCORDANCE OF PLATES208

Introduction

It is a privilege to be asked to contribute an introduction for English-speaking readers to this edition of the engravings of Baugean. Reprints of his book publications *Collection de toutes les Espèces de Bâtiments de Guerre et Bâtiments Marchands, qui naviguent sur l'Océan et dans la Mediterranée* (1814) and *Receuil de Petites Marines* (1819) have been available to French readers in individual facsimiles since 1971 and 1987 respectively. The engravings in these books represent perhaps half Baugean's total oeuvre, and for convenience, I will refer to them as the collection. The French reprints proved an invaluable resource to Mark Myers and myself when researching *Seamanship in the Age of Sail*, and this version in a single volume will make them available to a wider circle of maritime historians, ship modellers, and armchair sailors.

In the original publications the engravings were arranged in no particular sequence, and the French reprints followed the same plan, using only the captions in the original editions. To enhance the comparative value of this collection we have chosen to group the plates into categories, and although the captions offered here often allude to the original version, in most cases they represent a modern analysis of the subject of each illustration. When he originally published the engravings Baugean was dealing with contemporary technology, so a minimal caption was adequate, but for the present-day historian of ships and seamanship there is so much to be found in Baugean's work that a fuller description is entirely justified.

THE ARTIST

Since this publication celebrates the skill of the artist, it is unfortunate that we have so little solid information about his life and career. Jean-Jérôme Baugean was born in Marseilles in 1764, and is usually said to have died in 1819 (E Bénézit, *Dictionnaire critique et documentaire de Peintres, Sculpteurs, Dessinateurs et Graveurs*). However, an engraving, thought to be his work, portrays the Battle of Navarino, which occurred in October 1827. If the attribution is correct, it shifts the date of death forward, by almost ten years.

The few details available come from two sources: firstly, a short monograph on his life and work, *Jean-Jérôme Baugean: Peintre et Graveur de la Marine* by Jacques Vichot, published by L'Association des Amis des Musées de la Marine (the booklet is undated, but appeared about twenty years ago); secondly, a preface by Jean Ducros appeared with the reprint of *Collection de toutes les Espèces de Bâtiments de Guerre et Bâtiments Marchands*, published by Editions des Quatre Seigneurs in Grenoble in 1971.

We can only speculate about the details of his career, but on the evidence of the subject matter of his engravings (not just those shown here), he seems to have travelled to Belgium, London and the coasts of Italy, and probably voyaged to the Levant. He describes himself as 'Graveur du Roi', the king in question being Louis XVIII, who ascended the throne at the end of the Napoleonic Wars. Baugean certainly seems to have had royalist sympathies, and two of his engravings depict the surrendered Bonaparte on HMS *Bellerophon* on 14 July 1815, and the Emperor's subsequent transfer to HMS *Northumberland* on August 8. He was also overtly anti-British, which is hardly surprising for a Frenchman who had lived through the naval humiliations of 1793-1815: within this collection there is the artistic wish-fulfilment of a badly damaged British 74-gun ship (Plate 11), while the frigate dressed overall in Plate 17 was originally engraved

with the British ensign upside down under the bowsprit, a calculated insult since it covers the crew latrines; and the only naval engagements he chose to celebrate were the victories of the American frigates over their British opponents in 1812 (not in this collection).

ACCURACY OF OBSERVATION

In the absence of a photographic record, the work of contemporary artists like Baugean, the Roux family, or the van de Veldes, is of critical importance in assisting the historian to form an accurate opinion about the appearance of the ships of bygone eras. The 192 engravings reproduced in this volume are a perfect example of the usefulness of such work, but we have to ask ourselves how reliable these artists were. There is no question that Baugean was a keen-eyed observer, and in our opinion, more likely to get the technical details right rather than wrong. His Swedish frigate (Plate 26), for example, can be identified, and the features match the original plan very closely. Examples of his meticulous attention to detail could be multiplied, but in Plate 8 we have a couple of nice examples: firstly, the 'Y' shaped items depending from the gaff are the brails of the mizzen sail which has been unbent; secondly, the topsail yards are hoisted by means of tyes and halliards – in effect, a whip-and-tackle arrangement. As the yard is mastheaded, the upper halliard block (fly-block) is pulled down; when the yard is lowered to the cap, the block rises. Comparing fore and main, it can be seen that he has carefully represented this. Should a tye or halliard part, the fly-block became a dangerous missile, and to prevent it hurtling down, it was secured with a short rope becket to the backstay. In this plate, we can see this detail just above the block on the main mast.

However, like every artist, he had his quirks, and a couple of Baugean's 'signatures' are the life-buoy to be seen suspended from the mizzen boom in Plates 11, 13, 20, 21 and 25, and the way in which he shows the stowed anchor in many of his plates. I believe the life-buoy, with its grab-lines, was a distinctively French pattern, and his representation of it in Dutch and English ships, is perhaps a little suspect. (There is an illustration of the device on page 289 of *Seamanship in the Age of Sail*.)

When an anchor was weighed, the ring was run up to the cathead, and then the anchor was 'fished' by hooking a tackle to its lower end, and swinging the shank up to an almost horizontal position. Baugean tends to show the stowed anchor with the shank tilted further off the horizontal, than do his near-contemporaries, like the Roux family.

A distinguishing feature of the images in this collection is that clouds are never represented, and it might be imagined this is characteristic of Baugean's work. In fact, many of his other engravings feature carefully observed skies.

THE WARSHIPS OF THE PERIOD

In Baugean's time warships were primarily differentiated by the number of guns, the largest (those commanded by officers of full captain's rank) being divided into six 'rates'. First and Second Rates carried three full gun batteries – and were therefore called three-deckers – mounting between 90 and 120 guns (guns were also carried on the quarterdeck and forecastle, and sometimes even the poop). By the same terms Third Rates were two-deckers mounting between 64 and 80 guns; all these were regarded as line of battle ships. Below the ships of the line were a few small two-deckers of around 50 guns

which were used for convoy escort and as colonial flagships. Frigates were the heavy cruisers of the sailing era, having a single full gundeck and usually carrying 28 to 44 guns. From around 1800 a few frigates with up to 60 guns were built and classed as Fourth Rates but the majority were Fifths. All major warships were rigged as conventional three-masted ships.

The French and British navies used very similar terms for these ships. *Vaisseau de ligne* is the equivalent of 'ship of the line', and the collection offers examples mounting anywhere from 64 to 120 guns. Likewise, *frégate* translates as 'frigate', but thereafter terminology diverged slightly. Small Sixth Rates of 20-24 guns were called post ships (they were the smallest classes commanded by full, or post, captains) in the Royal Navy, whereas the French referred to such ships as *corvettes*, a term extended upwards to small frigates of 30 guns and downwards to what the British called 'sloops of war' and usually carrying 12 to 18 guns. In both navies these could be either ship or brig rigged so were called either ship-sloops or brig-sloops (*brick-corvettes* in France). A light sloop of war with 16 guns was described as *corvette-aviso* or, where appropriate, *brick-aviso*. The British also had smaller brigs rated 'gun-brigs' which were commanded by lieutenants rather than the 'master and commander' in command of a sloop.

Navies also operated many small craft with a variety of familiar mercantile rigs like schooners, luggers and cutters, while Mediterranean navies also adapted the local types, such as the chebec.

The rating system was a convention, ships often carrying more than their nominal force. The British compounded the problem by the introduction in the 1770s of the carronade, a lightweight short-barrelled but powerful weapon that at first was not counted as a genuine 'long' gun. Even when it both augmented and replaced conventional cannon, the old ratings tended to be retained, so a British '38-gun frigate', for example, usually mounted 46 or 48 guns and carronades. The discrepancy was greatest in the smaller frigates and ship sloops where the quarterdecks and forecastles had room for extra carronades. The US Navy generally followed the British system, but the discrepancy between rated and real force was even greater: a '44-gun frigate' was capable of carrying up to 60 guns.

In terms of naval architecture, French warships were very large and widely believed to be the best designed, but the British who captured many of them between 1793 and 1815 found them too lightly built for the harsh conditions of Royal Navy service, with its all-weather, year-round blockading commitment. Spanish ships were stronger, but their sailing qualities were not so highly regarded, while Dutch ships were rather old-fashioned and very small for their rate. British ships were traditionally smaller than French, but more robust in construction; however, from the 1790s the newer designs grew in size to almost match those of France. The great exponent of superior dimensions was the United States, which built the world's largest frigates and later very large ship sloops. Their successes in the War of 1812, along with the outstanding sailing qualities of the 'Baltimore clipper' type schooners, brought American ship design to the attention of European navies.

Baugean was active during and just after the Napoleonic Wars, and while he had clearly seen the ship types he depicted, his knowledge was based on the received wisdom (and prejudices) of French seamen and was rarely up-to-date. For example, Baugean was of the opinion that the English vessels were not as handsome or as well constructed as their French counterparts, but comments that the English 74s were handier in going about because they were shorter, carrying 28 guns on

their lower gundeck, as against 30. In fact, this was only partially true: new French 74s had 30 ports, but usually mounted only 28 guns; British 'Common' Class 74s were shorter, but numbers of larger 74s built in the 1790s were as big as French 74s.

It was true, however, that the Royal Navy, in 1793 the world's largest, did not possess the largest ships in each rate, nor those with the heaviest guns on the lower gundeck, nor the ship with the greatest number of guns: Spain's four-decked 136-Gun *Santisíma Trinidad* would carry off this last distinction, while the French *Commerce de Marseilles* and her 118-gun sisters were the largest ships in the world. The British battlefleet made up the deficiency with numbers, having a high proportion of small three-deckers of 98 guns in most squadrons.

The backbone of the Royal Navy, and indeed the standard ship of the line in every major navy was the 74-gun ship. In 1793, these were mostly of the 'Common' Class (1650 tons), but subsequently larger versions (1800 tons) were built and groups of these could function as the equivalent of a twentieth-century battlecruiser force. In the course of the war the British blockading strategy made it increasingly difficult for the French navy to contemplate fleet actions, so instead of unwieldy three-deckers they built some slightly larger two-deckers of 80 guns for use as flagships. Being fast and weatherly, these were well suited to act as lead ship for a flying squadron composed of 74s, and captured Frenchmen of this class were much valued by the Royal Navy as flagships of blockading squadrons.

The biggest British frigates were closer in size to the generality of their European equivalents, although many of them were moderate-sized ships of 36 and 32 guns rather than the 38- and 40-gun ships. Baugean was of the opinion that although the English frigates were good looking, and richly decorated with carved work, they lacked the grace and elegance of their French counterparts. He comments that they were often armed with carronades rather than cannon, but this is a simplification. They carried a full complement of carronades along the quarterdeck and forecastle, but only a few of the smallest ones mounted carronades on the gundeck. The carronade revolution started with the introduction of the iron carronade into the Royal Navy from 1778. The French replied in 1787 with a brass 36-pounder *obusier* (howitzer), but this was a poor weapon by comparison, and not replaced by a genuine iron carronade until about 1808. British frigates were therefore more powerful than their French equivalents; battleships were less affected, but even these often had quarterdeck and forecastle long guns replaced by carronades.

Baugean illustrates a couple of American frigates, Plates 23 and 24, and remarks that these fast, heavily built vessels, masted and armed almost like 74s, were designed to outmatch their British opponents. Actually this is a post-1812 perception – they were built in response to Barbary piracy, rather than designed with the British in mind, although Joshua Humphreys did consciously design them to be more powerful than any European frigates, and faster than any ship of the line – a sort of *Graf Spee* type 'pocket battleship' of their day. Perhaps fittingly for such a radical ship, *President* (1799), the subject of Plate 23, is the only named ship in the collection.

RIGS
Brig and snow
As to the brig (*brick*) and snow (*senau*), Steel's *Elements of Mastmaking, Sailmaking and Rigging* (1794) says that a snow was a little larger than a brig, set a square main course and a loose-footed gaff trysail, hooped to a 'snow mast' (or 'trysail mast'), an auxiliary spar abaft the main

mast; it did not set a main staysail. A brig did not set a course on the main yard (similar to the crossjack yard on a ship); set a main staysail, and a fore-and-aft gaff main sail, which was sheeted to a boom. He notes that some vessels were known as 'hermaphrodites', sometimes rigged as brigs, sometimes as snows.

From somewhere around 1825 onwards, the sole distinction lay in the presence or absence of the trysail mast. By the time Baugean was observing and drawing these vessels, things were in transition, brigs having laid aside the main staysail, and many bending a square main course to the main yard. Snows still retained the loose-footed trysail, not yet having adopted a main boom.

The word 'brig' has a convoluted history. It is a shortened form of 'brigantine', a word that, in the Mediterranean, originally applied to a large felucca. Only later was it applied to the northern brig. Baugean notes that, in French, the term *brigantin* was subsequently applied to the brig, and that the fore-and-aft 'brig main sail', or 'brig-sail', was called the *brigantine*.

Brigantine

Nowadays, 'brigantine' is accepted as synonymous with 'brig-schooner', that is to say a vessel which has the square rigged fore mast of a brig but the fore-and-aft rigged main mast of a schooner. However, Harold Underhill, in his *Sailing Ship Rigs and Rigging* (1938), says that at one time some authorities restricted the term to a brig-schooner which set a square topsail on the main (see vessel in the background in Plate 64). This, in turn, meant that some other expression had to be found for the much commoner version, a brig-schooner with no square topsail on the main. Perhaps rather pedantically, some people chose to refer to these as 'hermaphrodite brigs'. This had the disadvantage of being at odds with Steel's definition, given above.

Schooner

The French word for 'schooner' was *goélette*, which derives from a Breton word for 'seagull' (French *goéland*). Basil Greenhill (*Schooners*, 1980, page 19) suspects that the schooner rig may have developed from two sources, one with, and one without square topsails. Be that as it may, most of the schooners represented here set square topsails on the fore, and sometimes on the main, and appear to be of North American origin. According to Smyth's *The Sailor's Word-Book* (1867), 'Balaou [ballahou] schooners' (Plate 80) were 'common in Bermuda and the West Indies'.

I am at a bit of a loss to know what to call the square fore sail, which the French call the *voile de fortune*, but favour referring to it as a 'running fore sail'. René de Kerchove's *International Maritime Dictionary* offers two English alternatives for the German word *Breitfock*: 'flying fore sail' and 'monkey fore sail', but I suspect these are relatively modern expressions. In 'modern' schooners (from about 1850s onwards), the foot of the sail was commonly laced to the boom, but an interesting feature of all the schooners found in the collection is the absence of a fore boom, and the way the main sail is not laced to the boom, but just sheeted to it. The fore sail of those schooners seen in illustrations dating from about 1880 onwards is laced to a boom, and it is reasonable to ask if there was a reason for difference in practice between 1810 and, say, 1900.

One advantage of having a loose-footed fore sail is that the sail can be larger, and cut with a longer foot, so that it overlaps the main mast significantly; it can also be brailed-in quickly. When sailing close-hauled, this configuration creates what the modern sailor would think of as a 'slot', contributing significantly to forward drive. In the few modern reproductions of early nineteenth-century schooners, such as the training vessel *Pacific Swift* of Victoria, British Columbia, the fore sail is fitted with a boom, for safety reasons. Running downwind, a fore-and-aft schooner wings out the fore and main on opposite sides. On this point of sail, there is the danger of being 'caught' by the lee and having the sail gybe violently across to the other side. This can be obviated by securing a preventer rope to the forward side of the boom, a precaution not practical with a loose-footed sail.

In 'modern' schooners, the sail was laced to the boom, and taken in by letting go peak and throat halliards, lowering the gaff and sail down on top of the boom. It will be noticed that things were done otherwise in 1810. In Plate 80, the main gaff has been lowered most of the way, with the sheet remaining fast to the boom-end, while the fore sail has been brailed up and in to mast and standing gaff.

If the square topsails on fore, and sometimes main masts were set, the vessel could not sail as close to the wind as when only the fore-and-aft canvas was deployed. However, these would have added significantly to the vessel's manoeuvrability, and her speed, when heading downwind. On this latter point of sail, if the huge 'running fore sail' were set, the fore sail could be taken in, since there would be no purpose in winging it out.

The running fore sail, shown in Plate 42, was got aloft with three halliards, and other contemporary illustrations suggest that this was the usual way of arranging things with this type of sail, something which was also set in sloops and cutters. The sheets were made fast to a spar laid across the bulwarks, and indeed this seems of sufficient length to have handled a lower studding sail, if such an item were set. The yard and sail, lying on the bulwarks, just forward of the fore mast, to be seen in Plates 31 and 80 remains an enigma. It looks like a yard, with a sail bent to it, but this seems redundant if the type of running fore sail used in Plate 42 were used.

RIGGING

We need not discuss in any detail the rig of those vessels in the collection which were 'traditionally' rigged, and familiar to the English-speaking reader, since excellent accounts covering this are readily available, including: James Lees, *Masting & Rigging of English ships of War 1625-1860* (1979); and several modern reprints of Darcy Lever, *The Young Sea Officer's Sheet Anchor* (1808 and 1819). However, Baugean's prints do raise a few issues that require some consideration.

Dolphin strikers

The flying jib pulled the end of the flying jibboom up and to leeward. The dolphin striker acted as a strut under the bowsprit cap, to direct the counteracting pull of the martingale stay downwards. The advantage of the double dolphin striker, seen in Plates 13, 20 and 39, was that the weathermost of the two would better resist the leeward component of the pull. Some of the smaller merchantmen, for instance those portrayed in Plates 45, 65 and 76, have no dolphin striker at all.

Cat-harpings

After 1820 or so, it became the practice to secure the futtock shrouds to a chain necklace or iron band secured to the lower mast. Prior to that, the futtocks were seized to the lower shrouds, a much less satisfactory arrangement from an engineering point of view, and

futtock shrouds, top and topmast rigging were stiffened by transversely lashing the lower shrouds on each side together, at the point where the futtock shrouds were seized, with short lengths of hawser called 'cat-harpings'. The older method of securing the futtocks and the cat-harpings can be clearly seen in Plates 6, 10, 12, 22, 172, 179, 181.

Gaff topsail

A feature not described in the treatises on early nineteenth-century rigging by Steel, Lever, and so on, is the type of gaff topsail seen in Plates 16, 29, 38, 78, 112, and 118. This was spread on an upper gaff secured just under the mizzen topmast crosstrees and sheeted to the peak of the lower gaff. The existence of this sail, in that era, is confirmed from other sources, for instance in the work of the Roux family. For lack of a better term, I have chosen to refer to it as a 'gaff topsail', even though this invites confusion with the sails seen in Plates 41 and 114, and the 'jackyard topsail' in Plate 53. Harold Underhill's *Rigging of the Clipper ship and Ocean Carrier* describes and illustrates a similar looking 'monkey gaff' or 'signal gaff', which was fitted to the mizzen in sailing ships of the late 1800s.

Fidded royal masts

In Plates 2, 27 and 39 we see examples of royal masts which are fidded, and capable of being struck separately from the topgallant masts, abaft their respective topgallant masts, this having the advantage that they would not interfere significantly with the handling of the topgallant sail, while being sent down. This practice seems to have been a of relatively short duration. It is not mentioned in Charles Romme's monograph *L'Art de la Mâture* (1789) and although F A Costé in his *Manuel de Gréement* (1849) alludes to it, he indicates that at the time of writing it had virtually been done away with. The collection includes many engravings showing topmasts stepped abaft lower masts in various smaller craft.

ANCHORING

The stowed anchor was secured with a ring painter and a shank painter. When approaching a mooring, the latter was let go, and the anchor hung 'a-cockbill' under the cathead, ready to be dropped at the appropriate moment: see Plates 64, 55, 71.

The ship swung about the anchor in a circle, the radius of which was the amount of cable veered. It was important that the hemp cable be kept relatively taut, and the anchor turning in the ground as the ship swung about it, and thus prevent the cable fouling the arm of the anchor. A feature of many of the engravings (Plates 3, 10, 25, 50, 53, 70, 109, 181) is the fashion in which the mizzen topsail is loosed or sheeted home, to ensure that the cable will exert a steady pull on the anchor ring as the vessel rides to the wind. In tidal waters the current could fulfil this function.

A vessel which planned to remain at anchor for a considerable time was 'moored'; that is to say a second anchor was dropped, and the ship rode at a point midway between the anchors, swinging with tide or wind, but in a smaller circle than when at single anchor (see Plate 14).

When weighing anchor, the cable was hove in until the bow was more or less over the anchor, when it was said to be 'a-peak'. When the anchor broke free of the ground, the vessel would drift with wind or tide, and no time was wasted in bringing her under control of canvas and helm. The yards on fore and main were counterbraced so the ship would 'cast' in the desired direction (Plates 13 and 27).

DUTCH AND SCANDINAVIAN CRAFT

Nowadays, the maritime scholar likes to have things neatly labelled. In the past, nomenclature and classifications of types of vessels was extremely fuzzy. Fortunately, we do not have to contend with the terminological minefield that is offered by the craft of the Baltic and North Sea. Starting with Fredrik Hendrik af Chapman's *Architectura Navalis Mercatoria* (1768), we find apparent anomalies like 'frigates rigged as snows', a 'pink-built frigate', a 'cat with snow rigging', and so on. In Hans Szymanski's *Deutsche Segelschiffe* (1934), we find 'sloop-galeass', 'schooner-galiot', 'hooker-galeass', and 'hooker rigged as a brig'. Authors who have struggled with these anomalies more recently include: David MacGregor in *Merchant Sailing Ships: Sovereignty of Sail 1775-1815* (1980); Roger Morris, *Atlantic Sail* (1992); and Veres Lázló and Richard Woodman in *The Story of Sail* (1999).

Galiots are found in Plates 111-115. The Baltic galeass and galiot were small ketch rigged vessels, and according to Röding's *Allgemeines Wörterbuch der Marine* (1794), differed only in the configuration of the stern, that of the galiot being rounded. By this criterion, the vessel shown in Plate 113 would therefore more properly be called a galeass. Based solely on rig, the modern reader would be inclined to refer to them as ketches, but this lacks specificity. In Baugean's day, the Dutch kuff, the dogger, and the bombarde were similarly rigged.

Smack

The Dutch 'barques' shown in plates 117 and 118 would better be designated 'smacks' (Dutch *smak*; French *semaque*). The Belgian galiot shown in Plate 115 is very similar, but the mizzen is stepped a bit further forward, and is somewhat bigger relative to the main.

A few foreign terms, such as *bombarde*, *péniche*, *prame*, and so forth, will be discussed when considering the relevant Plate. Baugean uses the English spelling for 'sloop', etymologically related both to English 'shallop' and French *chaloupe*. Some other words which differ only in spelling are *dogre* (dogger), *cotre* (cutter), and *lougre* (lugger). The sloop was the civilian version of the naval cutter, with a less extreme version of the rig. The dogger (Plate 116) was a ketch rigged vessel, originally employed in fishing in the North Sea, but similar to the northern galiot.

FEATURES OF MEDITERRANEAN CRAFT

To northern eyes, the Mediterranean vessels which are the subject of many of the engravings exhibit several exotic features. Most obvious of all is the lateen sail, both by itself, and in unusual combinations with a southern variation of square rig, featuring pole masts. Until roughly 1750, northern ships set a lateen sail, but essentially only as a mizzen sail, which, as we shall see, was handled in a somewhat different way to the Mediterranean lateen sail. Scanning the engravings in the collection, we note three features that characterise the Mediterranean vessels:

1. A feature shared with many Arab craft was a preference for extending the stemhead high above the level of the gunwale, and decorating its top in some fashion (Plate 140). In the case of the speronare (Plate 109), this took the form of a Maltese cross. François Beaudouin in *Bateaux des Côtes de France* (1975), page 62, illustrates several types of stemhead ornamentation. Following ancient Mediterranean practice, in some types of vessel it was customary to nail a fleece, or in later days, a wooden replica of this (*capigliatura*) to the stemhead. Beaudouin refers to this prolongation as a *capian* (or *capion*; the Spanish word was *caperol*). Occasionally, these words refer to the sternpost as well, so the length of a boat might be described as '*de capion à capion*'.

2. The persistence of a remnant of the ram of the galley of the classical period, in the form of an éperon (Plates 102 and 109; its grating-like structure can be clearly made out in Plate 168). A painting by Vernet in the Timken Museum of Art, San Diego, makes it clear that the grating had a sanitary function.

3. The popularity in many types of Mediterranean craft of a high narrow stern, known to the French as *cul-de-poule* ('chicken-tail'), and to the Spanish as *culo de mona* ('monkey-tail'). Not confined to any one specific type of vessel, it was formed by swinging the bulwarks up and well aft of the sternpost, the *ailes* (*alettes*, *ailette*) or 'wings' on the sides being joined at their terminations with a narrow transom (see for instance Plates 49, 91, 99 and 143). The pinques of Baugean's day (Plates 96, 98, 168, 132 and 175) are transom sterned, but the *cul-de-poule* was found in earlier versions.

Confusion arises because the term 'pink' was also applied to merchant vessels from the Baltic. According to Smyth, *The Sailor's Word-Book*, pinks were especially favoured by the Danes, and characterised by a stern configuration which was rounded off below and fairly narrow above. Falconer says that vessels so built were referred to as 'pink-sterned'. However, judging by the draughts in Chapman, the northern stern configuration was not nearly as extreme as the Mediterranean examples.

In North America a type of stern reminiscent of the *cul-de-poule*, was characteristic of the post-Revolutionary War chebacco boat, the ancestor of the 'pinky'. Coincidentally, some Chebacco boats had high stems, and these were known as 'ram's head boats'. It is tempting to try and relate Chebacco Parish with the 'chebec', 'ram's head' with the fleece nailed to the stemhead, and the word 'pinky' to the pinque, but these can all be explained in other ways.

POLACRE RIG

Many of the square rigged vessels shown by Baugean are pole-masted, or 'rigged polacre fashion', that is to say, lower mast and topmast and topgallant are constructed of a single spar (Plates 37, 45, 50, 55, 70, 71, 76, 83, 86, 95, 99, 100, 101, 103, 107, 132, 173, 184). Although the mast could be a single tree trunk, it was usually built of two or more elements scarphed together, which nonetheless functioned as a unit.

French and English sailors used the word 'polacre' in somewhat different ways. The French describe pole-masted vessels as being *mâtés à pible*, rather than referring to them as being 'polacre rigged'. According to Jal in *Glossaire Nautique* (1868), *pible* was the Provençal equivalent of *peuplier* or 'poplar', which fits quite well with the idea that the mast was, or appeared to have been, hewn out of a single tree trunk.

The sails were similar in function to those in the conventional square rigged vessel, but several features were missing. According to Lescallier's *Traité du Gréement* (1791), these included lifts, top and crosstrees; topmast, futtock, and topgallant shrouds; and top-rope. Cleats nailed to the masts, and a Jacob's ladder running up the after side of topmast and topgallant masts (Plate 50), allowed the sailors to go aloft. Most of the vessels shown in the collection set course, topsail and topgallant. In just one of the Plates (50), we see a royal, a variation confirmed by the work of other artists, such as the Roux family.

The pole mast was not completely unknown in northern Europe: for instance, the pole-masted Norwegian 'cat' in Plate XLIX of David Steel's *Elements of Mastmaking, Sailmaking and Rigging* (1794), while the 'polacca' brigs and brigantines working out of Appledore, Bideford and Barnstable in North Devon, are later examples. Craft rigged in this way are claimed to have been built as far afield as Prince

Edward Island in Canada, by settlers from the West of England. According to Basil Greenhill in *The Coastal Trade: Sailing Craft of British Waters 900-1900* (1975), page 24, the rig was particularly well adapted to navigating the long tidal river leading up to Bideford. Greenhill felt that its origins lay in Scandinavia rather than in the Mediterranean.

In any case, from the point of view of the Mediterranean sailor, the advantage of the pole mast was that, if need arose, topgallant and topsail could be dropped *en paquet*, the upper sails falling in the lee of the sail below. This was particularly useful were the vessel struck unexpectedly by a violent Mistral squall, a not uncommon event in the Golfe du Lion in August. However, a major problem with the rig was the difficulty of replacing such a long spar, were the mast to be damaged. Lescallier notes that for this very reason the masts should be constructed of the very best wood, and of somewhat heavier scantling than conventional 'three-piece' masts.

The word 'polacre' was also applied to a type of vessel. Falconer's *Universal Dictionary of the Marine* (1769) says:

> POLACRE. A ship with three masts… generally furnished with square sails upon the main mast, and lateen sails upon fore mast and mizzen. Some of them carry square sails upon all three masts, particularly those of Provence… neither do they have horses (footropes) to their yards, because the men stand upon the topsail yard to loose or furl the topgallant sail and on the lower yard to loose, reef, or furl the topsail, which yard is lowered sufficiently for that purpose

The illustration actually shows such a vessel, although some authorities would call this a barque.

Solid agreement between the European lexicographers is lacking. Bourdé's *Manuel des Marins* (1773) agrees with Falconer that the fore mast sets a lateen sail, but Lescallier's *Traité du Gréement des Vaisseaux* (1791), Röding's *Allgemeines Wörterbuch der Marine* (1794) and the *Dictionnaire Encyclopédique de la Marine* (1793) indicate that the 'polacre' was similar to the 'barque' and had three square rigged masts. Forfait's *Traité Elèmentaire de la Mâture des Vaisseaux* (1788) says they could be rigged either way, but kept the lateen rigged fore mast if they did not venture out of the Mediterranean. The dictionaries of Willaumez, Romme, and Bonnefoux et Paris are even less clear on this point, remarking that 'some are rigged as chebecs, and others with lateen sails'.

The topsail and topgallant sails were rigged differently in conventionally rigged and polacre rigged vessels. In the former, buntlines on the forward side of the sail hauled the bunt of the sail up to the yard, while on the after side, clewlines hauled the clews up toward the centre of the yard. In Plate 20 we can clearly see a pair of buntlines on the topsail and a single one on the topgallant. In Plates 31 and 51 topsail and topgallant clewlines are to be seen on the after side of the sail. In the ordinary way, buntlines and clewlines were hauled as their respective yards were being lowered (for instance Plate 67), but in Plate 27 the yards have been fully hoisted, but buntlines and clewlines have been slackened off part way. The polacre topsails were fitted with two or three rows of reef-points, but lacked reef-tackles.

The great merit of the polacre rig was the speed with which the upper yards could be got down, and to facilitate this, topsail and topgallant yards were fitted with downhauls, clewlines and buntlines

being dispensed with. The clews of the upper sails were secured to the yardarms of the yard below, rather than being hauled up to the bunt of the yard, as in a conventional square rigged vessel (compare, for instance, the topsails and topgallants in Plate 27 with those in Plates 71 or 76). Topsail downhauls can just be picked out in 50, 70 and 71, and although not very apparent in Baugean's engravings, are carefully shown in the work of other contemporary artists. The fore topsail downhaul was made fast to the lower yard, ran vertically up to a block about a third of the way in from the topsail yardarm, back down to a leading block on the lower yard, and thence back to a leading block seized to the foremost main shroud , and then to the pinrail. The topgallant downhaul was made fast to the centre of the yard, and hence is not visible. These details are fully discussed by Dexter Dennis in an article in *The Mariner's Mirror* Vol 43 (1957), pages 63-9.

Although in general the mast was a single stick, larger polacre rigged vessels did in fact have fidded topgallants (Plates 70, 86). In 70 it can be seen that the topgallant was rigged in the conventional fashion, and we note that the men furling it are standing on footropes. Despite Falconer's often quoted remark about the lack of footropes, these were in fact fitted – for instance, they can be seen in the Antoine Roux watercolours Plates 37 and 43, in Jean Meissonier's *Segelschiffe im Zeitalter der Romaktik: Aquarelle u. Zeichnungen von Antoine Roux* (1968).

Since the mizzen mast was the smallest of the three masts, and hence the most likely to be in one piece in a polacre rigged vessel, it is surprising to find that not only was it commonly fitted with a northern style topmast and top (Plates 50, 70, 71), but that the mizzen topsail was fitted with clewlines, and a single buntline (Plates 45, 86, 101). In Plate 50 there is a mizzen topgallant which is rigged polacre fashion, while the topsail has clewlines. In this case, there is a lateen mizzen sail, but by Baugean's time in many vessels this had been replaced by a gaff mizzen, parallelling a similar development in 'conventionally' fitted square riggers.

In French, the word *polacre* (Italian *polaccone*) was also the term for the triangular fore sail of some tartanes, notably the Arlesian allège, the sail boomed out spinnaker-fashion in Plate 143.

LATEEN RIG

We will discuss lateen rig in some detail, since it is relatively unfamiliar to the English-speaking reader. Mediterranean maritime French was heavily influenced by the Catalan, Spanish, Italian and Provençal tongues, and for this reason the maritime terms used on France's Mediterranean coast, and particularly those having reference to lateen rig, often differ from those familiar to sailors on her Atlantic and Channel coasts. In particular there was a vocabulary that was limited to the royal galleys, reflecting their complicated rigging and handling, and including many terms not found in the standard maritime dictionaries of the day.

The triangular lateen sail is of great antiquity in the Mediterranean basin, dating back to the fourth century (George Bass, *A History of Seafaring: Based upon Underwater Archaeology*, page 135). The lateen was primarily found in Mediterranean vessels, notably in the regions of Provence and Languedoc, and never really caught on in northern waters, or for that matter on the Atlantic and Channel coasts of France, the lugsail, spritsail and gaff being preferred. Exceptions to this generality are offered by some Swedish galleys of the 1700s, which were rigged with lateen sails, and the substantial numbers of lateen rigged craft employed by the United States Navy during the hostilities with the Barbary pirates (see the chapter on 'The Gunboat

War 1801-1810' in Howard A Chapelle's *The History of the American Sailing Navy*). These, however, were historical aberrations, provoked by conscious imitation of Mediterranean vessel-types, and it is fair to say that the rig never caught on outside the Mediterranean basin. The lateen sail was more effective than the square sail when plying to windward, and was more suitable for use in vessels primarily propelled by oars, and especially when using both at once, but the sheer size of the sail became a problem if the wind strength increased beyond a certain point.

Simple version

If we consider the rig in its simplest possible manifestation in a dinghy sized boat, we have an unsupported stump mast; a yard (*antenne*), made from one piece of timber; and a single triangular sail. The essential items of rigging include six elements: a halliard (*drisse*); a simple truss or parrel to hold the yard close to the mast (*drosse*); a sheet (*écoute*); a vang (*oste*) to control the upper end of the yard; and two 'bowlines' (*orse à poupe* and *cargue d'avant*) which control the movement of the forward end of the yard, allowing it to swing up and out relative to the stem. The use of the term 'bowlines' can be justified because the name given the tackles which controlled the side-to-side movement of the lateen mizzen yard in the eighteenth-century British warship was 'mizzen bowlines'.

In vessels of any significant size, the yard consisted of two elements, an upper 'peak' (*penne*); and a lower 'butt' (*car* or *quart*), which overlapped towards the middle of the yard, and together with strengthening fishes (*jumelles*) or (*alepasses*) placed above and below, were lashed or woolded securely together to form a unit. In a large galley, the weight of the yard was concentrated at this overlap, which was closer to the *car* than the *penne*, and the tye (*aman*), with which it was hoisted, was secured to a point somewhat aft of the midpoint of the overlap, allowing the yard to hang with the *car* down and *penne* up. In smaller vessels, the overlap ran almost the whole length of the yard (see Plates 96, 184). Gravity causes the yard to droop a bit at the ends, so it assumes a graceful curve, rather than being dead straight. Likewise, when before the wind, the yard exhibited a curve so that *car* and *penne* were forward of the point at which the tye was secured. By the way, we note that in square rigged vessels of the fifteenth century, such as Columbus' *Santa Maria*, the main yard was doubled in a similar fashion. Since the *penne* of the lateen yard was longer than the *car*, it was significantly 'whippier', and it was precisely this flexibility at the peak that helped spill the wind if the sail was hit by a sudden gust. Functionally, the yard may be likened to a feather (Latin *penna* = feather) and the desiderata of a lateen yard, from the point of view of a Mediterranean sailor, were that it have 'a butt of iron, and a peak of fennel'.

Additional rigging

The head of the sail was secured to the yard by robands (*garcettes; matafians*), and these were of sufficient length to serve as furling gaskets. As is apparent in many plates, it was the custom, when the sails were furled, to keep the yards aloft. Plates 90 and 102 show how the Mediterranean sailors, precariously perched on the sloping yard, loosed, furled and reefed the lateen sails.

To aid in furling or reefing the sail, lines were secured to the foot and after leech of the sail, which for convenience we will call 'brails'. When hauled upon, they pulled the canvas up to the yard. When sailing with the wind on the quarter, the main sail might be clewed up, to give the wind an unobstructed shot at the fore sail – Plates 49 and

98. Another reason for partially clewing up the sail was to make it easier if the crew were assisting progress in light winds by rowing (Plate 134).

Many of the plates show two rows of reef-points, diverging at a narrow angle, as they ascend, from the head of the sail, a sailmaking practice followed for a very good reason: when a vessel heels, the effort of the wind can be imagined to be exerted at a point on the lee side of the keel, and hence the bow tends to head into the wind (and the ship 'carries weather helm', as it is called). This implies that as the wind and angle of heel increase, more after canvas needs to be taken away. An even more significant reduction of area of the after part of the sail can be achieved by hauling the upper leechline up to the yard (Plates 97 and 102).

We mentioned above the six items essential to sailing the smallest single-masted lateen rigged craft. As the size of the vessel increased, additional items of rigging were necessary, with the most sophisticated versions in the naval galley. The pinque in Plate 99 exhibits three lines which would be used to secure the sail: two 'leechlines' and what might be described as a 'clewline'. The upper end of the *penne* was sometimes fitted with a sheepskin 'bonnet' to prevent tearing the sail, should it become foul.

The unsupported stump mast which is adequate in the smallest craft would not suffice in larger vessels. The fore mast (*mât de misaine*) of a lateen vessel was called the *trinquette*; the main mast (*grand mât*) was the *mestre*. Instead of using the type of shrouds found in northern ships, which were made taut with deadeyes and laniards, lateen rigged vessels fitted tackles called *sartis* (sometimes referred to as *haubans à colonne*) to support the mast. Those on the weather side were hauled taut. In some of the smaller vessels seen in Baugean's engravings – for instance the feluccas in Plates 91 and 92, the masts are supported by a couple of pendants and tackles on each side. In the larger craft, a runner-and-tackle arrangement was preferred. The engraving showing the rigging of a royal galley in Admiral Paris, *Souvenirs de Marine* indicate that the blocks were set up with toggles, so that they could readily be slipped. This was necessary if the sail was to be set 'outside' the rigging.

In a dinghy, a simple rope halliard sufficed, but in larger vessels, a runner-and-tackle arrangement was employed, the yard being supported by a 'tye' (*aman*), which in turn was secured to a tackle, the falls of which were the 'halliards' (*drisse*). When the yard is hoisted, the halliard blocks are close together, and when it is struck, the upper block is close to the masthead. Baugean has carefully recorded this detail in many of the plates: for instance in Plate 96 the upper halliard blocks are almost at the mastheads, whereas in Plates 83 and 89 the upper block is closer to the deck.

Most of Baugean's vessels fit a vang (*oste*) of the simplest nature, but in Plate 49 fore and main vangs consist of pendant and tackle. In the largest galleys, extra tackles were used to haul the *car* aft, when going about – *mouton* on the *mestre*; *carguettes* on the *trinquette*.

SEAMANSHIP OF THE LATEEN SAIL

First of all, let us consider the lateen sail in its northern incarnation, the mizzen, fitted in all square rigged ships until roughly 1750, after which it was replaced by a gaff mizzen. When sailing by the wind, the forward part of the sail would have set best if the yard were on the lee side of the mast, while on the other tack, it would have been thrown aback. To avoid this, the yard could be shifted, or 'changed', by hauling the peak of the yard up toward the mizzen topmast, and pulling the butt of the yard aft towards the mast, and then dipping it

round abaft the mast. This manoeuvre, which for convenience we will call Method A, is described and illustrated on page 77 of *Seamanship in the Age of Sail*.

Likewise, when sailing by the wind, the Mediterranean version of the lateen sail will set best if the yard is to leeward of the mast – the 'good' way (*à bonne main*). For short tacks, progress will be made, even if the fore part of the sail is thrown aback against the mast, and partially aback, when the yard is on the weather side – sailing the 'bad' way (*à mauvaise main*, or *à bido*); see Plate 99. However, if a long board is to made on that tack, it is preferable to set the sail to best advantage, and this implies that the yard must be shifted from one side of the mast to the other.

There are two ways this can be managed. Firstly, Method A, lowering the halliard part way, and dipping the *car* around *behind* the mast, and resetting the sail. This is the method followed with the lateen mizzen in Mediterranean craft like the pinque in Plate 97 where there are mizzen topmast and mizzen shrouds, and in the settee variety of lateener called the misticou (Plates 52 and 87), which is discussed below. There is, however, another option, Method B: namely swing the yard the 'long way round', peaking it up to a near vertical position, and dipping its forward end around the *forward* side of the mast (*faire le car*, or *trelucher*). In some ways, it can be compared to a gybe with a gaff sail, except that everything goes around forward of the mast. In a dinghy, it is performed by turning away from the wind, letting go the sheet, hauling the butt of the yard back against the mast, and dipping it round on the other side, and recovering the sheet. This manoeuvre involves rotating the yard almost 360 degrees around the mast in a horizontal plane, and what is perhaps less obvious, it rotates 360 degrees axially while doing so. This manoeuvre is more easily managed if the mast is raked forward, as seen in many of the lateen rigged craft in the collection (for instance Plate 96). The best encapsulation of how this was managed in a dinghy is found in an article by François Beaudouin, 'La Pratique de la Voile Latine', in *Le Chasse Marée*.

Method B must be tricky enough for the dinghy sailor, but it is astounding to think of its being carried out aboard a lateen rigged royal galley. How this was executed is the subject of an excellent article by René Burlet and André Zysberg, 'La Galère sous Voile vers la Fin du XVIIe Siècle', in *Le Chasse Marée*. By untoggling the rigging, the yards could be shifted round in front of the mast, using Method B, and placed inside or outside the rigging, according to circumstances. By lowering the yard down upon the central gangway, sails of different sizes could be substituted, depending on the weather. This was no light work, since the main yard and largest main sail of a royal galley weighed in the neighbourhood of two tons.

The Alexandrian djerme, shown in Plate 110, offers an example of a variant of the lateen sail found in the Arab world. This particular engraving shows a triangular sail, rather than the four-sided settee, more commonly found in the vessels sailing the Red Sea, but it shares with the latter the feature that the yard is mastheaded, and upon going about, the yard tumbles over the top of the masthead, rather than having to swing round in front of it. Note that the main mast is supported by shrouds that are set up with deadeyes and laniards rather than the tackles seen in other comparable vessels, and that the sail is set 'outside' the rigging.

Tye and halliards

It is apparent that tye and halliards must be rigged in the appropriate way for these manoeuvres. For Method A it must be secured to the

yard, pass forwards through the mast sheave, and be set up forward of the mast. For Method B, things must be arranged exactly the other way around.

Inside or outside the rigging
Although this manoeuvre is not mentioned by later authors, Boteler, Smith and Mainwaring, writing in the days of the Jacobean navy, describe how the lateen mizzen could be unparrelled from the mast, got around, outside the rigging and 'goose-winged', when sailing before the wind. Here is Mainwaring's description from *The Seaman's Dictionary* (pages 155-6):

> GOOSE-WING. When we are going before a wind, or quarter-winds, with a fair fresh gale, we many times to make more haste, unparrell the mizzen-yard, and so launch out the yard and sail over the quarter on the lee side, and so are fitting guys at the farther end to keep the yard steady, with a boom we boom out the sheet, of the mizzen sail. This doth help give the ship some way, which otherwise the mizzen sail will not, especially before a wind. This sail so fitted is called a goose-wing.

If I understand this correctly, the yard was got around on the outer side of the lee shrouds, and forward of the lower mast, and something analogous was practised with the Mediterranean lateen sail. The yard may be 'inside' or 'outside' the side-tackles (*sartis*). In Plates 69 and 143 the wind is on the quarter, and the yard is 'inside'; the lines controlling the *car* have been eased off, allowing it to swing to the weather side of the bow; the *penne* is to the lee side, and the sail can be seen to be pressing on the lee rigging. In Plates 49, 89 and 90 the wind is further aft, and the yard has been shifted 'outside' and forward of the rigging. Had the mast been rigged northern-fashion, with shrouds, deadeyes and laniards, this could only have been managed with enormous difficulty, and indeed it cannot have been child's play with the craft shown here. In the galleys the manoeuvre was facilitated by the use of toggles, which allowed the tackles on the lee side to be slipped. The yard was then swung forward, and the toggles reinserted. The galleys had the manpower which allowed this to be done. What I find harder to imagine is the practice in intermediate sized vessels, which were big enough to require lateral support for the mast, but did not enjoy the luxury of a large crew.

Balancing the lateen sail
The canvas of a square sail is deployed evenly on either side of the mast, so when running before the wind, the sail has no tendency to make the vessel deviate from its downwind course. However, the lateen sail is inherently asymmetrical in relation to the mast, and while this matters little when sailing by the wind, as the vessel goes further and further off the wind, the amount of canvas on the *penne*, or lee side, increasingly exceeds that on the *car* end, and when almost before the wind, a single lateen sail would be grossly unbalanced, relentlessly pushing the bow to windward. This can be corrected by slacking off the *orse poupe* and *cargue d'avant*, allowing the *car* to rise, and hauling down on the *oste*, so that when dead before the wind, the yard is more or less horizontal and athwartships. This 'balances' the sail and obviates the need to carry a lot of weather helm.

With two lateen rigged masts the sails can be winged out on opposite sides, like the 'rabbit ears' of the television antenna – the French expression for this configuration was, in fact, 'hare's ears'

(*oreilles de lièvre*), and is demonstrated by the vessel in the background in Plate 143. This is the inspiration for John Smith's comment in *A Sea Grammar*, page 50, where he speaks of 'a caravel, whose sails 'stand like a pair of tailor's shears'.

A third way of overcoming the imbalance is demonstrated by the single-masted allège in the foreground of Plate 143. Here, the solution is the deployment of the fore sail, or *polacre* as it was called in Mediterranean craft, which is set spinnaker-fashion to weather. This immense sail was not set on a stay. The guys to hold its boom steady in a fore and aft direction can be seen clearly. Contrary to northern practice, the sail was left aloft when furled. The furling gaskets on the luff of the sail can be seen in Plates 52, 54 and 87.

An oddity about the lateen sail is that, when almost before the wind, it can be set either before or abaft the mast. Unlike the lug sail (see Plates 61 and 128) which on this point of sailing must be set forward of the mast, the lateen offers an additional option, as seen in Plates 57 and 98. The sheet is hauled well aft on the lee side; the vang has been hauled taut to pull down on the *penne*, and bowlines have been eased off so the *car* has swung aft and to weather, and been allowed to rise.

Alternating lateen and square rig
It would wrong to suppose that vessels were either square rigged or lateen rigged. The combinations of lateen and square rig, seen in Plates 100, 102, 103 and 173 seem rather weird to northern eyes, but were perfectly practical. Then there are craft which at one time in their career were lateen rigged, but converted to square rig later on. The chebec in Plate 84 is rigged in traditional fashion, while the polacre rigged chebec in Plate 86 is square rigged. The traditional tartane was lateen rigged, but that shown in Plate 107 has a square rigged main mast, while in Plate 69 we have a lateen sail with square topsail set above it. Even more surprisingly, Baugean describes the craft in Plate 111 as a 'square rigged tartane' (a very similar vessel is seen in the background in Plate 98).

Some vessels shift back and forth between square and lateen rig. Plates 96 and 97 show Genoese pinques, with their lateen yards struck. The latter has set square courses on fore and main, with the corresponding topsails furled and lowered, polacre-fashion. The anchored corsair in Plate 83 is airing its lateen and square canvas.

QUADRILATERAL FORE-AND-AFT SAILS
The settee sail
The lateen sail is triangular. A trapezoidal variant of it was known to English seamen as the 'settee', and there are examples of this in engravings 52, 87 and 88. This was the form of sail found in Arab craft until well into the twentieth century, and it can be thought of as intermediate between the lateen and the lug. The vessel represented in Plate 87 is called 'mistico' or 'misticou', a rig which was popular in Spanish Mediterranean vessels. The yard was so suspended that it peaks up at a similar angle to the lateen, but the forward end was shortened, and the sail cut with a forward leech. We note that in the three engravings mentioned, the side-tackles are set up to a structure which resembles the channels of northern craft, and this leads us to conclude that it was handled like a northern lateen mizzen: that is to say, the yard was shifted from side to side using Method A by dipping the forward end round abaft the mast, and this in turn means that tye and halliards should be before the mast. A close look at Plate 87, suggests that this was how things were arranged. Just how the crew managed to scramble up onto the yard to furl or reef the sails is a little

puzzling, but the fact that the sails are furled with the yards left aloft, confirm that furling was done in a similar fashion to the lateen. In the tartanes with square topsails, seen in Plates 69 and 184, we can only imagine that if the lateen yard was shifted at all, it could only have been done in the 'northern' fashion.

The lugsail

Lugsails were relatively straightforward to handle, and did not have the treacherous reputation of the lateen, where the watchword was: 'If you do not understand me, do not touch me.' On Atlantic and Channel coasts of France, and in the Adriatic, the lugsail was favoured. It differed from the settee in that its yard was proportionately shorter, relative to the mast; that the yard more nearly approached the horizontal; that the spar was made from a single bit of timber, unlike the two overlapping elements of a traditional lateen yard; and that it was reefed from the foot (Plates 78, 112, 122 and 123).

As with the lateen, lateral support to the mast was provided by runner and tackle. Halliards varied in complexity depending on the size of the craft. In small vessels the mast had no shrouds, but the halliards were set up to windward to provide support. In lateen rigged vessels the yards tended to be left aloft, even at anchor, but in those rigged with lugsail, the yards were lowered for furling or reefing (Plate 46). An exception to this is offered by the flambard in Plate 126. If it were necessary to shift the yard round the mast, this was done by Method A. Plates 12, 58 and 119 show lugsails fitted with spilling lines, but for the most part these are not shown. Larger luggers were fitted with fore-and-aft topsails (Plates 2 and 119).

Lugsails could be divided into two categories: the standing lug, and the dipping lug. In the former, the yard is kept on one or other side of the mast at all times, with the tack of the sail made fast close to the foot of the mast, and a relatively short section of the yard ahead of the mast (main mast in Plate 105). The tack of the dipping lug was secured well forward of the mast, which meant that relatively more canvas was thrown aback should the wind come from the wrong side (Plate 12). In the worst case, this could make it difficult to lower the yard, and might result in a knockdown. So, when making a long tack, the dipping lug was shifted to leeward, whereas the standing lug could be let stand, since so little canvas was aback.

The Adriatic version of the lugsail is idiosyncratic because it features a boom laced to the foot of the sail. The trabaccolo, shown in Plate 105, is the only example in the collection showing this feature. One imagines that these craft would have been able to sail a bit closer to the wind than the luggers of the Atlantic coast, because the sail would have set a bit flatter if laced firmly down to the boom. Modern craft rigged in this fashion are sailed competitively in the lagoon at Venice, and their sailors always lace the foot of the sail tightly to the boom, but perhaps by easing it off, as shown in Baugean's engraving, it allowed the sail to set better, when somewhat off the wind. Although not shown here, other contemporary sources make it clear that bowline bridles were fitted to both sails. Admiral Paris, in *Souvenirs de Marine* Plate 87, shows a trabaccolo with small square topsails on both masts. As with lugsails in general, these sails reefed to the foot. The yards were commonly set on opposite sides of the mast, so they could be winged out on opposite sides when running. By using a boom tackle abreast the mast, it was possible to hold the foot of a sail set on the weather side clear of the mast. The etymology of the word *trabaccolo* is debatable. The *Dizionario Etimologico della Lingua Italiana* says it is a diminutive form, which may be connected with an obsolete word, *trabacca* meaning 'tent', which in turn, is thought to have Arabic roots.

The sprit sail

The yards of lateen and lugsail offer two methods of holding the peak of a trapezoidal fore-and-aft sail out to leeward. A third method of achieving this was the sprit – something we are inclined to think of as a feature characteristic of northern craft like the Thames barge or the Dutch tjalk, but which was in fact used in many Mediterranean craft, notably the sacoleva, shown in Plate 104. Engravings by Jouve, dating from the seventeenth century, show feluccas and brigantins (a larger version of the felucca) rigged with spritsails, and the Maltese speronares in Plate 109 are canvassed in this fashion.

The gaff sail

The gaff is a the fourth method of extending the peak of a trapezoidal sail, and although most of the examples found in the collection are northern craft, such as schooners or the galiots shown in Plates 111 or 115, note that it is found in the 'square rigged tartane' also in Plate 111.

The liuto

The fore sail shown in the liuto in Plate 71 – really a variant of the staysail – could be though of as a fifth method of setting a quadrilateral sail. Clearly, it would function well enough when close-hauled, and be effective over much the same range as a trapezoidal staysail (compare the main topmast staysail in Plate 45). However, it would have generated more leeway than a gaff or spritsail, the tendency increasing the further one went off the wind. Off the wind, the most effective thing would have been to boom it out on a sort of extempore sprit, similar to the arrangement seen in the Provençal fisherman in Plate 141. This type of sail was found in the navicelli of the Ligurian coast well into the 1900s.

Houari

Houari (the word is related to English 'wherry') was the name given to the fishing lugger in Channel ports like Honfleur and Dieppe (Plate 131). However, other authorities, like Willaumez and Lescallier, apply the term to a vessel with an early version of gunter rig: that is to say, the sail had a leg-of-mutton or triangular configuration, the yard being hoisted almost vertically, in effect extending the mast upward.

Note

The original Plate numbers are given in square brackets at the end of the current captions, the titles of Baugean's volumes being shortened to '*Collection*' for *Collection de toutes les Espèces de Bâtiments de Guerre et Bâtiments Marchands, qui naviguent sur l'Océan et dans la Mediterranée*, and '*Petites Marines*' for those from *Receuil de Petites Marines*.

Bibliography

The following are the principal works used as sources in the Introduction:

Dictionnaire Encyclopédique de la Marine (Encyclopédie Méthodique, Marine) (Paris 1783-1793).

George Bass, *A History of Seafaring, Based upon Underwater Archaeology* (New York and London 1972).

Jean-Jérôme Baugean, *Collection de toutes les Espéces de Bâtiments de Guerre et Bâtiments Marchands, qui naviguent sur l'Océan et dans la Mediterranée* (Paris 1814).

Jean-Jérôme Baugean, *Receuil de Petites Marines* (Paris 1819).

François Beaudouin, *Bateaux des Côtes de France* (Grenoble 1975).

François Beaudouin, 'La pratique de la voile latine', *Le Chasse-Marée*, No 5, pages 45-53.

E Bénézit, *Dictionnaire critique et documentaire de Peintres, Sculpteurs, Dessinateurs et Graveurs* (Paris 1976).

P M J Bonnefoux et E M Paris, *Dictionnaire de Marine à Voiles et Vapeur* (second edition, Paris 1859).

Jean Boudriot and René Burlet, chapter entitled 'Définitions sommaires de bâtiments du levant', in *Chébec de 24 Canons Le Requin 1750* (Paris 1987).

M Bourdé, *Manuel des Marins* (L'Orient 1773).

Howard A Chapelle, *The History of the American Sailing Navy* (New York 1949).

Fredrik Hendrik af Chapman, *Architectura Navalis Mercatoria* (Stockholm 1768).

F A Costé, *Manuel du Gréement* (Paris 1849).

Dexter Dennis, 'Notes on the Polacre Rig', *The Mariner's Mirror* Vol 43 (1957), pages 63-9.

Jean Ducros, Preface to the reprint of *Collection de toutes les Espéces de Bâtiments de Guerre et Bâtiments Marchands*, published by Editions des Quatre Seigneurs (Grenoble 1971).

William Falconer, *An Universal Dictionary of the Marine* (London 1769).

P A L Forfait, *Traité Elémentaire de la Mâture des Vaisseaux* (Paris 1788).

Robert Gardiner, *Warships of the Napoleonic Era* (London and Annapolis 1999).

Basil Greenhill, *Schooners* (London and Annapolis 1980).

Basil Greenhill and Lionel Willis, *The Coastal Trade: Sailing Craft of British Waters* (London 1975).

Irene de Groot and Robert Vorstmann, *Sailing Ship Prints by the Dutch Masters from the 16th to the 19th Century* (Maarsen, Netherlands 1980).

John Harland and Mark Myers, *Seamanship in the Age of Sail* (London and Annapolis 1984).

Augustin Jal, *Glossaire Nautique* (Paris 1848).

René de Kerchove, *International Maritime Dictionary* (second edition, New York 1961).

John Leather, *Spritsails and Lugsails* (London 1979).

James Lees, *Masting & Rigging of English ships of War 1625-1860* (London and Annapolis 1979).

M Lescallier, *Traité du Gréement* (Paris 1791).

Darcy Lever, *The Young Sea Oficer's Sheet Anchor* (London 1808 and 1819).

David MacGregor, *Merchant Sailing Ships: Sovereignty of Sail 1775-1815* (London 1980).

Henry Mainwaring, *The Seaman's Dictionary* (c1644), in G E Manwaring and W G Perrin (eds), *The Life and Works of Sir Henry Mainwaring*, Vol 2 (Navy Records Society, London 1922).

Jean Meissonier, *Segelschiffe im Zeitalter der Romaktik, Aquarelle u. Zeichnungen von Antoine Roux* (Berlin 1968).

Roger Morris, *Atlantic Sail* (London 1992).

Admiral François-Edmond Paris, *Souvenirs de Marine* (6 vols, Paris 1882-1908).

J H Röding, *Allgemeines Wörterbuch der Marine* (Hamburg and Halle 1794).

Charles Romme, *Description de l'Art de la Mâture* (Paris 1789).

W H Smyth, *The Sailor's Word-Book* (London 1867).

David Steel, *Elements of Mastmaking, Sailmaking and Rigging* (London 1794).

Hans Szymanski, *Deutsche Segelschiffe* (Berlin 1934).

Harold Underhill, *Sailing Ship Rigs and Rigging* (Glasgow 1938).

Harold Underhill, *Rigging of the Clipper ship and Ocean Carrier* (Glasgow 1979).

Jules Vence, *Construction et Manoeuvre des Bateaux et Embarcations à voilure Latine* (Paris 1897).

Veres Lázló and Richard Woodman, *The Story of Sail* (London and Annapolis 1999).

Jacques Vichot, Jean-Jérôme Baugean, *Peintre et Graveur de la Marine* (Paris nd, c1980).

Admiral Willaumez, *Dictionnaire de Marine* (Paris 1831).

André Zysberg and René Burlet, 'La galère, un voilier mediterranéen', *Le Chasse-Marée*, No 29, pages 32-51.

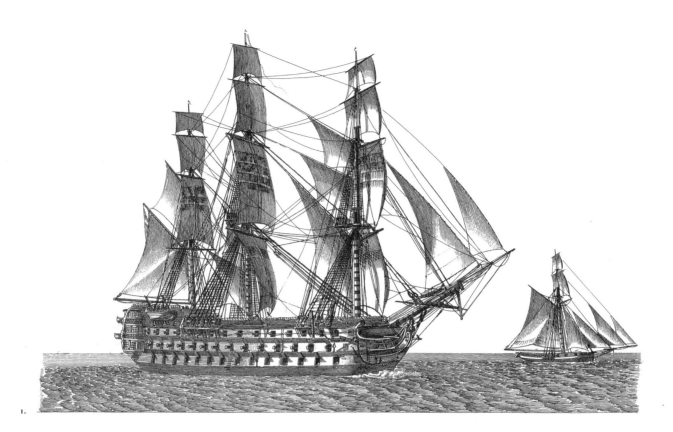

A BRITISH three-decker, with all main staysails set. Note the upper gaff topsail (which was an 'unofficial' sail, presumably run-up on board by the sailmaker) and that the royal masts are not fidded; separate royal masts were introduced in the 1790s. We cannot advance an explanation for the trim of the fore yards, compared to those on main and mizzen.

Baugean notes that British three-deckers were shorter than their French equivalents, and consequently seemed to have more freeboard. In fact, the French built only very large three-deckers whereas the British fleet included relatively high numbers of moderate-sized Second Rates of 98 guns (which seemed tall for their length) as well as a few First Rates of 100-120 guns.

To the right is a cutter, at the time recognised as a characteristically English craft, although other navies did build a few. [*Petites Marines* 32]

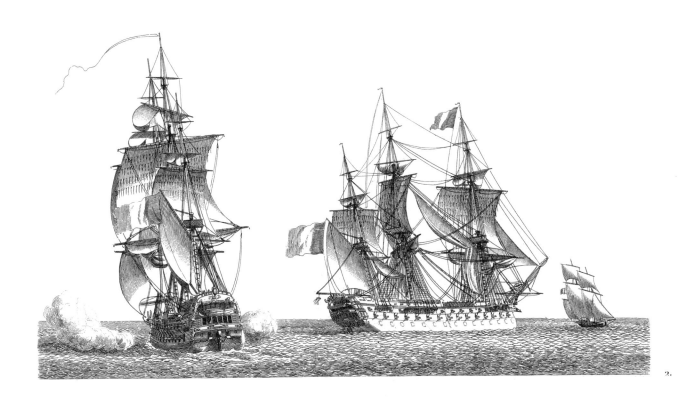

2.

\mathcal{A} 74-GUN ship sailing large, on the starboard tack, and firing to salute the admiral who has hoisted his flag in the three-decker at centre. The flags and stern configuration of the 74 make it clear the vessels are French. Both vessels have top-gallant crosstrees, and the three-decker has fidded royal masts, which could be struck behind the topgallant masts (compare Plate 27). The flagship is hove to, main topsail to the mast; main topmast staysail and mizzen staysail brailed up, and his flag hoisted at the fore, indicates he is a vice-admiral (compare Plate 20). The truth of Baugean's observation about the relative pro-portions of French and British three-deckers is apparent: the French ship is of greater length and has more gunports per tier, by comparison making her seem 'snug' (as seamen termed it).

In the background is a chasse-marée, as characteristically French a ship type as the cutter in the previous Plate was English. [*Collection* 60]

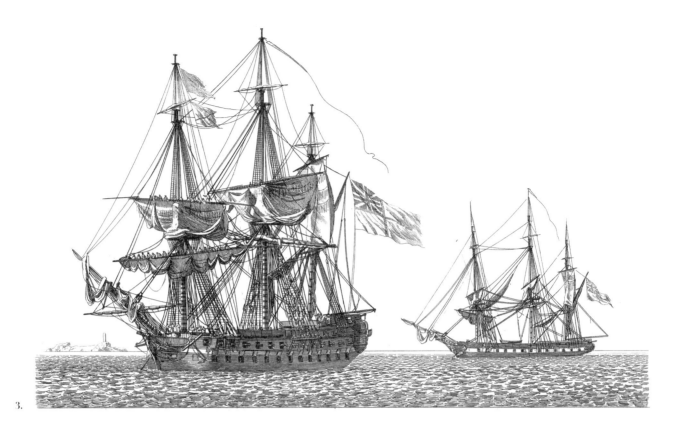

3.

A_N English 74-gun ship and a frigate, sailing in company, have just anchored and are engaged in furling sail. The topsails are draped over the lower cap and top; jib and fore topmast staysail have been hauled down, main topmast staysail, and mizzen staysail brailed up; studding sail booms have been run out, to keep them out of the way of the men on the yards, and in both cases mizzen topsails remain set, in order to push the stern round to leeward.

Baugean is of the opinion that the English vessels were not as handsome or as well constructed as their French counterparts, but felt that the English 74s were handier in going about, because they were shorter, carrying 28 guns on their lower gun deck, as against 30. In fact, this was only partially true: French 74s had thirty ports, but usually mounted only 28 guns; British 'Common' Class 74s were shorter, but numbers of larger 74s built in the 1790s were as big as French 74s – and just as unhandy.

In the background is one of the smaller British frigates, with thirteen gunports on the main deck. She is hoisting out her boat. [*Collection* 19]

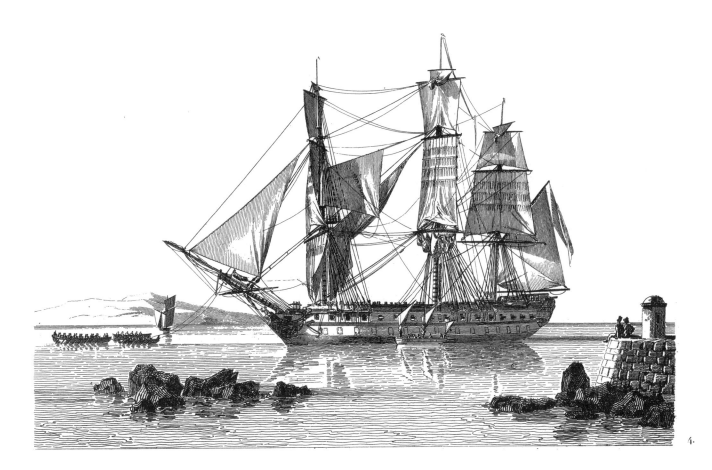

4.

\mathcal{A}N 80-gun ship of the line, being towed by her boats in a dead calm. In this case most of her canvas is set in the hope of profiting from any breath of air which might spring up. If the boats could get the vessel moving through the water, sometimes it was better to furl canvas to reduce air-resistance. One of the boats lies alongside, and three others are towing.

The very large two-decker of this type was characteristically French. With up to sixteen gun-ports a side in each battery, their broadside was more powerful than that of a British 98-gun Second Rate; but being longer and lower, they were faster and more weatherly. Much favoured later in the war as flagships – Villeneuve's *Bucentaure* at Trafalgar was such a ship – their main drawback was that the inordinate length made them susceptible to structural problems. [*Petites Marines* 75]

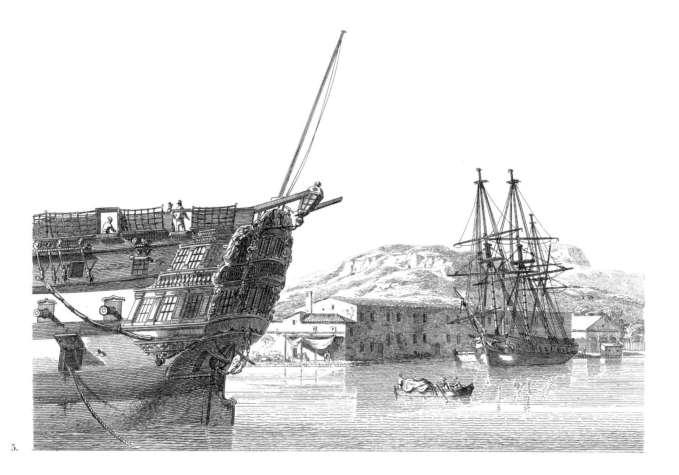

5.

S TERN of a British 74-gun ship, obviously intended to contrast with the stern of the French two-decker opposite. Although British ships had individual decorative details, from the 1760s onwards the overall scheme was more or less standardised, with 'architectural' features like pilasters and bas-relief balustrading between the rows of 'lights' or windows; there were also carved figures for quarter-pieces and low-relief carving on the taffrail. These carvings are beautifully indicated here.

One of the most obvious differences between national styles was the form taken by the lower finishing (sometimes called the 'drop') of the quarter gallery. This is the elaborately decorated support for the lower part of the gallery. In French and Spanish ships of that date it took the form of a forward sweeping volute, while in the English vessels it was more conical (compare Plates 3, 7, 10, 13, 14, 21, 23, 25, 26, 28, 159). Another difference was the fashion in which the vessel's name was displayed. The French preferred to place it in small letters, inside a decorative framework or cartouche, while in British ships of the 1770-1780s the name was painted in large letters across the upper counter. Somewhat later, practice changed, and most British ships painted out their names for security reasons.

This engraving is full of fascinating details: fixed davits for the jolly-boat over taffrail; the hammock netting; rigols over the half-ports on the upper deck; the rudder-chains with their tackles, stopped at intervals across the transom and up to the mizzen channels. [*Collection* 36]

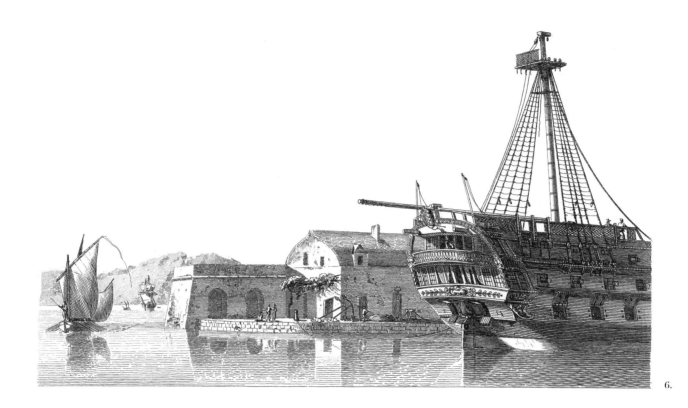

6.

\mathscr{S}TERN of a French 80-gun ship of the line, show-ing the classic horseshoe shape associated with the French designer Jacques-Noël Sané. The French ship has an open gallery, a feature given up around 1800 for most British ships of the line. The other obvious differences shown here include: the way the stern davits are arranged; the configuration of the lower finishing piece of the quarter gallery; enclosure of the ship's name in a cartouche, and the decoration of the upper counter; half-ports for the stern-chasers. This Plate does not show rigols placed over the ports to shed water as in the English ship, but these were in fact in use in French ships at that time. After a brief flirtation in the 1790s with revolutionary iconography – the Cap of Liberty, for example – French decorative work settled down to rather restrained classical and abstract imagery, like the wreaths along the upper counter. [*Collection 57*]

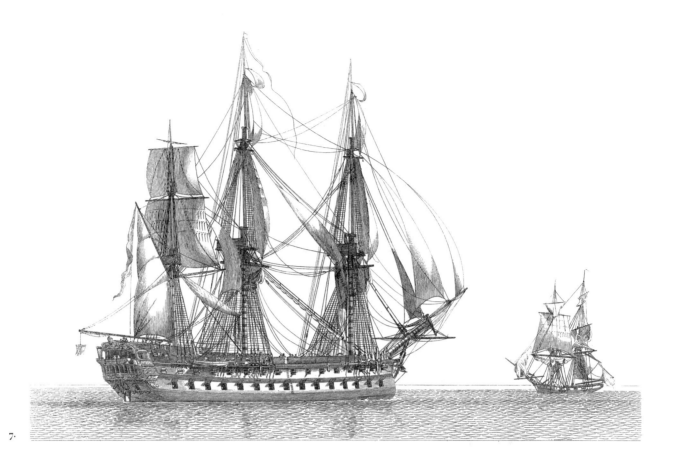

7.

\mathscr{F}RENCH 74-gun ship, sailing on the port tack in a light breeze. The mizzen topsail and topgallant have been thrown aback, mizzen staysail, main topmast staysail and spanker, all brailed in, and the courses brailed up. Baugean says this was done either to wait for a boat, or to slow down for another vessel in the same squadron. As well as a small boat slung under the taffrail, the ship carries boats under quarter davits, an innovation of the later part of the war.

In the background, a brig is hove-to, main topsail to the mast, and the peak of the fore-and-aft main sail dropped, to 'scandalise' the sail. [*Collection* 1]

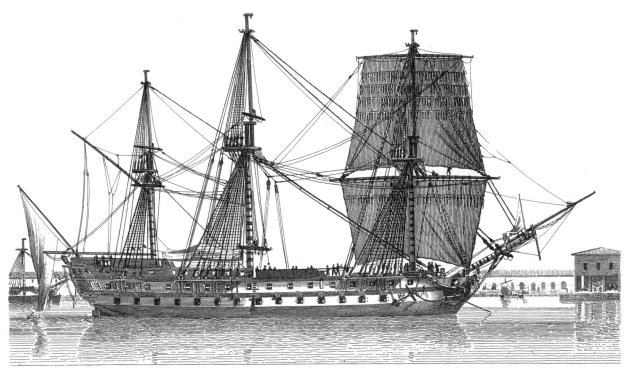

8.

\mathscr{F}RENCH 80-gun ship moored fore and aft in the dockyard basin, under refit. Main lower yard and topgallant masts have been struck. Baugean thought the 80-gun ship was the ideal ship of the line – handier than the three-decker, but more heavily armed than the 74. He says this ship was armed with 36-pounders on the lower gundeck, 24-pounders on the second gundeck and 12-pounders on the quarterdeck. The crew have bent her fore course and fore topsail to the yards, to make sure they are a good fit. The starboard bowline has been hauled. As mentioned in the Introduction, he has meticulously represented the halliard fly-blocks and mizzen brails. [*Petites Marines* 54]

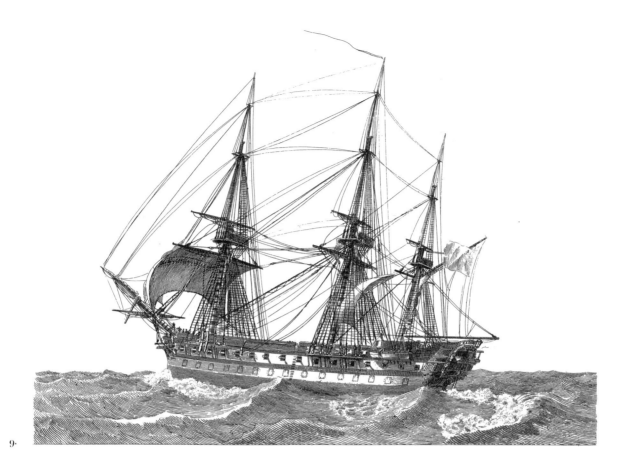

9·

\mathscr{F}RENCH 74-gun ship running before the wind.
The ship is prepared for heavy weather, with lower-deck gunports closed and guns secured.
Despite the conditions, the topgallant and royal masts are aloft. The topgallant yards have been
sent down, and can be seen stowed in the lower rigging, starboard side fore, and port side on
the main. Everything has been taken in, save the fore course, a small fore topmast staysail and
the mizzen staysail. The fore course was particularly useful in this circumstance since it exerts
a lifting force on the bow, all other square sails having the opposite effect. [*Petites Marines 43*]

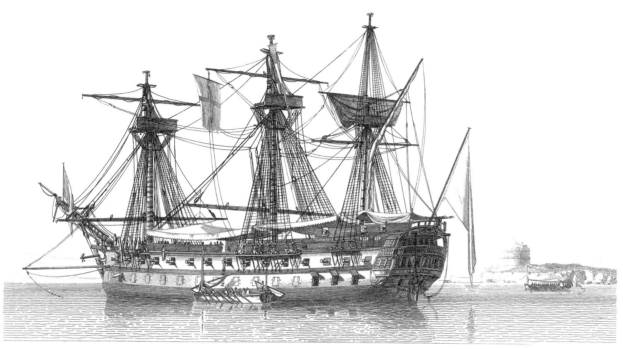

10.

\mathcal{F}RENCH 74-gun ship at anchor, partially de-rigged. It appears to have thirty gunports on the lower gundeck, plus stern-chasers. A detail shown here, and in Plate 8, are the heads of the ringbolts for the breeching-tackles, indicated as two points on either side of the lower gunports. Other items of interest include: fore and main lower yards are lowered, and topmasts are struck; the mizzen topsail is loosed; relatively elaborate awnings are spread; the lower studding sail boom is deployed for use in securing the ship's boats; the boat-rope for the launch is visible; cat-harpings are seen at fore and main; a signal, flown *en bannière*, is seen at the main topmast yardarm. This method was used in a calm, when a flag would have hung limp, to ensure that a signal was readily visible.

In the background a barge with awning fitted flies a flag, presumably that of a senior officer. [*Collection* 35]

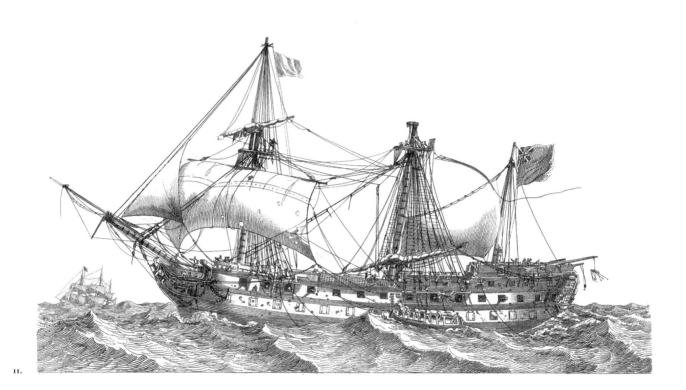

II.

*A*BRITISH 74-gun ship which has sustained major battle-damage. Wooden battleships could absorb enormous punishment and were very rarely sunk in action, the French *Vengeur* at the Glorious First of June being one of the unfortunate few. Instead, close-range rapid fire smashed in the upperworks, dismounting guns, filling the gundecks with murderous splinters, and demoralising those who survived; at some point the losing crew's will to resist crumbled and the ship surrendered.

While the British aimed at the hull, the French were said to prefer destroying the top-hamper, so in this ship the spritsail yard, fore topgallant, main topmast and topgallant and mizzen mast have been shot away. The main yard is sprung and has been lowered to the gunwale. A spare topmast has been lashed to the stump of the mizzen. The ship is proceeding as best it can, under a jury rig consisting of jib, fore course, and mizzen staysail. The boat alongside is in danger of being overturned, and the men are clinging to the gunwale on the high side. [*Collection* 72]

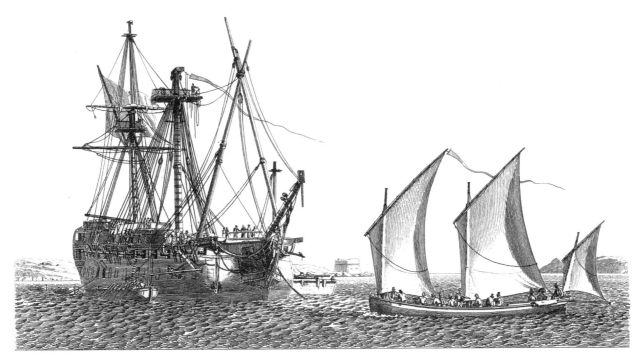

12.

\mathcal{U}NLIKE modern steel ships, the 'wooden walls' were capable of a surprising degree of self-maintenance and repair. This shows a French 74, with port anchor down, and a masting pontoon alongside. Sheers have been erected to allow the fore lower mast to be replaced. The starboard anchor hangs at the cathead; the lower boom is deployed on the starboard side, to secure one of the ship's boats. The futtock shrouds are unrigged on the main, but the cat-harpings can be seen. The mizzen topsail is kept available, with the mizzen topmast aloft. A *canot* (pinnace), rigged with dipping lugs, is shown on the port tack, with the forward parts of the sails aback. [*Collection* 39]

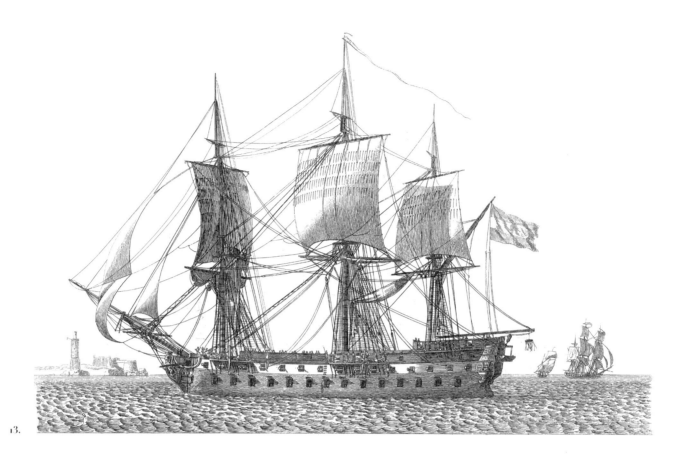

13.

SPANISH ship of the line getting underway. Baugean says that the Spanish vessels had foreshortened beakheads; that the counter was almost vertical; and he considers that the sculptures were not as tasteful as those in French ships. The British regarded Spanish ships as very strongly built (especially those constructed at the dockyard at Havana in Spain's Cuban colony), but they were less impressed by their design, and some captured vessels were considered poor sailers.

The port cable is up and down, indicating that the anchor is a-peak, or even clear of the bottom. The yards are counter-braced, with topsails set; the jib is being hauled up; main topmast staysail and mizzen staysail are loosed. Note the double dolphin striker and life-buoy at end of the mizzen boom. [*Collection 26*]

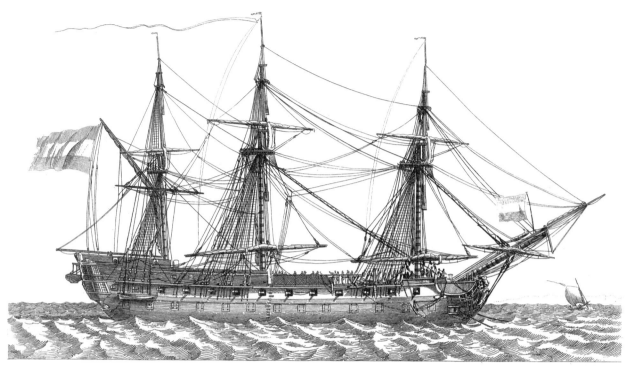

14.

\mathcal{D}UTCH ship of the line of 64 guns. For much of the eighteenth century the Netherlands in effect relied on a British alliance to provide them with a battlefleet, concentrating their own naval energies on smaller ships for trade protection. However, Britain became an enemy during the American Revolutionary War and the Netherlands were forced to undertake a big programme of ship construction in the 1780s; this depicts one of these ships. Traditionally small for their rate, Dutch warships were also conservatively designed, and Baugean rightly notes that these vessels were heavily built, and had lots of freeboard, but in his opinion the head and cutwater profile was not graceful.

The vessel is shown moored, both bower anchors down, and the sheet anchor has been shifted to the cathead ready to be let go in emergency. Fore and main topmasts and all three topgallant masts are partially struck, and the fore and main yards lowered, in order to reduce top-weight. A most interesting feature is the old-fashioned harbour stow given the topsails, with the bunt of the sail furled up and down the heel of the topmast. This reflects the fact that there was much about the Dutch navy that was antiquated at this time, from organisation to ship design and, it seems, seamanship. This is the sole example of the practice to be seen in this series of engravings. Furling the sail 'topsail fashion', as the Swedish author F C Rosvall calls it (*Skepps-Manövern*, Stockholm 1803), had fallen out of favour in other navies by 1800 at the latest. [*Collection* 50]

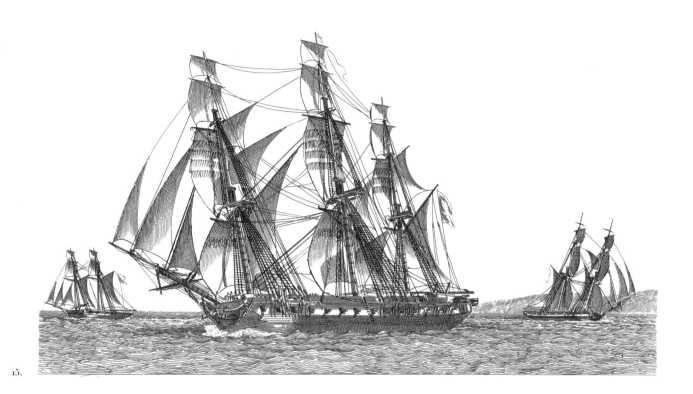

15.

\mathscr{F}RENCH frigate, brig and topsail schooner sailing by the wind. These three types represented the sailing navy's equivalent of the modern cruiser, the frigate being the largest and most powerful, but the smaller brig was often built in the largest numbers, while schooners were valued as fast reconnaissance and dispatch vessels. Note the frigate's gaff topsail. [*Petites Marines* 49]

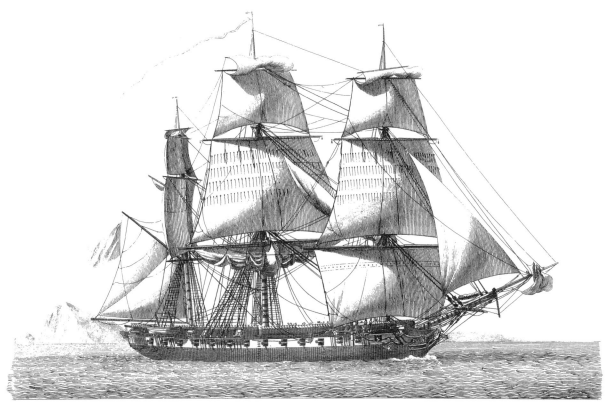

16.

F RENCH frigate sailing by the wind on the port tack, backing sails on the mizzen, striking royals and hauling down the flying jib. The intention of both manoeuvres was to momentarily slow the ship down, perhaps to await orders, perhaps to allow slower vessels sailing in company to catch up. Note the way the lee topping lift is touching the mizzen and the brailed-in upper gaff topsail.

From 1786 the French had a standard specification for 40-gun frigates, with fourteen main-deck gunports. Most, but not all, were designed by J-N Sané, and there was some variation. This may be regarded as a typical French frigate, which could be differentiated from a British-built ship primarily by the shape of the head: the headrails did not fair so smoothly into the hull; the forecastle bulwarks were often interrupted right forward (or ran across the ship in a flat barricade); and French frigates rarely featured a spare 'bridle port' forward for chase guns. The shape and decoration of the stern and quarter galleries were also different, and British frigates usually sported more, and larger, gunports along the upperworks, required by the high proportion of carronades in their secondary armament. [*Petites Marines* 41]

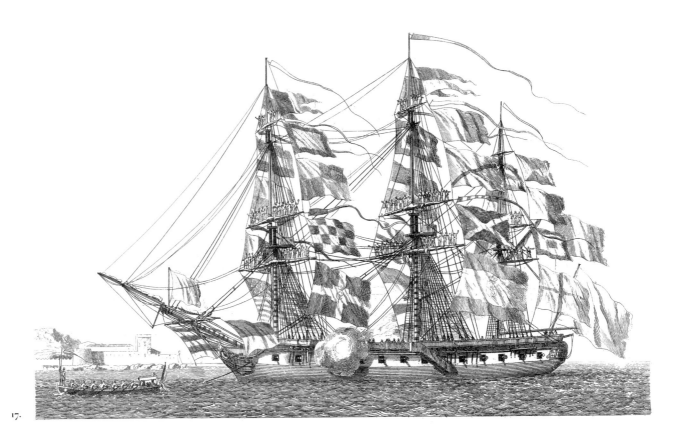

17.

\mathcal{N}AVAL honours: celebratory. A French frigate dressed overall, and firing a salute. The dignitary being honoured is under the awning in the barge to the left. Note the accommodation ladder. This is an early representation of a ship with yards manned in honour of a VIP, but the custom went back at least a little further. There are illustrations of George III's visit to the British fleet in 1790, showing the yards manned. This Plate can be compared with Plate 20, where the men are manning the shrouds on the appropriate side. Interestingly, in the first edition (published in 1814) the British ensign was treated with special disdain, hoisted upside down under the bowsprit and over the heads (the crew's latrines), but in the post-war world of Anglo-French détente the engraving was reworked to remove this calculated insult. [*Collection 46*]

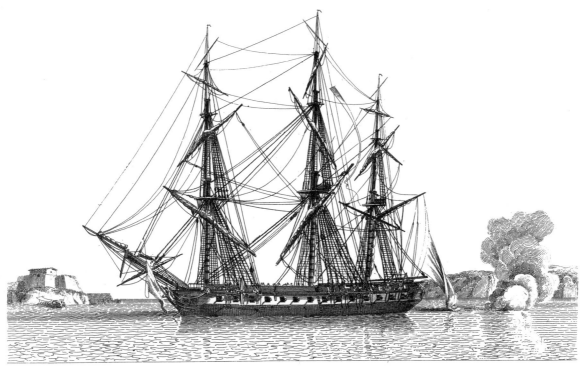

18.

Naval honours: funerary. French frigate, with yards a-cockbill, and flag at half mast, as a sign of mourning. Bracing and topping the yards in contrary fashion, cocked this way and that, was an internationally recognised sign of mourning, indicating that the ship's captain had died. In the far background, left, a barge, is heading towards the shore, perhaps bearing the body of the deceased for burial ashore. Dana says that in some Catholic countries, a similar practice was followed on every Good Friday. [*Petites Marines* 55]

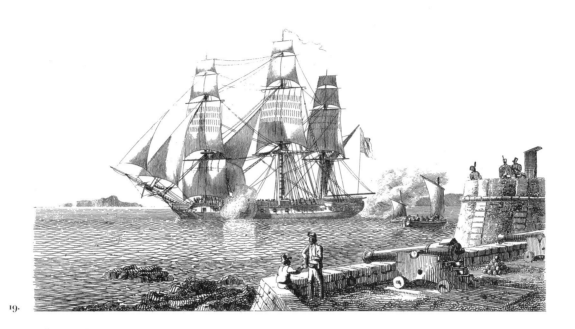

19.

ℕaval honours: saluting. French frigate firing a gun salute on entering a port; this would have been answered shot for shot. The vessel, all plain sail to royals, is proceeding with a very light wind on the starboard quarter, main sail furled, mizzen brailed in. A lug rigged ship's boat is seen in the middle distance. The cannon in the foreground, originally intended for use at sea, has a hole cut in the cheek of the carriage for a breech-rope, and we see a cover over the touch-hole. Ready-use shot are stacked in a conical pile. This would not have been done at sea, where the shot were stowed in racks. [*Petites Marines* 6]

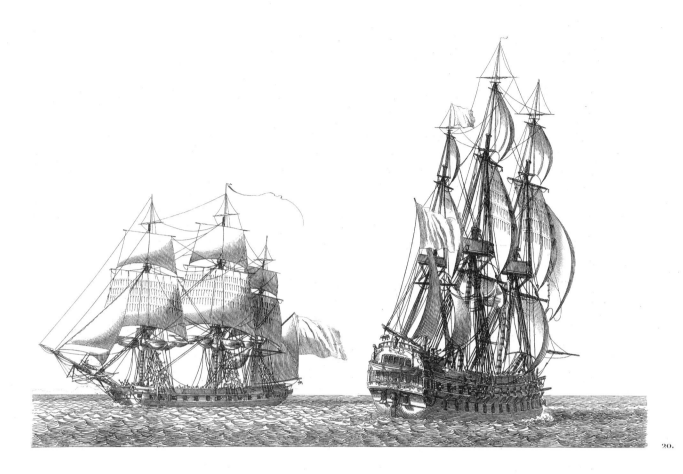

20.

\mathcal{N}AVAL honours: cheering. The frigate close-hauled on the starboard tack is honouring the rear-admiral, whose flag flies at the mizzen of the 74-gun ship, by cheering him. Part of the crew have gone aloft on the lower rigging, and to facilitate this, fore and main courses are brailed up. Note the double dolphin striker. The larger vessel to the right is close-hauled on the opposite tack, with main course in the brails; note the loose-footed spanker, not bent to the boom. [*Collection* 67]

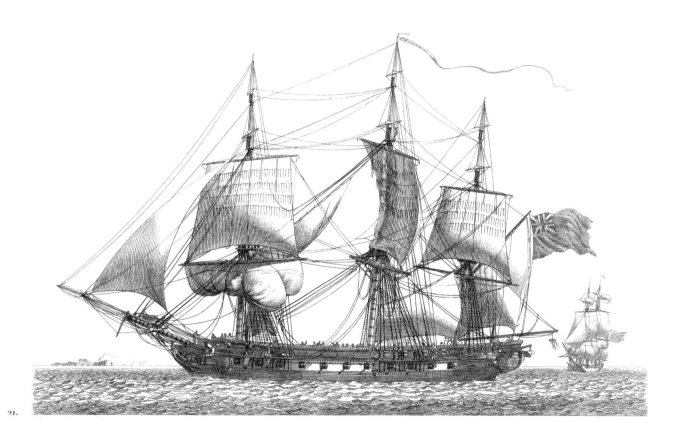

21.

\mathcal{E}NGLISH 36-gun frigate hove-to, main topsail to the mast. She is probably one of the 36-gun *Euryalus* class, the most numerous type of frigate in the Royal Navy of that era. Baugean says that the English frigates were good looking, were more richly decorated with carvings, but in his opinion lacked the grace and elegance forward, of their French counterparts. He comments that they are often armed with carronades rather than cannon, but in fact while they usually carried a full complement of carronades along the quarterdeck and forecastle, only a few of the smaller ones mounted carronades on the gundeck as Baugean implies. This vessel has fidded royal masts, and we see a French pattern life-buoy at the mizzen boom. Fore course and main topmast staysail are partially brailed up. A vessel heaves-to by balancing those sails which are filled with some backed canvas, so that the vessel remains more or less in the same place, just making a bit of leeway. [*Collection* 29]

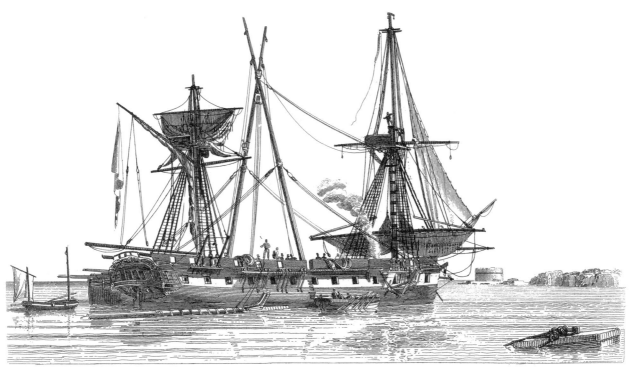

22.

\mathscr{A}NCHORED English frigate replacing its main mast. Although it was preferable to re-step a mast using a masting crane or sheer-hulk, necessity sometimes demanded that this be done in the roadstead. A pontoon is secured on the port side, but the sheers have been stepped athwartship on the vessel's deck. The main mast is secured under the starboard quarter. Other points of interest: the fore topsail yard has been lowered to the top; the fore yard has been struck, and the course is being aired; the studding sail booms are topped up; mizzen topsail loosed as commonly done when at anchor; one of the ship's boats is secured to the stern, its mizzen lugsail set, to keep it clear; the oars outboard of the launch alongside have been left a-trail in the water, rather than being boated. An intriguing question here is that if the frigate did not have access to a dockyard, where would the lower mast come from? The Mediterranean fleet under Collingwood kept the sea for years with little recourse to a dockyard, but in the final analysis there was always Malta as well as Port Mahon after 1808. In fact, at that point the latter yard was pretty much denuded of stores as a result of the parlous state of Spanish finances. [*Petites Marines* 38]

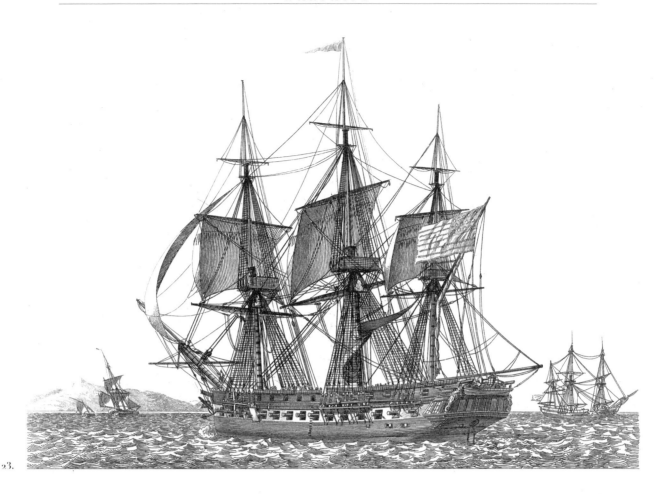

23.

USS *President*, one of the famous American spar-decked frigates and sister of the *Constitution*. Although other portraits are identifiable, this is the only named ship in Baugean's collection, a fitting tribute to the originality of the concept. Baugean makes the following comment on the Americans frigates: they are very fast and powerful, mounting perhaps thirty 24-pounders on the gundeck, which with the lighter pieces on the upper deck, brings the total to around 50 guns; they are sparred almost as heavily as 74-gun ships; and have the stern decorated with carvings, which although neatly done, are not in particularly good taste. *President* was launched in 1800, and is shown with gunports along the gangways, but with no visible guns. After their reverses in 1812, the British made much of the fact that these 'spar-decked' frigates were 'double-banked' like razéed 74s. In fact, by 1812 it was not the custom to carry weapons in the waist, and this leads to the conclusion that Baugean drew the ship some-what earlier, probably during the Barbary Wars (she has a commodore's pendant at the main truck). The vessel, having weighed anchor, is getting under way, under reefed topsails and jib, apparently in expectation of heavy weather; the mizzen staysail is being loosed.

In the background is a merchant vessel, with fore and main yards struck, two anchors down, and the ship's boat ready for lowering. [*Collection* 13]

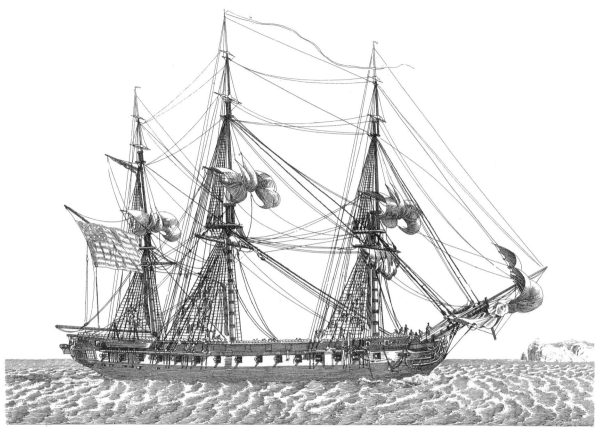

24.

Aᴍᴇʀɪᴄᴀɴ frigate, running before the wind, and preparing to anchor. Baugean remarks that the Americans had built extremely heavy frigates, masted and armed almost like 74s, which were designed to outmatch their British opponents. Actually this is a post-1812 perception – the establishment of the Federal Navy was initially a response to Barbary piracy and not conceived with the British in mind. Joshua Humphreys, however, intended them to be more powerful than any European frigates, and faster than any ship of the line, the 'pocket battleships' of their day. It is not clear that there are any guns on the gangways: ports are indicated there, but they may be painted false ports, all the others being open with guns run out. The ship depicted is very similar to the *President* portrait, but some details vary: this vessel has quarter davits and the bill-board (that protected the chains from the flukes of the anchors) is differently positioned.

There are crosstrees at the topgallant mastheads, but the royal masts are not fidded. The topsail halliards have been let go, buntlines kept fast, so the bunts of the topsails are hauled up above their respective yards. The topmen are racing up the shrouds to furl the sails. The gaff topsail is furled. [*Petites Marines* 34]

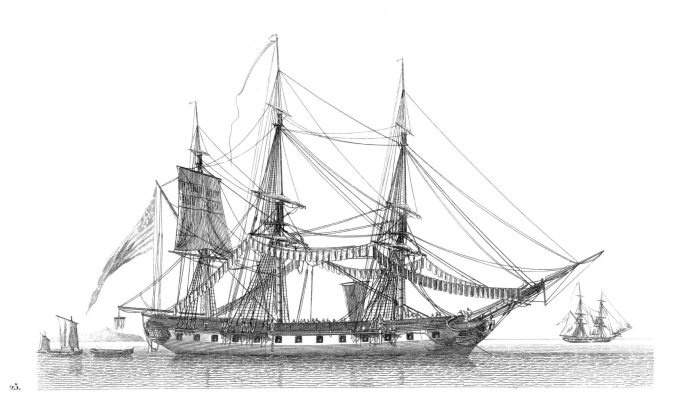

25.

\mathscr{A}MERICAN frigate at anchor. The mizzen topsail is set, and the wind-sail seen just abaft the fore mast was used in hot weather to ventilate the gundeck; the crew have washed their hammocks, and these have been triced up to dry. Although the big 24-pounder armed spar-decked frigates are best remembered, there were only three of them and most of the US Navy's early frigate force was made up of more conventional ships. This is one of the smaller frigates, possibly the *Boston*.

In the background a brig is drying its canvas. [*Collection 2*]

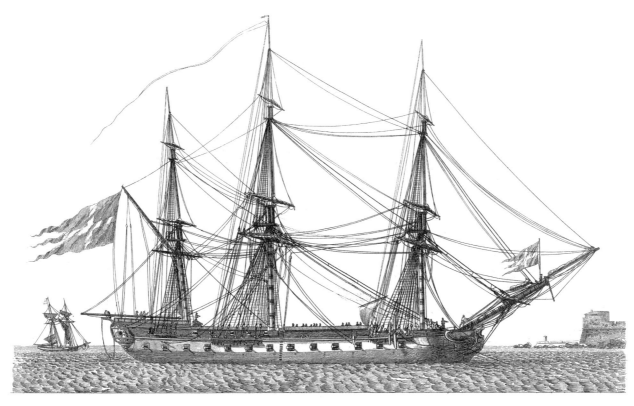

26.

SWEDISH frigate at anchor. Baugean felt that the bow and stern lacked grace, although the ships looked quite well when viewed from the beam. The thing that characterises them is the way the great cabin is placed on, and not under, the quarterdeck, giving the vessel the layout of a razéed 74-gun ship. This provides excellent evidence that Baugean worked from life, since this is a very accurate portrait of one of the *Bellona* class frigates designed by the celebrated F H af Chapman. Although usually armed with 18-pounders, they were intended to carry 24-pounders in wartime – and the *Venus* was so armed when captured by the Russians in 1798. They were widely admired and copies of the draught exist in many archives, confirming both the layout and Baugean's decorative detail. A wind-sail is being used to ventilate the berth deck.

In the background is a topsail schooner. [*Collection* 31]

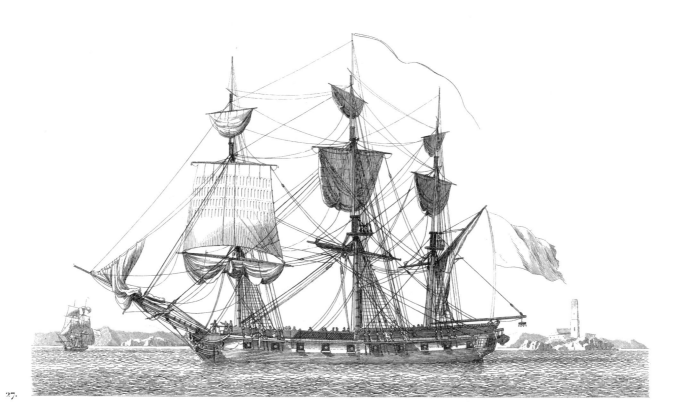

27.

\mathcal{B}ELOW the frigate in the naval hierarchy came
the ship rigged vessels of 18-24 guns called *corvettes* by the French and 'post ships' (because
despite their small size they were still a post captain's command) by the British. This is a French
corvette mounting 20 guns on the main deck, with a small quarterdeck and forecastle also
armed. A number were captured by the Royal Navy, where in marked contrast to the usual
admiration for French design, they were generally regarded as slow and leewardly.

This one is making sail from anchor. The cable is up and down, and the yards counter-braced.
This clearly shows fidded royal masts, fitted so they can be struck abaft the topgallants. There
is not much wind, and once the anchor breaks from the ground, the helm will put a-starboard,
and the ship will drift backwards, turning so the sails on the main and mizzen will fill on the
port tack. Topgallants and topsails have been mastheaded, so that the clewlines can be let go,
and the sails sheeted home in an instant. Jib and spanker are loosed, so they can be run up
and sheeted home at the appropriate moment. [*Collection 64*]

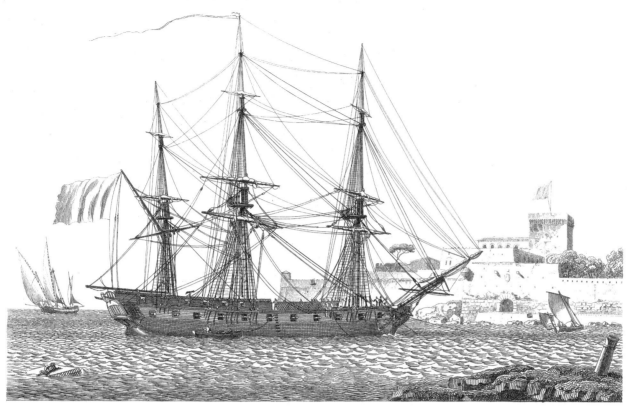

28.

𝒻RENCH corvette warping its way into port. The vessel is armed with 22 guns (probably 8-pounders) on its main deck, with lighter pieces and swivels on the quarterdeck. With wind against it, a warp has been run out to some fixed point on shore, such as the cannon-bollard to be seen bottom right, and the ship is heaving its way into harbour using its own capstan. The men working the capstan are to be seen just abaft the fore mast. The lower and topmast yards have been braced as for port tack, to cut down wind-resistance. A second warp can be seen below the beakhead, and we might imagine that it being taken ashore by the ship's yawl, which is beating its way in against the wind to the right. (The French verb *touer* means 'to warp', while *remorquer* is 'to tow'.)

In the background is a pinque. [*Collection* 59]

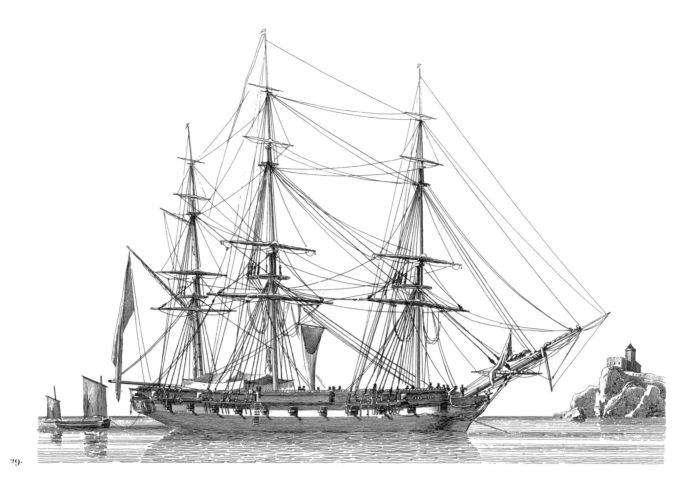

29.

A BRITISH post ship (corvette) of 20 guns in the lower battery at anchor. A number were built to this design during the War of American Independence, but by about 1800 they were regarded as obsolescent, having been replaced by large sloops of a flush-decked layout – *ie* without quarterdeck and forecastle, so lower in the topside and more weatherly. This one sets an upper gaff topsail. The wind-sail suspended from the main stay, and the awning over the quarterdeck indicate that the weather is hot. [*Petites Marines* 118]

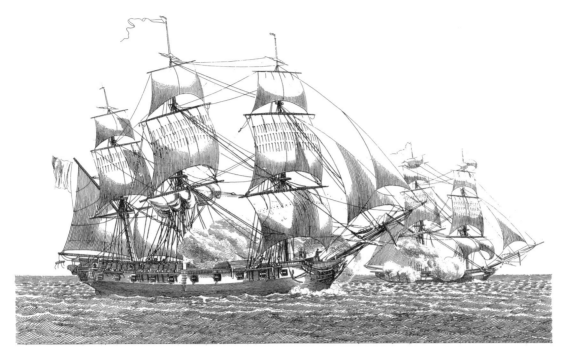

3o.

\mathcal{I}<small>N</small> Baugean's books there is little to suggest he lived through the greatest naval conflict to date, although this is one engraving that does. Two types of small cruiser are shown in action against one another: a ship-sloop to leeward engaging a brig to windward. The brig came to be the most common type of minor warship in most navies, but in battle they were at a slight disadvantage in that a three-masted ship could lose more spars before becoming unmanoeuvrable.

Baugean, presumably discussing French usage, says that corvettes have between 24 and 40 guns: anything above that is a *frégate*, and below that an *aviso* (or dispatch vessel). [*Petites Marines* 29]

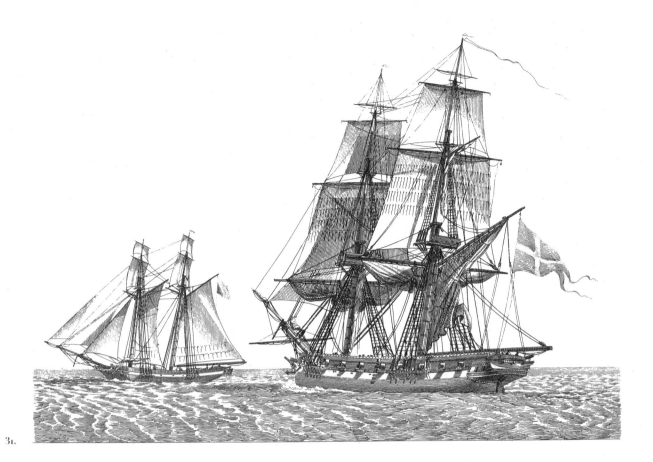

31.

\mathcal{B}Y 1815 the brig was to be found in virtually every navy, and the vast majority were of the same form – a flush gundeck exposed to the weather with minimal platforms and storerooms below. A few Spanish brigs had quarterdecks, and the Danes built a few strange experimental craft with below-decks armament, but this Swedish brig of war was typical. She shows a set of conventional stern windows and quarter galleries, but most had plainer transoms.

Baugean says that the merchant marine was made up in great part of brigs between 200 and 500 tons capacity. In the navy, they were armed with between 14 and 22 long guns or carronades (in fact, the British had some with only 10 and 12 guns). He notes that in French the name *brigantin* had been applied to them, and that the fore-and-aft 'brig main sail', or 'brig-sail', was called the *brigantine*. This example is shown running before the wind, courses and brig-sail in the brails, and the partially brailed in brig-sail is represented in a spirited fashion. Note the upper gaff topsail; reef-tackles; jewel-blocks at the topsail yardarms, for the topmast studding sail halliards; and hammocks protruding above the gunwale.

The schooner in the background has upper and lower topsails on both masts. The square fore sail, bent to its yard, can be seen at the foot of the fore mast. [*Petites Marines* 31]

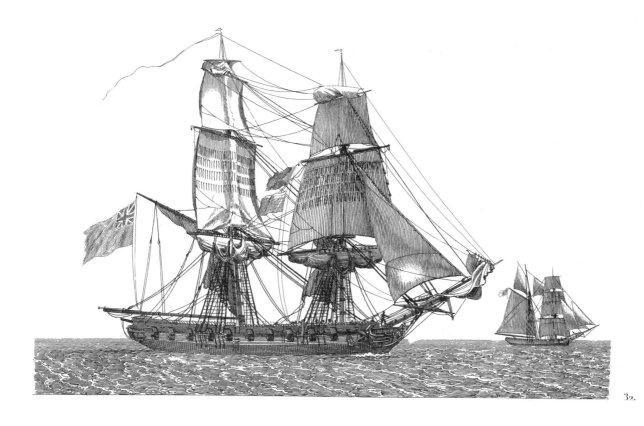

32.

*E*NGLISH brig of war hove-to. Although they had ten ports a side, they were always rated as 18s, and in general Baugean seems to exaggerate their size; the height of the barricades also seem too great, giving the brig the appearance of a deck over her guns. The hinged gunports, also seen in Plate 39, are an unusual feature: many vessels of this size used 'plug' covers called 'bucklers', rather than port-lids (see Plate 31). When it was necessary to stop the vessel, to pick up a boat, wait for orders, and so forth, it was 'hove-to'. Sail was shortened, and whatever left set was balanced, some drawing, and some aback, so that the vessel remained more or less in the same place. Here, the royals and flying jib have been taken away; courses and brig-sail brailed up; main topsail and topgallant have been thrown aback, by bracing in their yards (whalers were the only vessels which habitually hove-to by backing the fore topsail).

In the background is a brig-schooner. [*Petites Marines* 53]

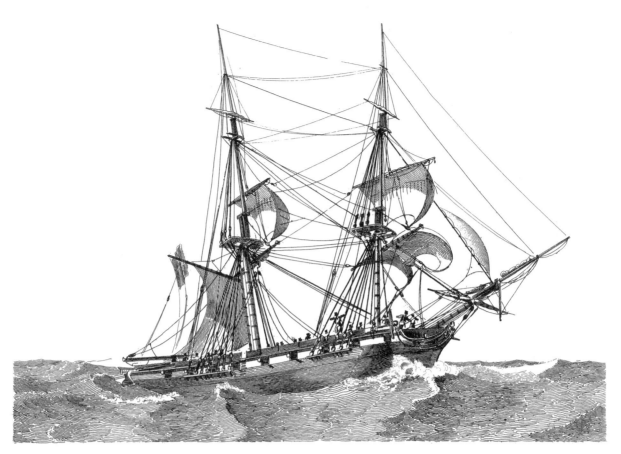

33.

\mathcal{A} n 18-gun brig of war in blowing weather. Two or three reefs have been taken in the topsails and the crew are in the process of clewing up the fore course, hauling upon the clew-garnets and easing off tacks and sheets on both sides. There was much argument among seamen at this time, as to whether weather or lee clew should be taken in first. Rarely can we fault Baugean's draughtsmanship, but comparing the tops and crosstrees of the two masts, it is apparent that he has represented them from two different perspectives. On the other hand, the figures seem better proportioned to the usual size of naval brigs. [*Petites Marines* 103]

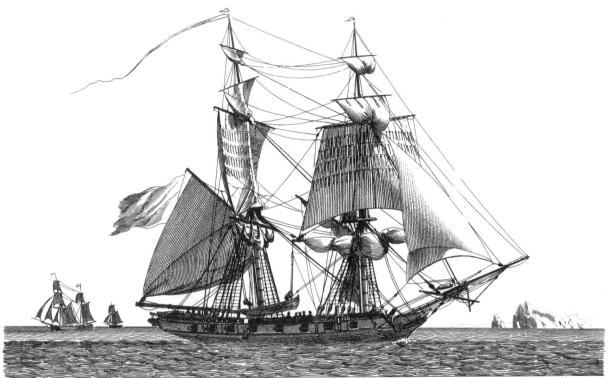

34.

\mathcal{A} 16-GUN brig hove-to and putting a boat in the water (compare with Plate 36). The main topsail is aback, wrapped around its top and mast, while the fore topsail is drawing. Both courses are brailed, up, but the wind is causing that on the fore to balloon out between the brails and buntlines. The tack of the brig-sail has been triced up. This particular brig sets a gaff trysail on the fore, instead of a main topmast staysail. There was no special name for the rig in English, but in Italian they were described as being *armate a verga secca* – see Flavio Serafini, *Vele nella Legenda* (Milan 1979).

Bow and stern of the boat are suspended from tackles at the yardarms and at the lower mastheads, and by using these, it can be swung out clear of the bulwarks. Men are stationed in bow- and stern-sheets, ready to unhook the tackles, once the boat is in the water.

In the background is a galiot. [*Petites Marines* 79]

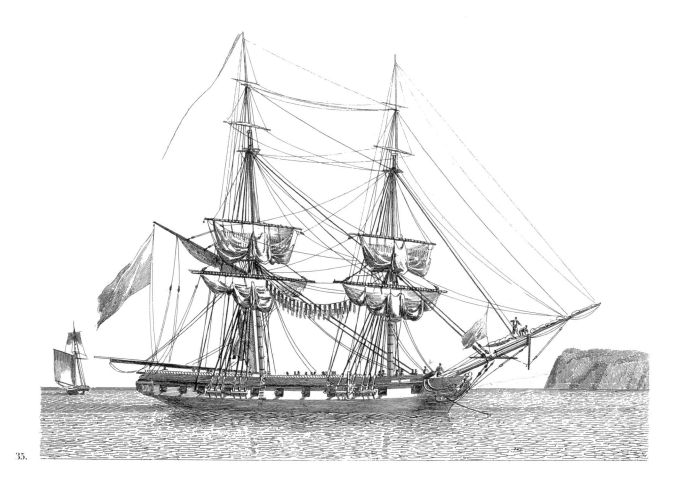

35.

A BRIG of war at anchor, with sails loosed. This is another of Baugean's rather over-sized looking brigs, with quarter galleries and tall barricades, ten gunports a side plus a bridle port. Note the hammocks suspended for drying, and the fashion in which the bunts of topsails and courses are disposed, with the buntlines run up all the way.

In the background is a sloop. [*Petites Marines* 108]

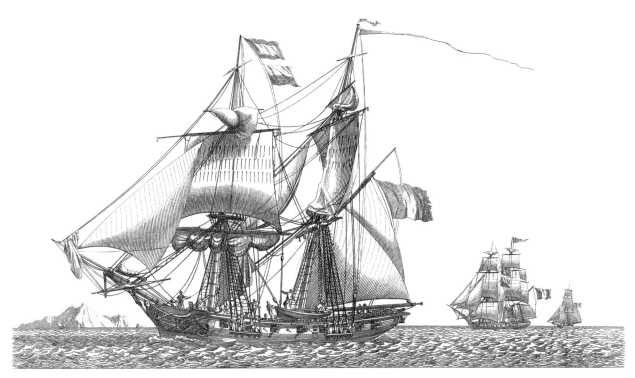

36.

A Frenchi 16-gun brig of war hove-to, getting her boat aboard and repeating signals. It is a very convincing portrait of these utilitarian craft, with a simple scroll head instead of a figure and plain quarters without galleries; setting the channels below the gunports is characteristically French, Royal Navy brigs having theirs either above or at the mid-line of the ports.

The flying jib has been furled; topgallants are lowered to the topmast caps; main topmast staysail is brailed in; fore course brailed up; the brig-sail is pressing against the lee boom topping lift ; main topsail has been braced aback and lies pressed against mast and top; square main sail, spritsail, royals and fore topmast staysail are furled. The lee topgallant studding sail boom is seen on the fore, and we can pick out fore and main mast and yard tackles secured to stem and sternpost of the ship's boat. In the background are a frigate and a naval cutter. [*Collection* 11]

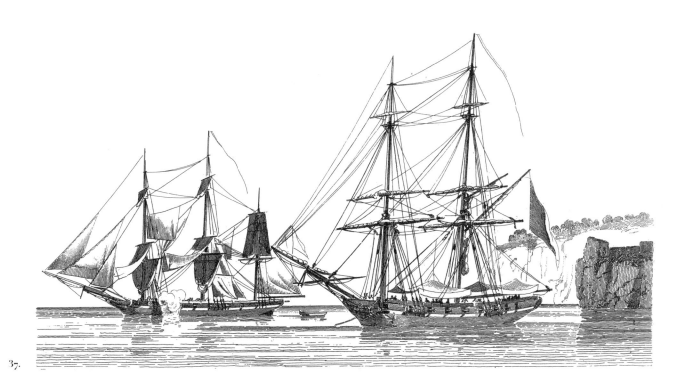

37.

\mathcal{A}RMED Greek vessels at anchor. The closer vessel is a brig of about 18 guns. Details of interest include the awnings and gaff topsail, with its gaff lowered to the main mast cap. The ship rigged vessel in the background is a flush-decked ship-sloop of a layout that became popular from the 1790s onwards. She has her mizzen topsail set and other sails loosed to a bowline.

Although nominally part of the Ottoman Empire at this time, the Greek marine was regularly armed for privateering and defence. [*Petites Marines* 87]

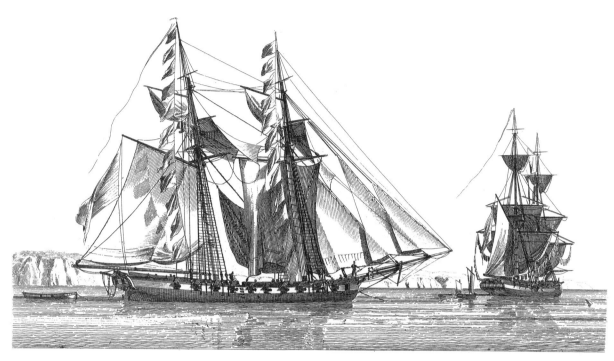

38.

𝒜MERICAN armed schooner at anchor, airing its canvas and bunting. This vessel represents the largest type of privateer schooner, with 20 guns or more. Note the gaff topsails, reef-points on the jib, and the fashion in which the topgallant masts are fidded, allowing them to be struck abaft the topmasts. The canvas includes what looks like a redundant main staysail.

In the background is a brig of war airing its canvas and drying hammocks. Note the way the topmast studding sail booms are raised. [*Petites Marines* 35]

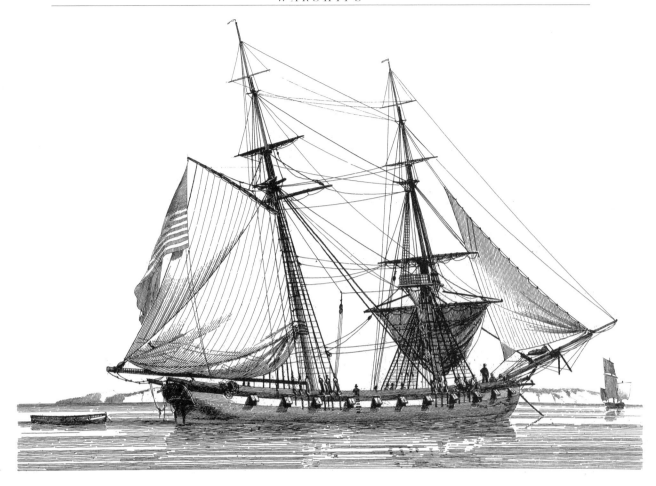

39.

A HEAVILY canvassed American brig-schooner of about 400 tons, pierced for 22 guns, lies at anchor. By the end of the War of 1812 very large purpose-built privateers of this pattern were being built for the attack on British trade; in general terms the vessel depicted resembles the famous *Prince de Neufchatel*. These predominantly fore-and-aft craft proved more successful than conventional warships in escaping the British blockade and when the war ended the US Navy was planning a squadron of about twenty for the *guerre de course*.

In vessels of this size, the main sail was reaching proportions where it became a brute to handle. Note the footrope under the after end of the boom; the fly-block of the fore topsail tye and halliards, beside the fore top; the fidded royal mast on the fore and topgallant mast on the main; the double dolphin striker. [*Petites Marines* 63]

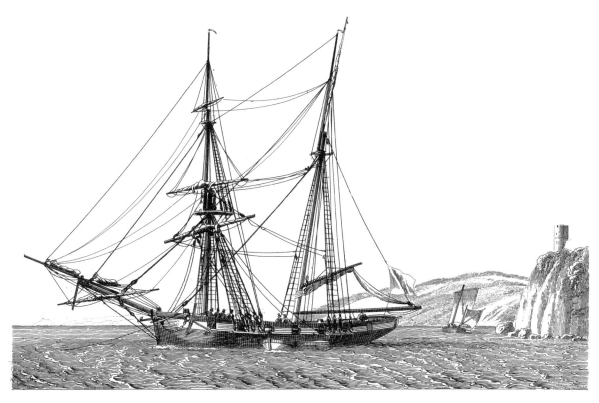

40.

\mathscr{B}RIG-SCHOONER warping. A hawser is being hauled in manually by the men beside the fore mast. The boom main sail has been furled in a different fashion to that seen elsewhere in the collection. It is difficult to know what to make of the yard and sail up against the main topmast: if there were a second yard, we could interpret it as a topsail – see the brigantine in the background of Plate 64 – but it seems too substantial for a jackyard topsail.

In the background is a small vessel with lug- and spritsails. [*Petites Marines* 62]

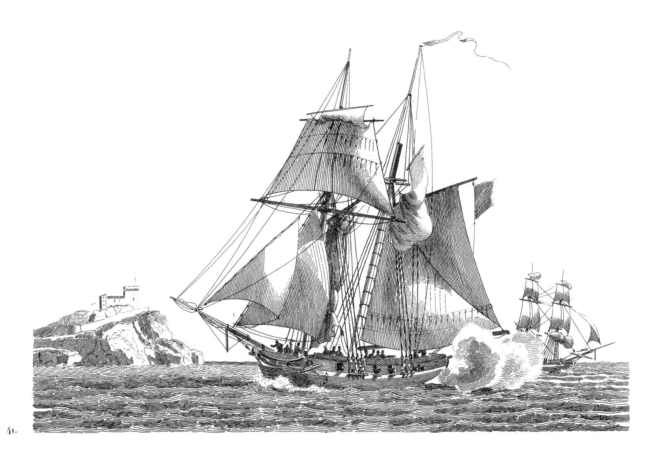

41.

SCHOONER, of about 10 guns, sailing large, and firing a shot from a stern-chaser at a brig in pursuit. Being able to point higher (*ie* closer to the wind), the schooner had an advantage over square rigged ships in chase, but the lack of substantial square canvas that could be backed was often a handicap in a manoeuvring action. The fore sail has been brailed in; the jackyard gaff topsail is being taken in; and the halliard of the fore upper topsail has been let go, leaving the sheets fast.

The schooner is now under the cover of the fort on the headland, so the brig in the background will have to abandon the chase. [*Petites Marines* 107]

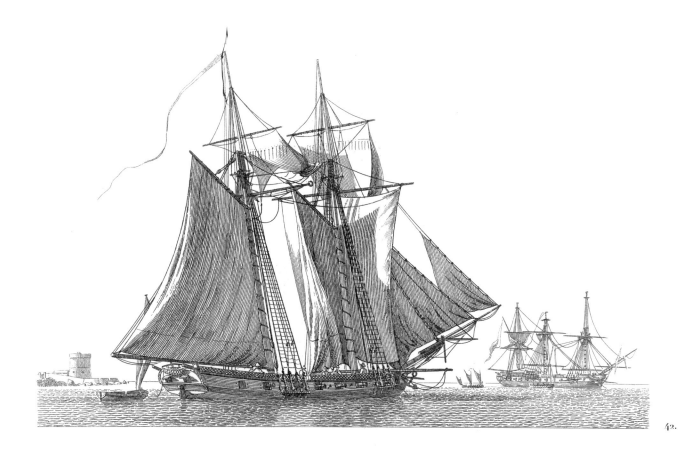

42.

\mathcal{A} SCHOONER, armed with about 16 guns, at anchor, airing her sails. In addition to the fore-and-aft fore and main sail, she is rigged with two square topsails, a square running fore sail, jib, flying jib and outer jib. A spar is laid across the bulwarks abreast the fore mast, and serves as boat-boom. It would have spread the foot of the running fore sail, and perhaps a studding sail of some sort. An interesting detail is the hammock-like net between the stern davits. Baugean remarks that schooners were fast vessels, much used in commerce, especially by the Americans.

In the background a frigate is at anchor, with mizzen topsail loosed; topgallant masts, and main topmast have been struck. [*Collection* 6]

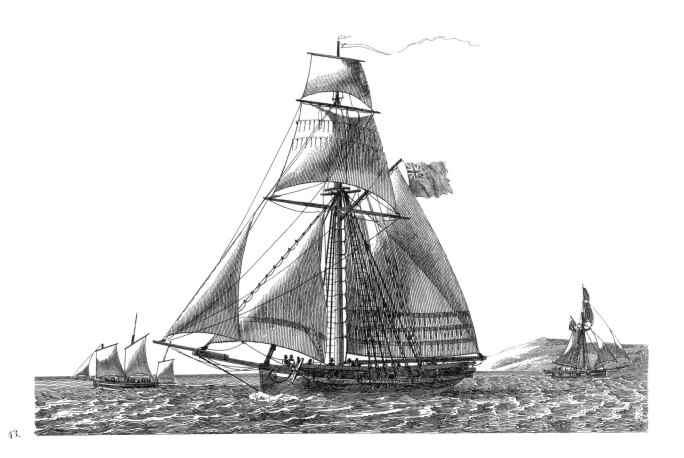

43.

\mathcal{C}UTTER sailing by the wind. These vessels derived from a fast-sailing clinker-built (also known as cutter-built) type developed along the English Channel coast, and much used for smuggling and privateering. Mounting 6 to 18 guns, they proved ideal naval reconnaissance and dispatch craft, and after experience with hired examples in the 1760s the Royal Navy began to build its own.

The hull was broad but sharp-lined, with a tall raked mast and a long flat-steeved bowsprit, from which an immense acreage of canvas could be spread, including square topsails in appropriate conditions.

In the background is a lugger or chasse-marée and another cutter. [*Petites Marines* 71]

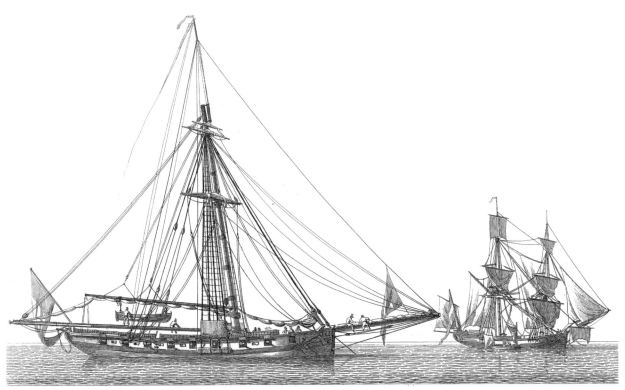

44.

*D*UTCH cutter at anchor. Although a type closely associated with Britain, the success of the cutter in Royal Navy service led both the Netherlands and French navies to build limited numbers during the 1770s and 1780s, some like this one reaching substantial size. Eventually, all navies found the huge gaff main sail too unwieldy in the largest cutters and from this developed the brig of war, where the canvas was spread over two masts.

In the background is a Swedish snow drying her sails. The characteristic feature of a snow, vis-à-vis a brig, was the loose-footed fore-and-aft main sail, set on a snow mast just abaft the main mast. In this case, a supernumerary ringtail (*tapecul*) is rigged as well. [*Collection* 9]

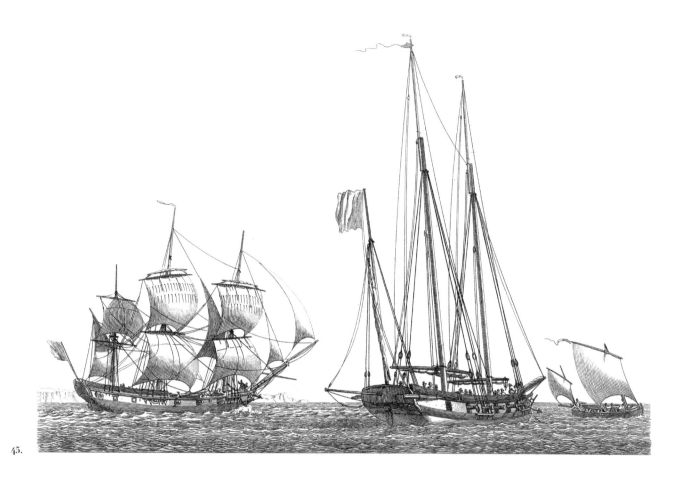

45.

\mathscr{F}RENCH armed lugger at anchor. In many ways the French equivalent of the English cutter, these were used as dispatch boats and privateers, and armed with up to 18 guns. The topmasts are fitted abaft the lower masts, and it is canvassed with three lugsails, with topsails on the fore and main. The lugsail on the ringtail mast is sheeted to an outrigger. The bowsprit was very long and almost horizontal. Note the long sweeps (oars) lashed to the quarter; these were used to move the vessel in calms.

To the left is a Venetian armed merchantman, sailing by the wind. Baugean says that these relatively small but well built vessels were characterised by considerable sheer and within the Mediterranean trade were generally known as corvettes. The example here is lightly armed with 14-16 guns, and is polacre rigged on fore and main. Note the loose-footed mizzen, and absence of a dolphin striker. The topgallants are not set.

In the background is a small lug rigged boat. [*Collection 34*]

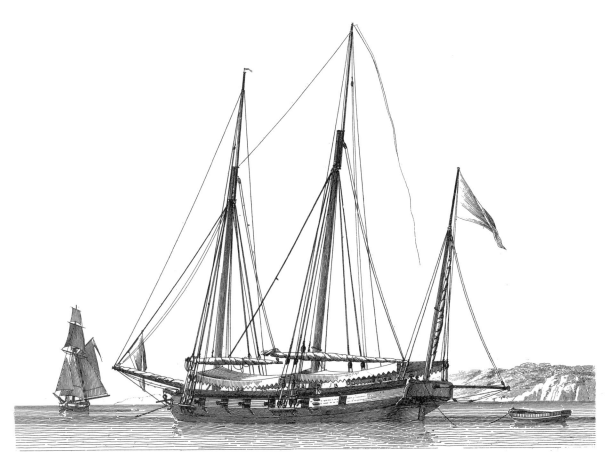

46.

\mathscr{A}RMED lugger at anchor; a closer view of the type of craft in the previous Plate. It is a very large example, with bulwarks high enough for full gunports to be cut in them. Lugsails of the size required by this kind of vessel were difficult to handle and required large crews, so the biggest luggers tended to find themselves in naval service, or high profit-margin (often synonymous with illegal) trades. The topgallant masts step behind the lower masts, and the mizzen is stowed vertically abaft its mast.

In the background is a sloop. [*Petites Marines* 68]

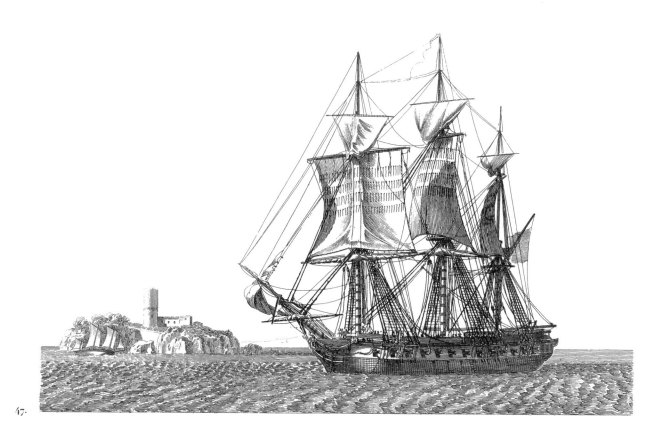

47.

\mathscr{F}RENCH gabarre weighing anchor. *Gabarre* in this context was the French term for an armed transport, or naval storeship. Baugean says they were similar to frigates in size and layout, but built with fuller lines, offering greater capacity for the transportation of troops, munitions and supplies. This one mounts 26 guns in its main battery. The French *gabarre* was also used to describe a lighter or barge and, earlier, 'gabbart' was used in this sense in England, the term persisting in Scotland well into the nineteenth century.

There is a small lugger close in with, and almost obscured by the island. [*Petites Marines* 36]

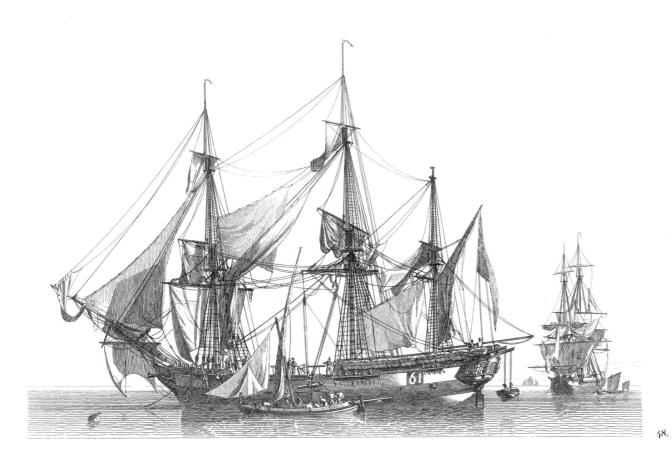

48.

*A*BRITISH transport airing her sails and embark-
ing cannon from a lighter. For all hired transports an identifying number was prominently
displayed on the sides, fore and aft, and painted on the fore topsail to facilitate recognition at
a distance; the number was also listed in *Lloyd's Register* alongside the ship's name. Few
contemporary illustrations depict a spritsail deployed, but here the artist has shown the 'water-
holes' to allow drainage if the lee side dipped too low in the sea. Main topgallant and mizzen
topsail are hauled forward by their bowlines and a middle staysail is shown. Note the bales
secured to the gunwale aft. In the background is a similar vessel, with the number painted on
the fore course.

The design of the lighter indicates a Mediterranean roadstead, possibly Spanish. [*Collection 32*]

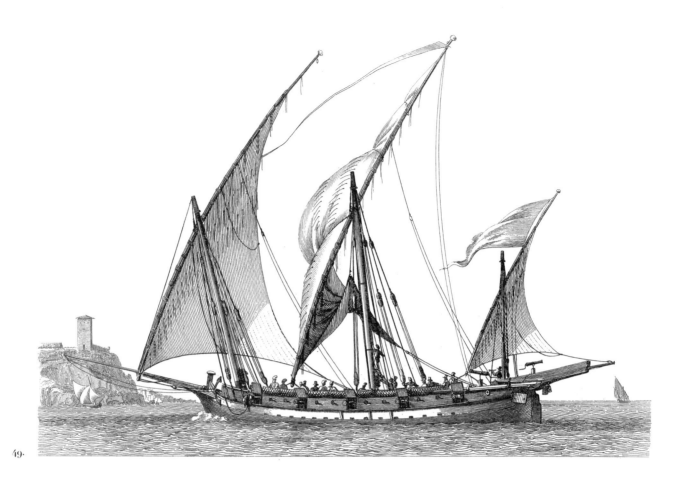

49.

SPANISH chebec. Mediterranean navies employed a number of lateen rigged types as small cruisers and dispatch vessels, of which the best known is the chebec. The Spaniards had a reputation for building excellent chebecs, and this example, a typical small warship or privateer, is armed with 10 guns, plus stern-chasers aft, besides the swivels guns. Note beakhead, and long bowsprit, tall stemhead and *cul-de-poule*. All three masts are lateen rigged, the fore and main with forward rake. One can pick out the tyes of fore and main yards forward of the mast, where they are made fast to the yards. The brails and vangs (*ostes*) are clearly shown, and the brail on the main has been partially hauled up. Notable details include: captain with his speaking trumpet; the man standing on the fly-block of the halliards at the main mast; items hanging below the wings at the stern (possibly poultry coops); anchor buoy forward; sweeps lashed along the quarters; scuppers, oar ports and netting. [*Collection* 33]

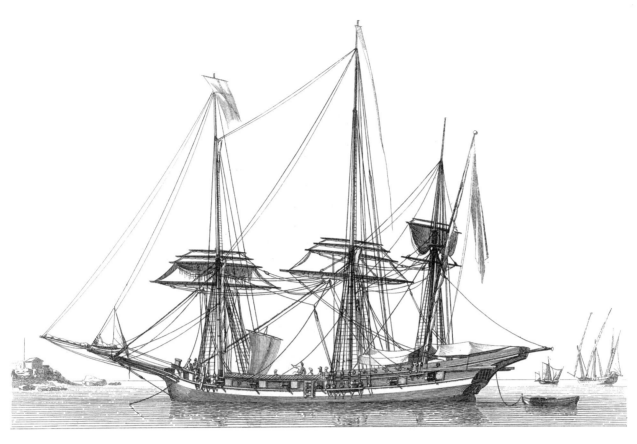

50.

\mathcal{G}ENOESE chebec at anchor. These were charac-
terised by a fair bit of sheer, a beakhead or *éperon* and the bulwarks aft extended by *ailes* to
form a *cul-de-poule*. The masts could be square rigged, polacre fashion, lateen rigged or com-
binations of these. This example is armed with about 14 guns, plus swivels, and has all three
masts square rigged up to royals. Note the lack of dolphin striker; recurving stemhead; Jacob's
ladder on the fore and main topmasts; the way the lateen mizzen is peaked up; the wind-sail
forward for ventilation; awnings aft; downhauls for fore and main topsail yards can be made
out on the port side.

In the background is a pinque and a liuto. [*Collection* 17]

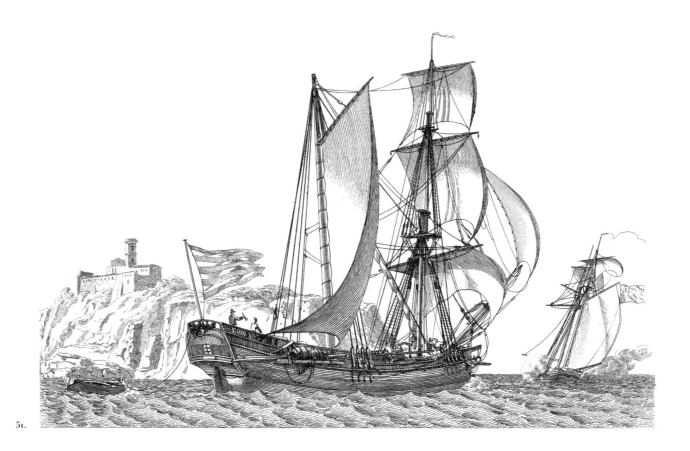

51.

*P*ORTUGUESE patache. The term was centuries-old, going back to the great days of Portuguese exploration when they had accompanied the caravels, but the actual design had, of course, changed over time. These were used as packet boats, and by customs officials. Baugean says they were heavily built, not very fast, and that they were declining in popularity in his time. This one is rigged as a sort of ketch; it would be a brig-schooner if the after mast had a topmast.

In the background is an British topsail schooner, firing a salute. [*Collection 43*]

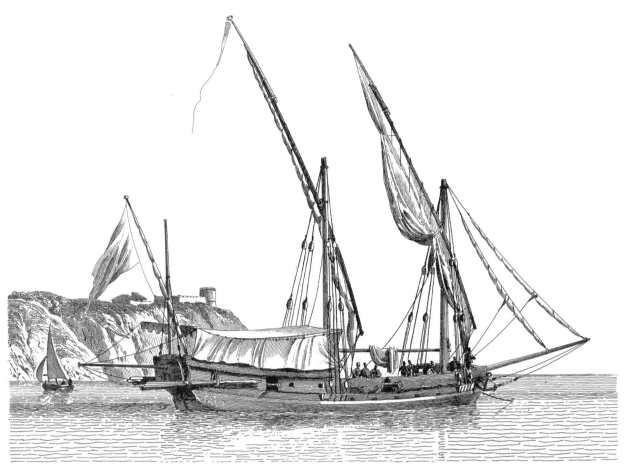

52.

\mathscr{A} LIGHTLY armed Spanish aviso at anchor. In southern European navies an *aviso* was a small sloop or type of dispatch vessel, the term being related to the English 'advice boat'; it was the smallest class of warship and used for communication purposes. This example is rigged as a mistico (compare Plate 87), and can be propelled by oars, which are stowed outboard on the quarters. There are two long guns a side, but the vessel would have relied on speed to keep out of danger. Note the way the awning has been extended to shade the deck from the sun. [*Petites Marines* 113]

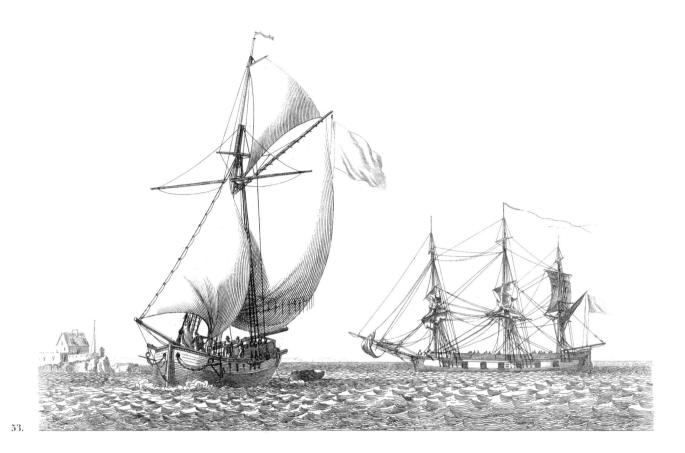

53.

\mathcal{T}o the left is a French sloop on the starboard tack, towing its boat. Baugean says that the sloop differs from the cutter only in that its mast does not have a marked rake aft. Those found on the Atlantic coast rarely set a square topsail, but like this one, a jackyard gaff topsail. Despite the apparent gunports, this vessel is a merchantman.

The prame in the background was a flat-bottomed vessel, of very solid construction, specially designed as an escort for invasion craft. It was armed with long guns, heavier pieces than a vessel of that size would ordinarily carry. They were built specifically for the Boulogne Flotilla, to support Napoleon's planned landings in England, and were 37 metres in length, and drew 2.5 metres of water. Propelled by sail and oar, prames could transport 50 horses or 120 men, besides a crew of 38. They were usually armed with twelve 24-pounders, and mortars were sometimes carried. This one has just cast anchor, and is drifting back under the influence of the backed mizzen topsail. The word 'pram' was earlier used to describe various kinds of small, shallow-draught scows and ferries. [*Collection* 65]

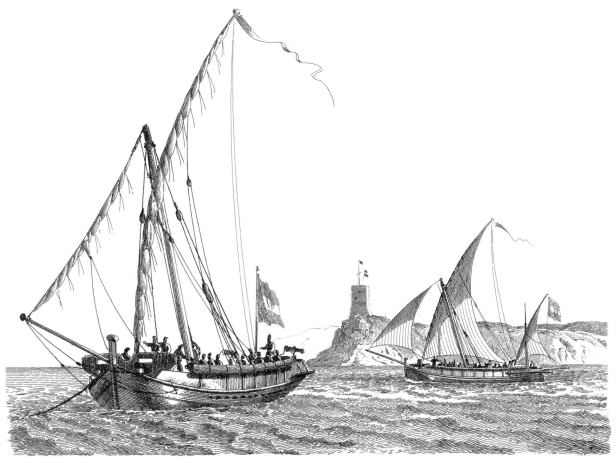

54.

\mathcal{S}PANISH balancelles. For their role as gunboats, these examples are fitted with swivel-guns and two bow-chasers of heavier calibre (compare Plates 31 and 61 of Paris, *Souvenirs de Marine*). These craft were of Neapolitan origin, but adopted and adapted by others, particularly the Spanish – hardly surprising, given the family connections of their ruling houses. The craft had much in common with some types of Catalan fishing boats, were intended for rowing and sailing, and built with bilge keels to facilitate beaching. A feature not visible here was the very markedly cambered deck. [*Petites Marines* III]

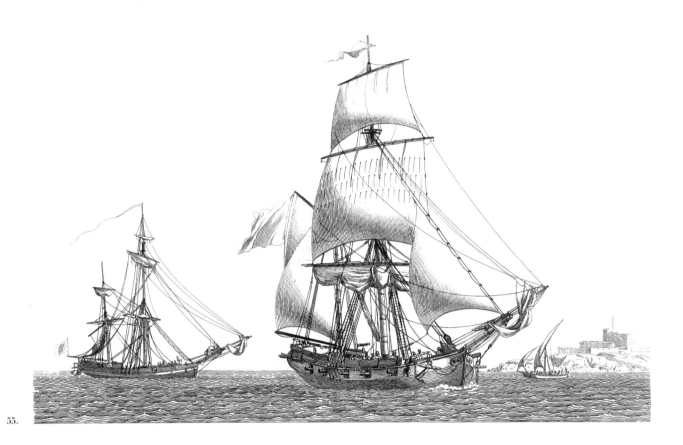

55.

\mathscr{F}RENCH bombardes in the Mediterranean. As their name suggests they were originally intended for shore-bombardment, being designed to carry a pair of heavy mortars forward of the main mast. Like early English bomb vessels, they were ketch rigged, but known in French as *galiotes à bombes*. Baugean says that they were no longer used in the navy of his day, the bombardment mission having been taken over by frigate-built bombs, which were easier to handle.

The term survived, however, for merchant vessels of the kind shown here, which were sometimes armed as small cruisers or privateers. The fore mast is rigged polacre fashion, but with a fidded topgallant mast, and they set fore staysail, fore topmast stayail and jib. The mizzen could be fitted with a lateen sail, but these examples have gaff mizzens, and the vessel to the left sets a mizzen topsail. The ketch to the right has 10 guns plus swivels. The anchor is cock-billed at the port cathead, indicating that the vessel is approaching, or leaving, its moorings. [*Collection* 45]

56.

A demi-galère, or half-galley. This was a galley of less than maximum size. Although galley fleets were rendered obsolete by the three-masted broadside warship, limited numbers survived in some Mediterranean navies down to the Napoleonic Wars, often merely for their importance in the penal system – 'galley slaves' were in fact usually criminals and political prisoners by this stage rather than prisoners of war.

The lateen sails are furled and the gaskets hang down from the yards. The mizzen sail is deployed to help keep the vessel head to wind. The oars are partially retracted, and stowed in such a way that they present a graceful sweep. A large awning is spread. These vessels could not fire a broadside, but note the bow-chaser, with four lighter cannon also firing forward – in effect, a tactical extension of the ram. [*Collection* 49]

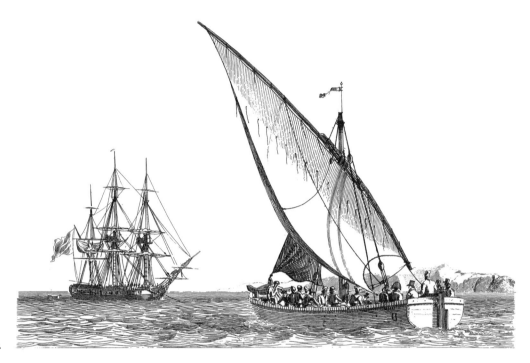

57.

\mathcal{W}ARSHIPS of the sailing era were equipped with a large and varied outfit of boats, anything up to seven in number. Sailing ships rarely came alongside wharfs, and enclosed docks were not common, so boats were used to manoeuvre the ship in calms or in restricted waters; they were used to store and water the ship; to transport their crews; and in wartime to extend the ship's 'reach', in amphibious landings, cutting-out expeditions, and on independent patrol.

The largest was the launch, called in French the *chaloupe*. Up to 12 metres in length, this was the ship's main means of transporting heavy objects like water casks, cannon or anchors; but it could also carry the largest number of people, as in this case of a frigate's lateen rigged launch sailing back to the ship with the wind astern

The lines controlling the lower end (*car*) of the yard have been slackened to allow it to rise, and the sheet hauled aft so the sail will not press against the rigging or mast (compare Plate 98).

In the background, a frigate is at single anchor. An unusual detail at this date is the spritsail topsail yard, just forward of the dolphin striker; in the Royal Navy they continued to be issued, but were more valued as spare fore topgallant yards than for their original function. [*Petites Marines* 17]

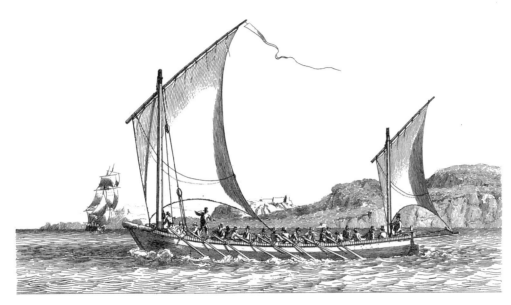

58.

SHIP'S launch (*chaloupe*) under sail and oar. It is relatively under-canvassed. Note the bow-fender on the steeply raked stem – Baugean says this was a vessel of Breton design, and is not the usual French navy pattern. It is close-hauled on the port tack, with the lugsails trimmed flat to compensate for the forward motion due to the oars. [*Petites Marines* 18]

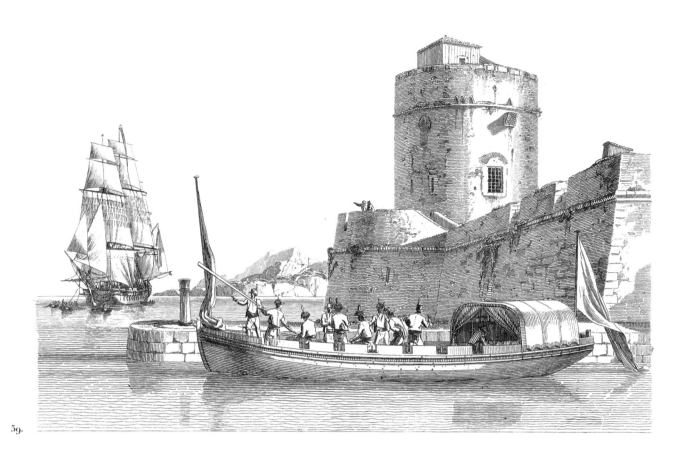

59.

\mathcal{T}HE *grand canot* of a French ship of the line, the equivalent of a Royal Navy barge or pinnace, usually a senior officer's 'personal' boat. Judging by the elaborately uniformed crew, the shelter aft, and a command flag, it is being used by an admiral or flag officer.

In the background a ship under tow with its own boats demonstrates one of the prime functions of such craft. [*Collection* 71]

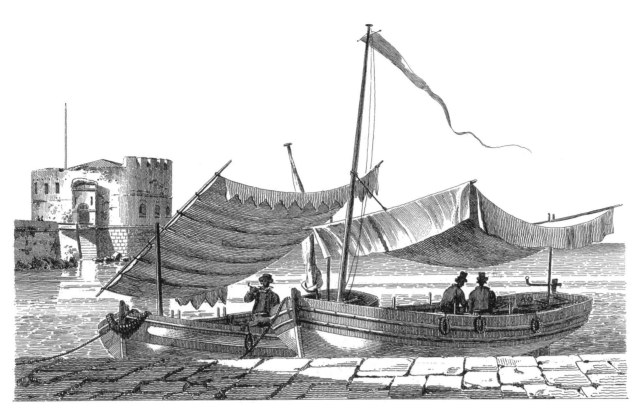

60.

SHIP's boats with their boat-keepers relaxing in
the shade of extempore awnings. Interesting details include the fenders, single thole-pins on
the nearest boat and double on the other, and an iron tiller (with upturned pommel) in the
foreground boat. [*Petites Marines* 116]

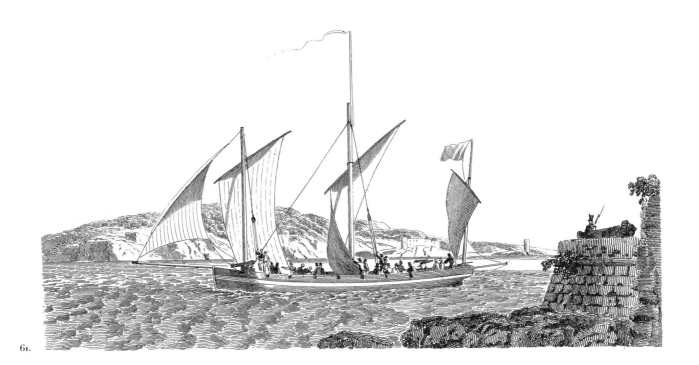

61.

Péniche making sail. The word is related to English 'pinnace', French *pinnasse*, rather than the port of the same name on the Portuguese coast. According to Bonnefoux et Paris, *Dictionnaire de Marine*, about 400 of these were constructed as landing-craft, part of the Boulogne Flotilla intended to invade England. The larger of two classes built were 20 metres long, drawing 1.5 metres of water. They were armed with a 4-pounder gun and a 16-centimetre mortar, plus swivel guns. Forty oars were manned in large part by the soldiers, who were to carry out the landing. They were narrow and relatively unstable, and although fast under sail they were clearly unsuitable for Channel conditions in anything except a flat calm. [*Petites Marines* 109]

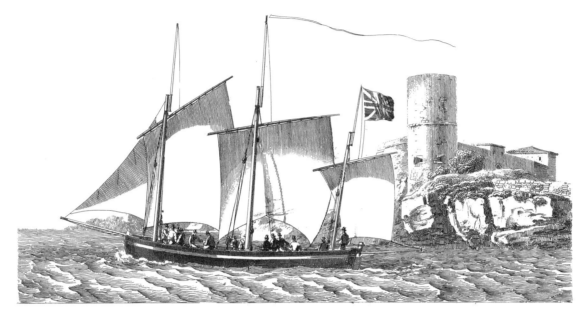

62.

\mathcal{A} British ship's boat (*canot*) close-hauled on the port tack, rigged with a jib and three dipping lugsails, that on the mizzen being sheeted to an outrigger. It is much better canvassed than the boat in Plate 58. Topmasts are rigged abaft the masts. Baugean notes that the English ship's boats were lighter built and a bit smaller than their opposite numbers in the French marine. The Dutch artist Pieter Le Compte (1802-1849) produced a lithograph (reproduced on page 220 of Irene De Groot and Robert Vorstmann's *Sailing Ship Prints by the Dutch Masters*) which is clearly a copy of this, although reversed right for left. He describes it as an English Channel Pilot Boat, and it does bear some resemblance to a Deal lugger.

Baugean's grasp of flag etiquette may be thought dubious, but the Royal Navy was sparing in its issue of ensigns and the Union Flag, as flown from the boat's mizzen, was often used in captured vessels. [*Petites Marines* 19]

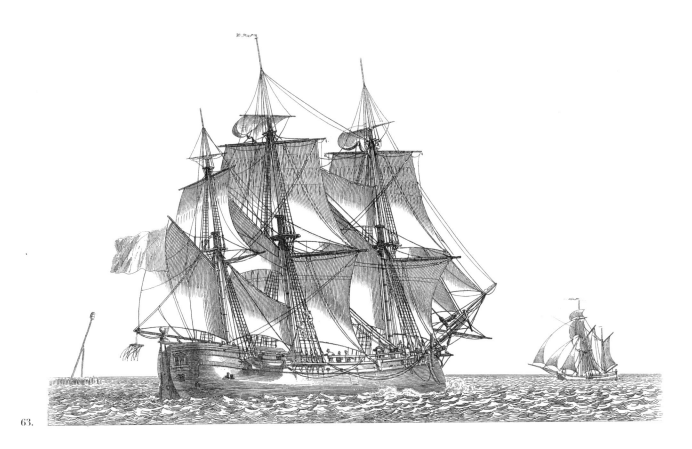

63.

\mathcal{D}UTCH FLUTE, by the wind on the starboard tack. These ship rigged vessels were built with full lines, for carrying between 300 and 900 tons of freight, not for speed. The hull form was descended from the seventeenth century type whose efficiency enabled the Dutch to take over the majority of the world's carrying trade. By the end of the following century, some features, like the excessive tumblehome, had been toned down, but they remained cost-effective bulk carriers. In this example, the rudder head is decorated with a man's head, and the tiller comes in over the bulwarks. In larger examples, the tiller is accommodated in a slot in the stern.

In the background is a galiot. [*Collection* 8]

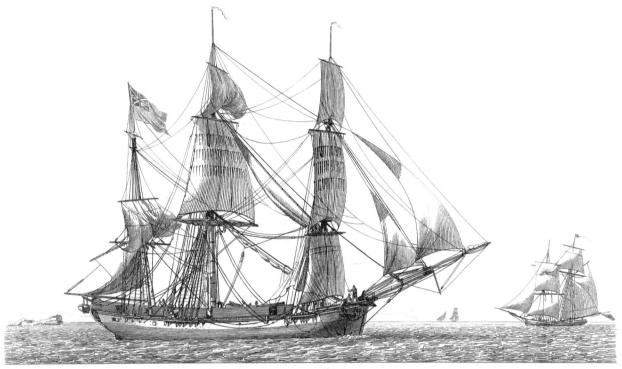

64.

\mathcal{L}IGHTLY ARMED British merchantman of about 400 tons, making sail. Baugean notes that bigger versions of such a ship would have had quarter galleries and a beakhead; in fact, the absence of these features as shown here characterises the vessel as a bark or cat. The anchor is catted, but not fished (that is to say the stock has not been hauled up horizontal for stowing), and the vessel is running before the wind under jib, fore topmast staysail and square canvas. The main topmast staysail is loosed; the main topgallant and mizzen topsail have not been mastheaded; the main staysail is furled; and the peak of the spanker gaff has not been hauled up. The main course is furled, since on this point of sail it would have prevented the fore course drawing properly.

In the background is a brig-schooner (or 'true brigantine'). [*Collection* 15]

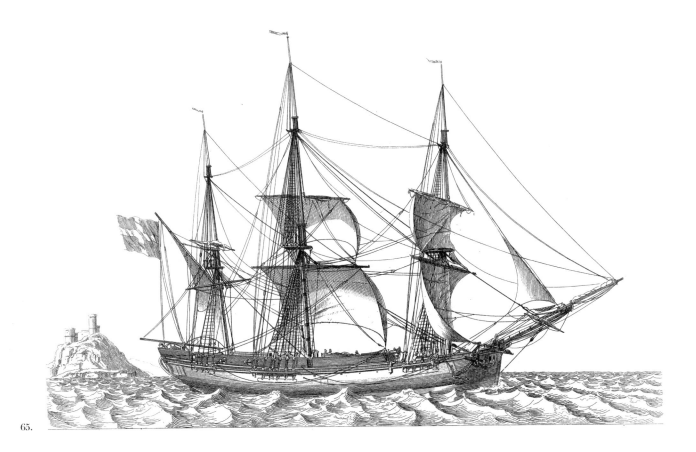

65.

SWEDISH merchantman tacking under reefed topsails. Baugean says that the Swedes built seaworthy merchant ships of simple construction, from 300-600 tons. There is little in the way of hull decoration, and no dolphin striker. The fore and main topsails are reefed, and the mizzen topsail furled. The vessel has been on the port tack, and has run up into the wind, throwing the fore course and topsail aback, pressing against the top, mast and rigging, so the bow is pushed off to port and onto the new tack. The sheet of the mizzen has been slacked off to allow the stern to approach the wind, and the main yard, and main topsail have been swung, filling the sails on the main on the new tack. The lower forward starboard corner of the fore course is being hauled forward by the tack. [*Collection 23*]

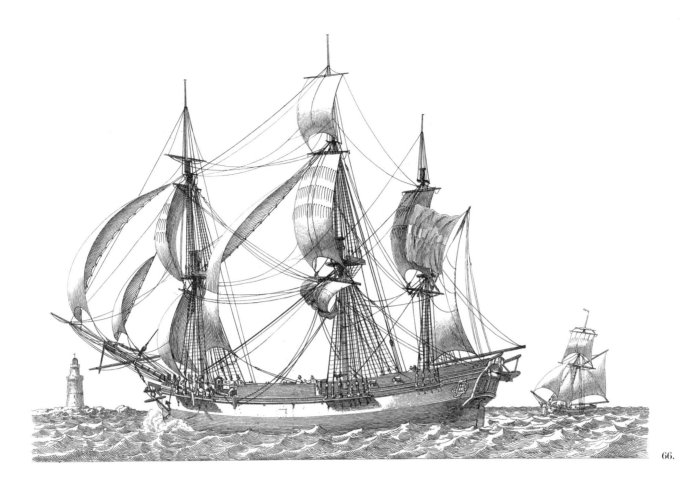

66.

*D*ANISH merchantman running in to her moor-
ing. An unremarkable, lightly armed cargo vessel of a type that was common in all the mer-
chant marines of northern European states, this example has quarter badges and (probably) a
beakhead, so is not as plain as the previous ships. The main course is brailed up, and the sheets
of mizzen and main topgallant staysail loosened. Main topgallant is set; corresponding sail on
fore, furled. Amidships there is a loading port, which was probably caulked shut for the voyage.

In the background is a polacre rigged sloop. [*Collection 40*]

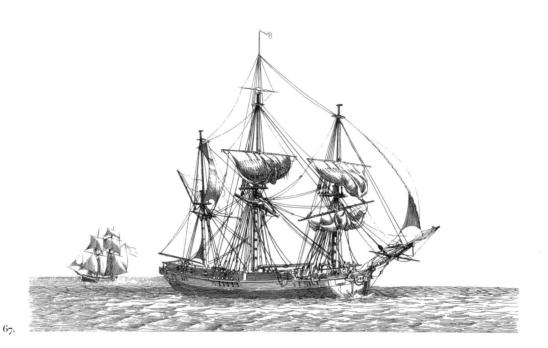

67.

*L*IGHTLY armed Swedish merchantman on the point of dropping its anchor. Baugean notes that these are solidly built but devoid of decoration, and based on that, it may be a bark or a cat. Ocean-going ship rigged vessels of this period were very similar and determining the nationality of an individual ship depended on relatively minor details. Fore and mizzen topgallant masts have been sent down. The anchor hangs at the cathead ready to let go; topsail halliards let go, and clewlines hauled; main sail furled; and fore course in the brails.

In the background is a topsail schooner. [*Petites Marines* 13]

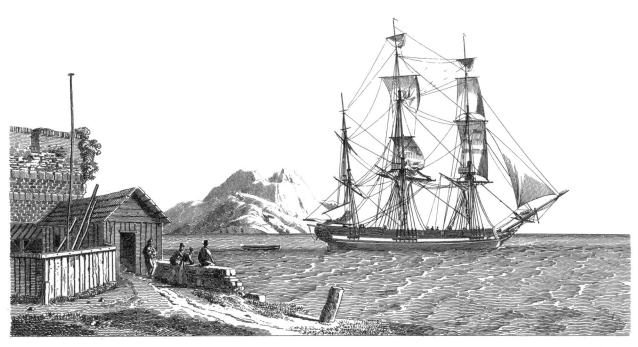

68.

AMERICAN merchantman getting under sail from anchor. Facing embargo, sanctions and economic warfare during the great European conflict of 1793-1815, American shipowners had responded by building cargo-carriers with better sailing qualities, and these relatively advanced designs gave them an advantage in some trades when peace returned. Baugean thought the Americans built the finest looking merchant ships, but remarked that, at the time of writing, it was becoming harder to tell the nationality of a vessel by appearance alone. Merchantmen were sparsely manned compared to warships, and for this reason the topsails are being hoisted separately, and the square canvas on the mizzen has not been deployed at all. Note the use of fore and main trysails instead of topmast staysails, increasingly common in the early nineteenth century. [*Petites Marines* 70]

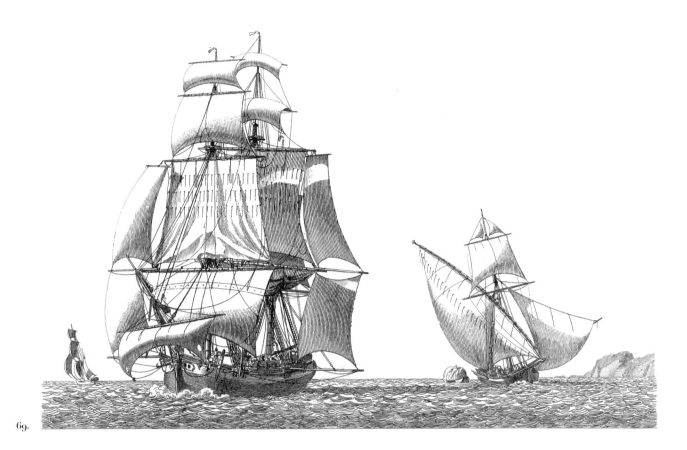

69.

\mathcal{M}ERCHANT ship running before the wind. This engraving offers many interesting details. The wind is dead aft, so that the fore topsail is blanketed by the corresponding sail on the main, and hangs limp. The main course has been brailed up, and the sheets on main topgallant and main royal slackened off, to give the wind the best shot at the square canvas on the fore mast. The fore-and-aft headsails have been hauled down, but the spritsail is filling nicely; note the water-holes. Lower and topmast studding sails are set to starboard on the fore, and to port at the main. An alternative would be to set them on both sides of the fore mast. At this date, lower main studding sails were rather uncommon.

In the background, a tartane is towing its boat, which is loaded with hay. It is rigged with lateen main sail; large fore sail or *polacre*; square topsail, with raffee topsails. The French called these 'pigeon-wings' (*ailes de pigeon*), a very apt term in this case, although it was used for sky-scrapers and other types of flying kites as well. An odd feature is the configuration of the reef band, which approaches the yard at each end. This gives a mistaken impression, since the reef-band on lateen sails was not parallel to the yard, but diverged from it towards the peak of the sail (see Plate 143). This meant that when the sail was reefed, more canvas was taken away aft than forward, which had the effect of not forcing the vessel's head into the wind, and so not requiring that excessive weather helm be carried. [*Collection* 52]

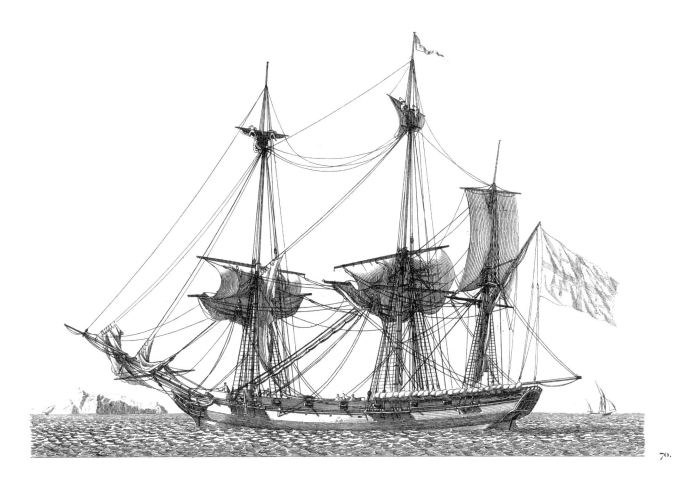

70.

*T*HIS handsome Greek merchantman has just dropped her port anchor, and is drifting back, under the influence of the backed mizzen top-sail. Described by Baugean as a 'merchant corvette' (a term which seems to have denoted a vessel with a flush weather deck like the warship she was named after), this ship exhibits generous sheer; she is lightly armed with about 14 guns and carries some protection along the quarterdeck rail (this may be bale goods or rolled hammocks as in warships). Fore and main masts are polacre rigged, with separate topgallant masts. Topsail downhauls are hinted at. [*Collection* 48]

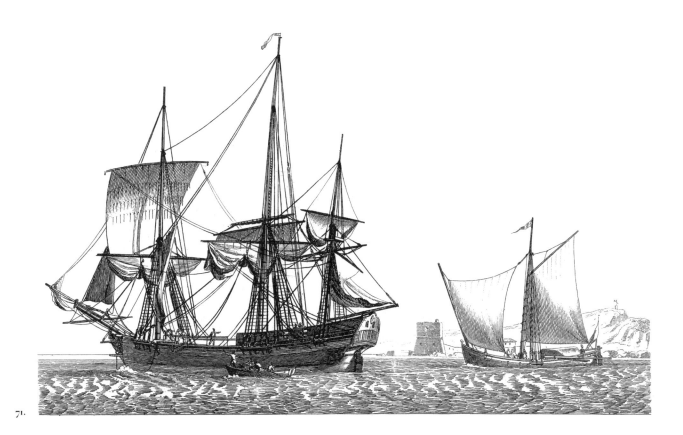

71.

\mathcal{V}ERY lightly armed and relatively undecorated Neapolitan merchantman making sail from her moorings. No dolphin striker is present, and the anchor is catted but not yet fished. Fore and main masts are polacre rigged, with topgallant on the main. The main topmast staysail has been loosed preparatory to setting. There is no evidence of topmast yard downhauls on the fore.

To the right is a liuto, literally a 'lute'. Baugean says these vessels had substantial carrying capacity and were used as coasters on the Tuscan coast, indeed from Genoa to Naples. The oddly shaped fore sail is discussed in the Introduction. [*Collection* 51]

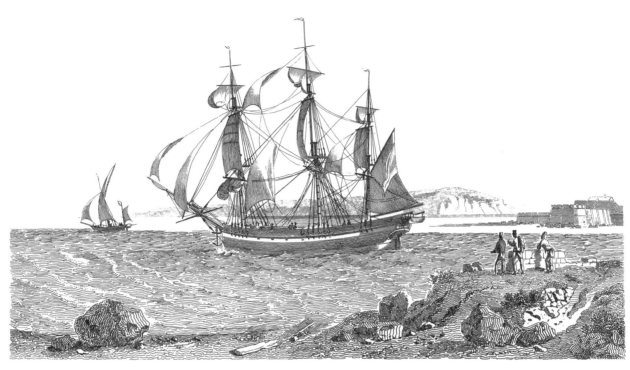

72.

\mathcal{S}MALL merchantman making sail from anchor. The anchor hangs under the cathead, ready to be fished, and the topgallants are being hoisted. Baugean says that vessels from 5oo-7oo tons capacity were ship rigged; vessels from 15o-5oo tons were rigged as brigs; and those smaller than 15o were schooner rigged. This is acceptable as a generalisation for the period in which he worked, but there were exceptions – in particular, many smaller vessels were ship rigged, and coastal craft carried a greater variety of rigs than merely that of the schooner.

In the background is a tartane. [*Petites Marines* 98]

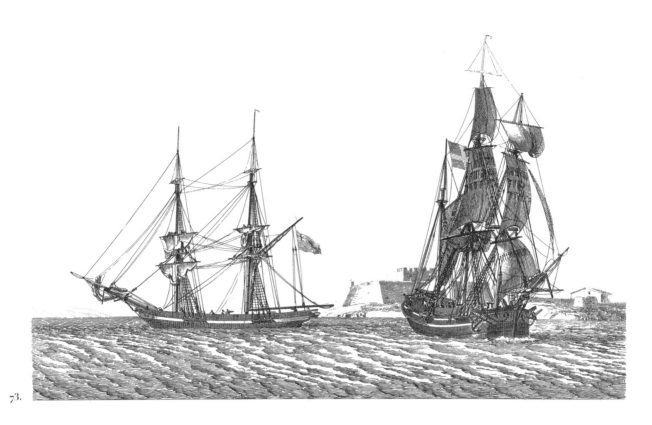

73.

\mathcal{A}N ENGLISH brig has just anchored, and a Swedish merchantman is running to her anchorage. The brig lies head to wind, port anchor down, her crew on the topsail yards furling sail. Today we would describe the Swedish vessel as having a barque rig. The anchor hangs at the cathead, ready to let go ring and stock painter when the moment comes. A surprising feature for such a small vessel is the main royal mast, fidded abaft the topgallant. [*Petites Marines* 46]

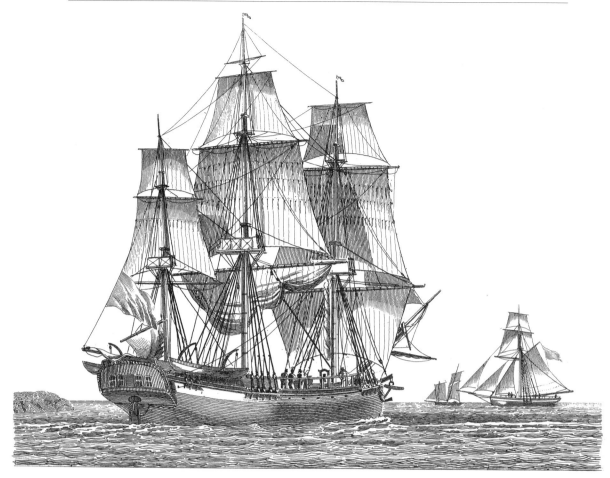

74.

\mathcal{W}HALER, sailing with wind large on starboard quarter. The gaff mizzen has been dropped and the main course partially brailed up to avoid blanketting the fore course. The whale-ship was one of the first specialist sub-categories of ocean-going merchantmen; originally they tended to be ship rigged, like Baugean's example, but the barque rig became more common in the nineteenth century. Because they often spent years away from their home port, and in some circumstances had to encounter pack ice, they tended to be very sturdy vessels. They were identified by a large complement of double-ended whale-boats (or whalers), carried under davits along the topsides and/or nested on deck; two can be seen here under their curved davits. [*Petites Marines* 112]

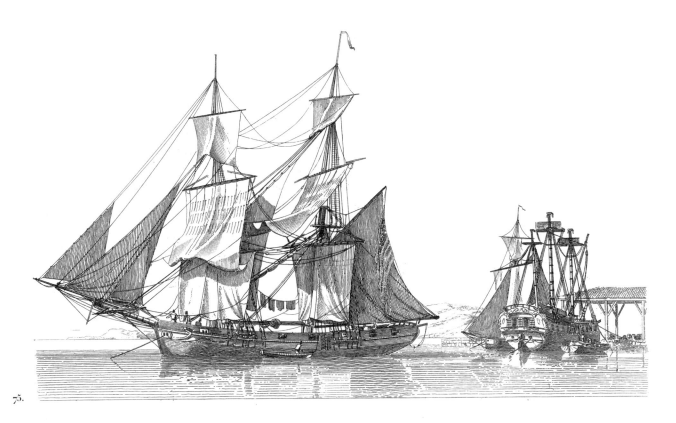

75.

\mathcal{A}N AMERICAN merchant brig, at single anchor, airing her sails. Although a trading vessel, the brig is well armed: decades of neutral trading in a world at war had taught American shipowners the value of a substantial defensive armament. A slightly surprising feature is the apparent co-existence of main staysail and main course (traditionally, these were alternatives). Note the hammocks drying and spare spars on gallows.

In the background is a de-rigged merchantman, and beside it a Bermudian vessel, airing its canvas. [*Collection* 41]

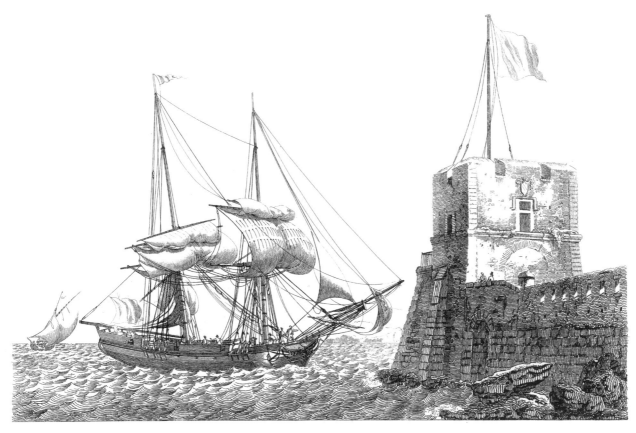

76.

A FRENCH polacre rigged brig running to her moorings. Note the relatively elaborate beakhead, with the absence of quarter badge and dolphin striker. Many Mediterranean brigs were rigged polacre fashion, because, as can be seen here, everything could be got down quickly in the event of a squall, even by a small crew. Note the absence of a main course, and the furled main staysail.

In the background is a tartane. [*Collection 42*]

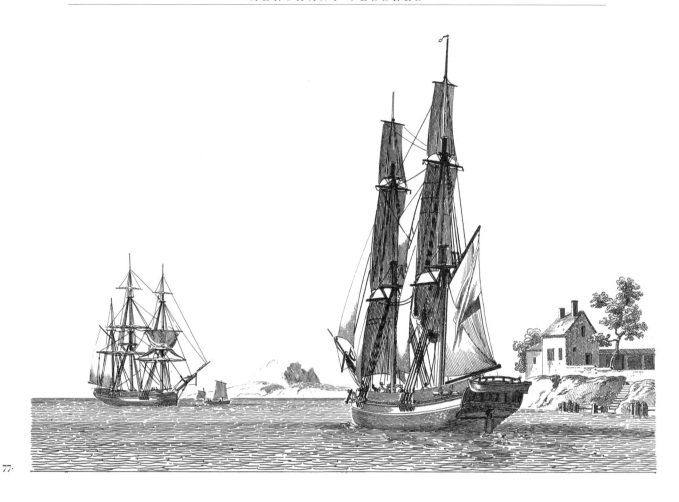

77.

*B*RIG seen from port quarter. It is proceeding to sea under the influence of a light breeze. Like the vessel in Plate 78, she has no spritsail yard. In the background, a merchantman lies at anchor – like that in Plate 73, she rigged as barque. She is airing her fore topsail, and has the mizzen set. [*Petites Marines* 78]

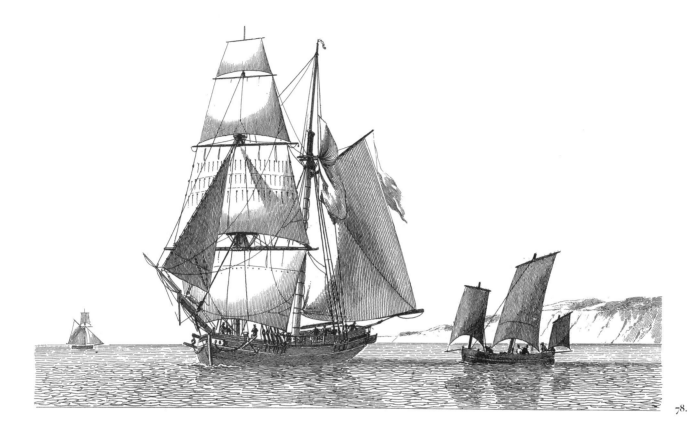

78.

\mathcal{B}RIG-SCHOONER in a light breeze. The jackyard gaff topsail has been struck; there is no spritsail yard. Unlike warships, with their built-up bulwarks to protect the gun crews from small-arms fire, merchantmen like this one had only a light structure of rails on the weather deck. In suitable conditions these may have fitted canvas dodgers to shelter the crew.

To the right is a small Normandy fishing lugger, and on the horizon is a sloop. [*Petites Marines* 77]

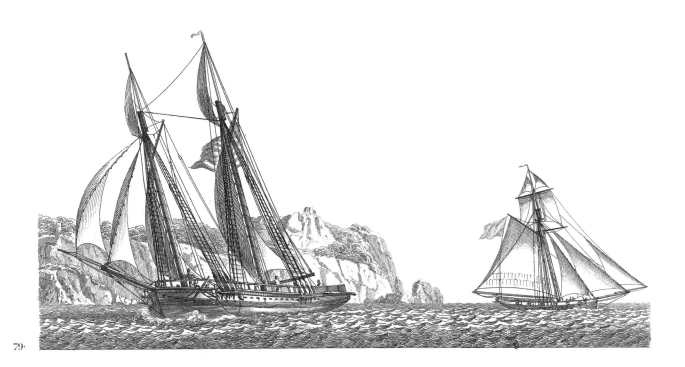

79.

\mathcal{A}MERICAN pilot boat and Bermudian sloop. The left-hand vessel is schooner rigged, but does not set square topsails; note iron-stocked anchor and anchor-buoy. Although all fast-sailing schooners tended to keep the weight and windage of their topsides to a minimum, in this case the very light railing may reflect its use as a pilot boat. The sharp-lined but shallow 'pilot boat model' became the inspiration for the development of fast schooners in the years after 1815 – the so-called 'Baltimore clipper' pattern.

Baugean says that Bermudian boats, like that on the right, abound in American waters, and are the models for the sloops and cutters in use in Europe. [*Collection* 56]

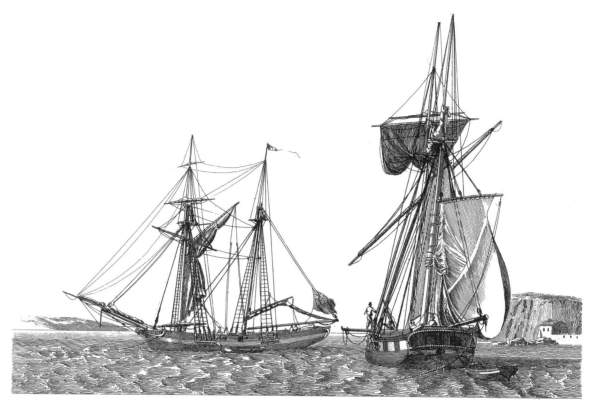

80.

\mathcal{B}ALAOU (or ballahou) schooners. These North American schooners were in widespread use, and somewhat more lightly built, loftily masted, and slightly differently rigged from their European cousins. The latter usually set a square top-sail on the main mast (see Plate 42). Baugean says that they had a capacity of 30 to 300 tons, and when employed as privateers carried 18 to 20 guns or carronades. The main sail was taken in by lowering the gaff, while the loose-footed fore sail was brailed up and in (note the stow of these sails in the vessel on the left). The yard, with furled sail, seen forward of the fore mast on the vessel to the left, and in Plate 31, is discussed in the Introduction. [*Petites Marines 4*]

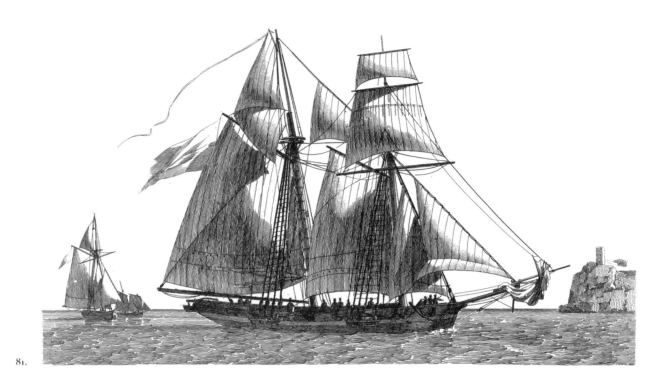

81.

\mathcal{M}UCH valued for their speed and ability to sail close to the wind, schooners were built in a variety of sizes, the largest being of around 400 tons. This example would mount about 10 guns, and is rigged with a square topsails on the fore. The topsail can be reefed, and is fitted with a single buntline, and the vessel is close-hauled on the port tack. We can infer she has just gone about, since the main sail is pressing against the lee boom topping lift and the main topsail against the peak halliard. The flying jib has been lowered, and to balance the sail plan, the tack of the main sail has been triced up a little. The set of the foot of the jib is interfered with by what may be a tripping-line, which would have served to facilitate getting the clew of the sail over the fore stay when tacking.

In the background is a sloop and a lugger. [*Petites Marines* 61]

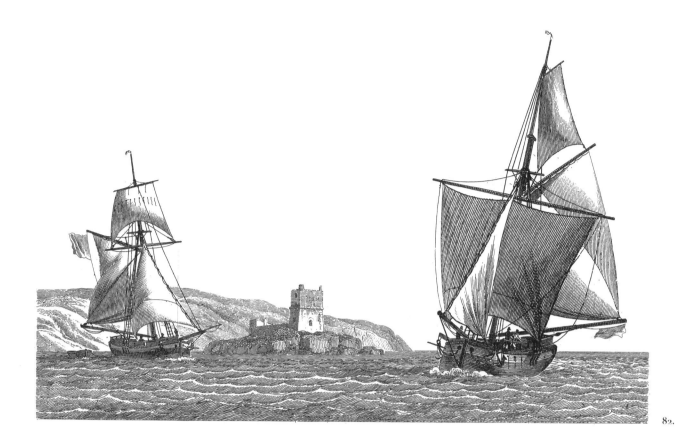

82.

SLOOPS under sail. Cutters and sloops were rigged in similar fashion, but cutters were employed by the navy, the customs and revenue services, and (on the other side of the law) for smuggling and illegal trading, whereas the sloops were used for everyday commerce. Cutters tended to have a more extreme hull form, with sharper lines, and were originally characterised by a long, flat-steeved bowsprit that could be run in to one side of the stemhead. Up to about 1800, the cutter's mast exhibited substantial rake, but this was going out of fashion, since it tended to throw more strain on the rigging when pitching. The cutter in Plate 43 has a more or less vertical mast. The sloop on the left has a square topsail, while that on the right has a jackyard topsail, and a running fore sail (*voile de fortune*) set on a longer yard under the top. It is hard to determine the nature of the item on the boom footrope. [*Petites Marines* 69]

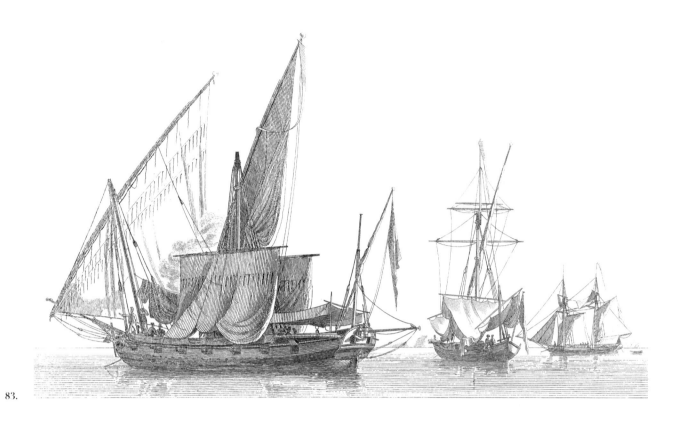

83.

\mathcal{V}ARIOUS types of French Mediterranean privateers (loosely termed 'corsairs') at anchor. Baugean does not comment on the rigs, but from right to left, they are a schooner, tartane and what seems to be an armed pinque. The last is airing both its lateen and square sails. This ensemble emphasises the fact that although northern European rigs, like the schooner, were to be found in the Mediterranean, there were also a number of rigs – and indeed hull forms – unique to that sea. Many sail-plans were based on the ancient lateen sail, a large triangle of canvas hoisted from short, often raked, masts; the hull form were often derived from the galleys of the Middle Ages and late Antiquity. [*Collection* 3]

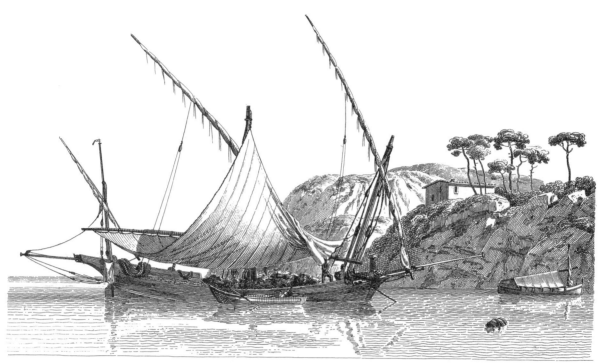

84.

*S*PANISH chebec at anchor. Baugean notes that these are used for the coasting trade, as would be the case here, but comments that they are often armed for privateering, with up to 24 cannon. The overhanging stern and stemhead configurations, derived from galley practice, are characteristic. This example has three lateen masts, but they were often rigged differently. There are actually four lateen sails and yards to be seen, the fourth being employed as an awning. [*Petites Marines* 47]

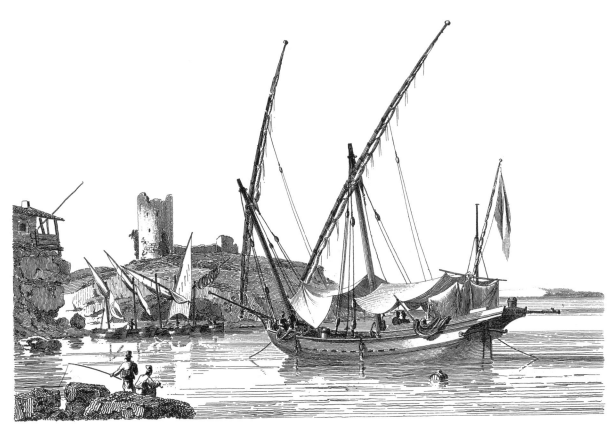

85.

SMALL chebec at anchor. Baugean says these vessels were much favoured for privateering, being armed with up to 20 guns. Like the previous example (Plate 84), this one seems to be engaged in trade, but at one time there were substantial numbers of them in the French and Spanish navies, not to mention the maritime forces of the Barbary 'pirate' states. Note the beakhead, *cul-de-poule*, fenders, and scuppers. [*Petites Marines* 88]

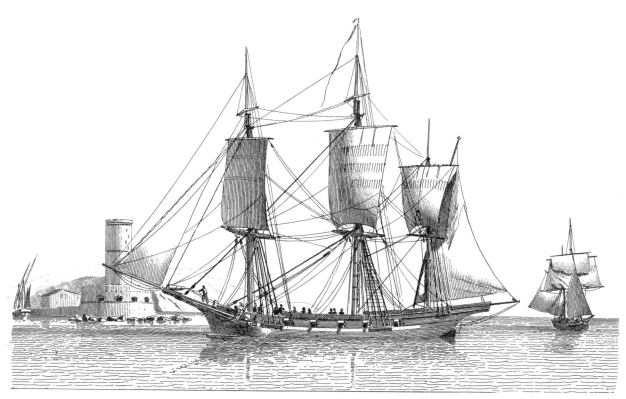

86.

\mathcal{C}HEBEC, armed with 12 guns, coming in to her moorings. The hull is typical of this type of craft, but with a more warship-like tier of gunports in the built-up bulwarks. Indeed, the masthead pendant and the line of hammock netting atop the rail suggest naval service. However, the principal feature is that like the chebec shown in Plate 50, she is square rigged, a development of the eighteenth century (compare Plates 84 and 85). Fore and main are rigged polacre fashion, but have fidded topgallant masts. Note buntline on the mizzen topsail. [*Petites Marines* 106]

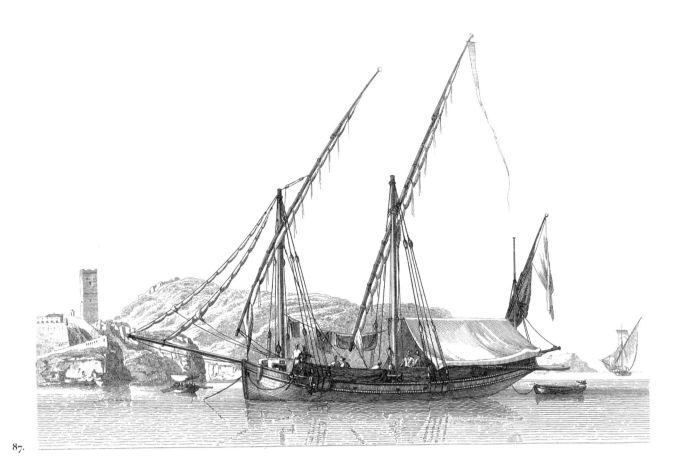

87.

\mathcal{T}HE misticou (variants *mystic*, *mystique* and *mist-ico*) was a vessel in use on the coasts of Spain. Baugean says their trapezoidal sails had the advantages of lateen rig, but not its disadvantages. The halliard is in front of the mast, imply-ing that when going about, the forward end of the yard was dipped abaft the mast, rather than being allowed to swing forward of it. A popular rig for privateers, it might be considered a cross between the lug rig of the chasse-marée and the classic lateen. The vessel shown here has a straight stem, long bowsprit, two headsails, and three masts, which are not inclined forward. Two bow-chasers and other guns behind the waistcloths, are visible. As common in these craft, the long sweeps for propelling the vessel in a calm are lashed to the quarter.

In the background is a tartane with a square topsail. [*Collection* 30]

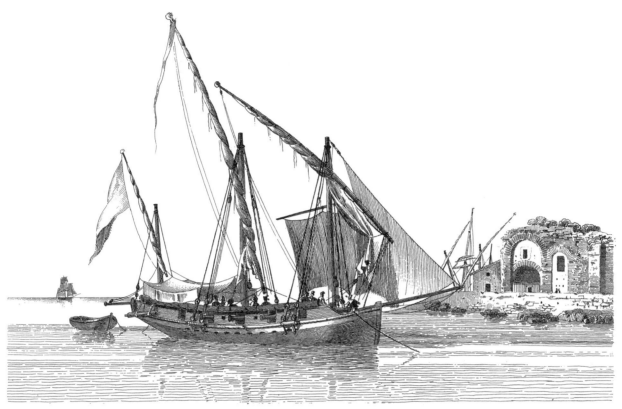

88.

SMALL Spanish misticou rigged privateer at anchor (compare previous Plate). The vessel, which can be propelled by sail or oar (note the sweep ports between the guns), has ports for 10 guns, but a bow-chaser is capable of being fired over the stem. Note the *treóu*, or square sail for use when the weather was unfavourable. The similar vessels in Plates 52 and 87 have structures which look like channels, but the mast is supported with tackles; but in this case there are deadeyes and lanyards. The bundles lashed to the quarters seem to be a bit too short to be sweeps – perhaps they were used as a fender; as oars for ship's boat; or as firewood for the galley (compare Plate 108). [*Petites Marines* 97]

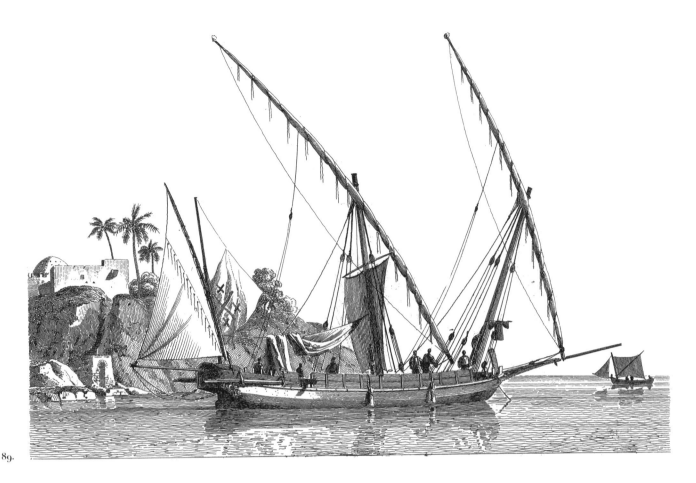

89.

\mathcal{A} KIRLANGHI, a lightly armed Greek chebec, at anchor. It has three lateen rigged masts, with the fore mast raking markedly forward; the mizzen is set to keep the vessel head to wind. Note recurved stemhead, square stern, oars stowed outboard, and boat fenders. Baugean remarks that the Greek seaman were audacious, but felt that such success as they had against the Turks was mostly because of the incompetent Ottoman leadership. The flag is the same as that seen in Plate 70.

In the background is a Greek scapho, a small local boat. [*Petites Marines* 72]

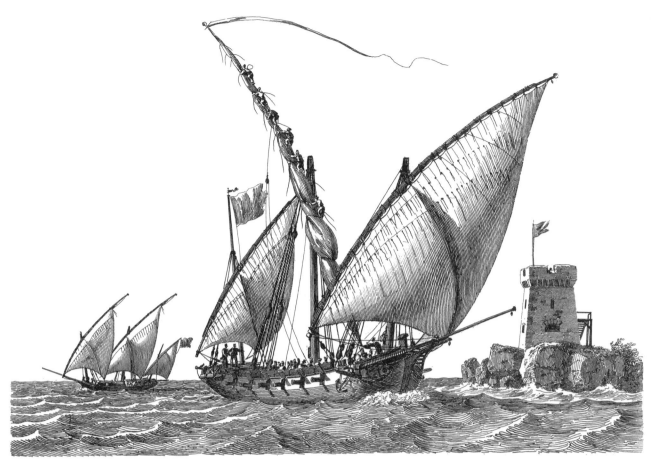

90.

A LATEEN rigged privateer running to anchor. Baugean describes this vessel, which is armed with at least 12 guns, as a *barque*, perhaps because it, and the vessel in the background, seem to have transom sterns; in other respects, it resembles a chebec. Note the configuration of stemhead; the light grating platform that forms the beakhead; and spars or oars stowed outboard. There is a wealth of detail in this lively rendition. The men have scrambled aloft and are in the process of furling the main sail. Note the brails on the fore sail, and its two rows of converging reef-points, and the single reef-band on the mizzen.

In the background is a similar vessel with all three lateen sails set. [*Petites Marines* 73]

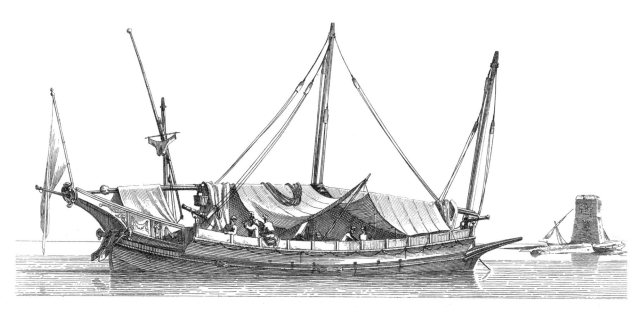

9ᴸ.

\mathcal{N}ᴇᴀᴘᴏʟɪᴛᴀɴ felucca at anchor. Related in hull form to the chebec, these were lightly built vessels, propelled by sail and oar, which rarely ventured beyond sight of the coast. They carried three masts, lateen rigged, with fore and main inclined forward. Very picturesque, they were often included by Claude Lorraine in his marine pictures. This one is armed with four swivel guns. Very characteristic are the beak (*éperon*) forward, the fashion in which the bulwarks aft are prolonged as wings (*ailes*) to form the common *cul-de-poule* stern configuration. The quarters were often decorated, another practice deriving from the traditional forms of the galley. [*Collection* 7]

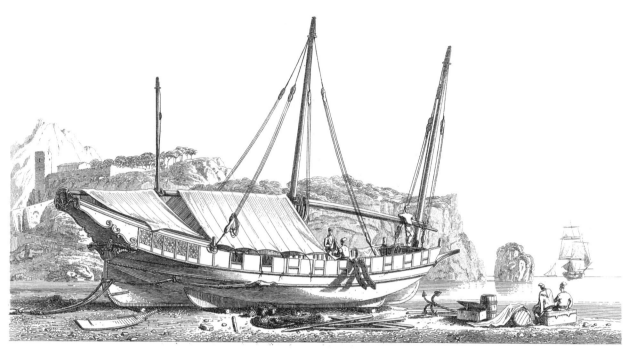

92.

SICILIAN felucca pulled up on beach. Note the relatively straight stem and sternpost and rounded form of the forefoot and stern, which facilitate the beaching process, whether executed bow- or stern-on. The bilge side-keels ensure that the craft does not roll over on its side. Heavy hooks are fastened to the wale, to which the pendants of the beaching tackle are secured (compare those in Plate 91). The beakhead, boarding ladder, and elaborately decorated wings (*ailes*) of the open stern, can be seen. The topsides seem to be made up of panels, some of which appear removeable to make gun- or sweep-ports. [*Collection* 20]

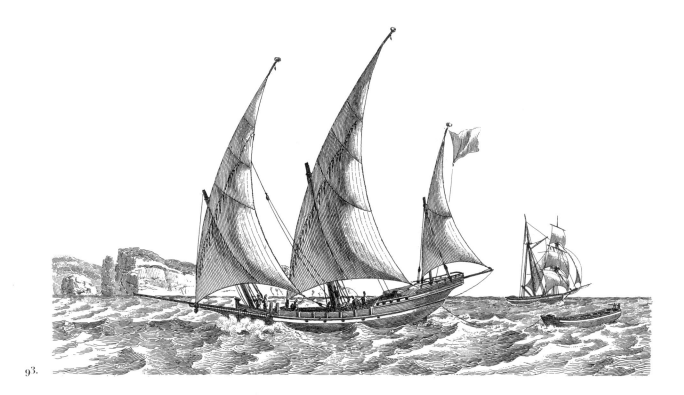

93.

ℱÉLOUGUONE: this was the term in Genoese dialect
for a large felucca. Characteristic beakhead, stemhead and stern can be seen, although the
quarters are less elaborately decorated than those in the previous Plates. The way the sail is
represented makes it possible to see three brails secured to the after leech, and one to the foot
of the sail. She is towing a boat which is palpably too large for stowage inboard.

In the background is a brig-schooner. [*Petites Marines* 101]

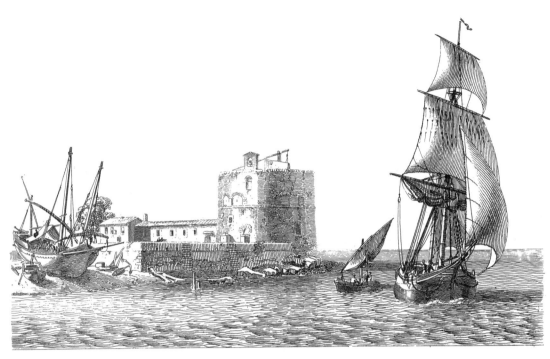

94.

\mathcal{B}OMBARDE, seen from the bow, and felucca hauled up on a slip. The bombarde, which was essentially a ketch, was polacre rigged on the main mast, with a topgallant mast (compare Plate 55). Baugean says that the felucca was only used for voyages which did not take the vessel far from land, and which allowed it to be beached at night. They were primarily in use on the Italian coast.

The tower in the background is typical of many of the structures depicted by Baugean in his Mediterranean scenes. Such structures had been built all round the coasts of the Mediterranean since the Middle Ages and functioned as watch-towers to give warning of attack from the sea (note the belfry on the roof), to provide some refuge for the locals at such times, and after the invention of gunpowder to supply a more active form of defence; in more peaceful times they became signal stations and lighthouses. [*Petites Marines* 21]

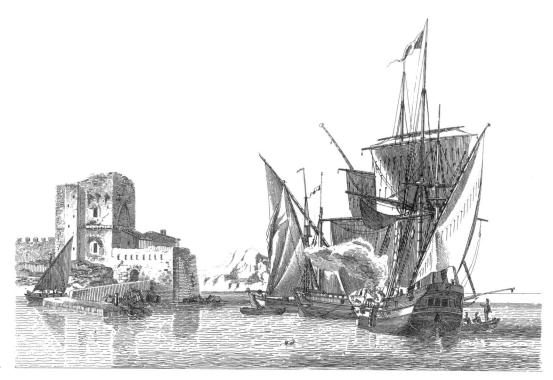

95.

\mathcal{V}ARIOUS Mediterranean vessels at anchor; in effect, a study in the variety of stern shapes. Nearest is a chebec. The form taken by the open stern is interesting, with a row of cabin 'lights' like northern vessels. Fore and main masts are polacre rigged, while the lateen mizzen has a square topsail above it. Smoke is rising from the galley, and a boat is shoving off from the starboard side. The stern of a pinque can be seen beyond it and further away a tartane is airing her canvas. [Petites Marines 28]

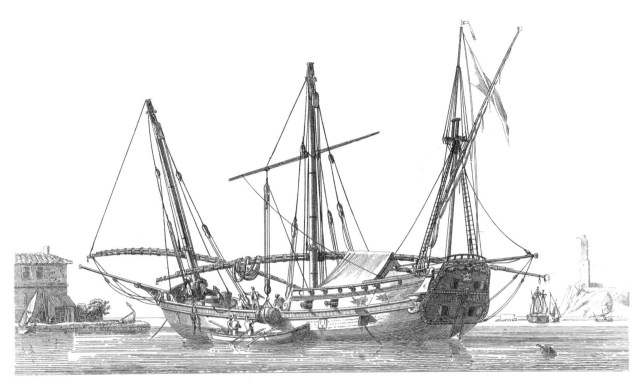

96.

\mathcal{G}ENOESE pinque. Baugean says that these were formerly very much used in the Mediterranean. They were built for cargo carrying rather than speed, having full lines and a capacity of about 300 tons. If armed to defend themselves against the Barbary corsairs, they could mount four 6- or 8-pounders forward, and six aft, besides other lighter pieces like swivel guns. In bad weather the lateen sails were replaced with square canvas (see Plate 97). A lateen rigged fore mast came under a lot of strain when going about, and some pinques replaced this with square canvas, and the disadvantages inherent in the very large sail area of the lateen sail encouraged the gradual displacement of this by other rigs. This pinque seems to be using one of her square yards to load casks from the boat alongside. The Genoese pinques in Plates 132 and 168, are similar, but the former sets a small square topsail on the mizzen. [Collection 5]

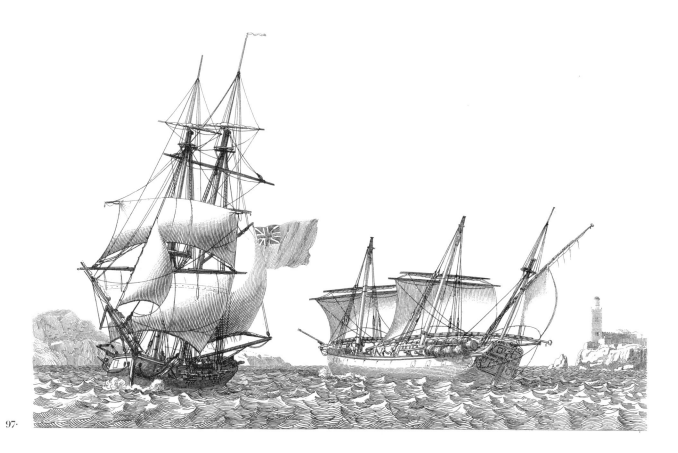

97.

\mathcal{T}HE PINQUE on the right has struck its lateen yards (which are stowed over the deck), and replaced them with square sails on fore and main. Note the casks stowed outboard of the poop; the forward inclination of the fore mast, and the way the lateen mizzen is reefed, with the after part of the sail securely furled (compare previous Plate).

The British brig, to the left, is sailing with the wind on the starboard quarter under fore course, reefed brig-sail and fore topsail, and fore topmast staysail. There are a couple of oddities in the engraving: the main lower yardarm should be visible, and the main topsail yard is mastheaded, but no sail bent to it. [*Collection* 58]

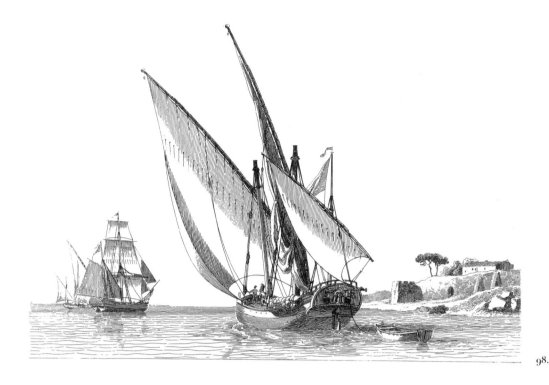

98.

*L*ATEEN rigged pinque seen from astern (compare Plates 96, 97 and 99). This vessel is sailing downwind, towing its boat, with some of its cargo stowed outboard on the quarter. The sheet of the fore sail has been slacked well off, and the main sail brailed up, to avoid backwinding the fore sail (*trinquette*). The mizzen yard lies on the weather (after) side of the mast, with the sheet hauled far enough aft to prevent the sail draping itself around the rigging and mast. The *orses* have been eased off to allow the forward end of the yard, or *car*, to rise.

The ketch in the background resembles what Baugean calls a 'square rigged tartane' (compare Plate 132). [*Petites Marines* 10]

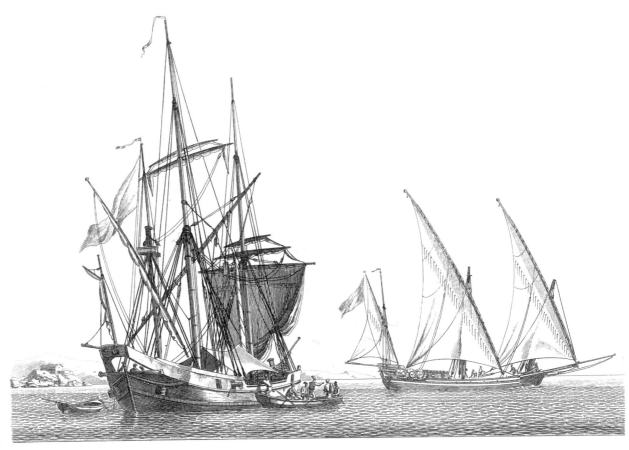

99.

To the left is a lightly armed Neapolitan barque at anchor. Fore and main are rigged polacre-style, including topgallants; mizzen is lateen rigged, and could set a square mizzen topsail if required. Note the gaff rigged ringtail mast, *éperon*, recurved stem, *cul-de-poule*, awnings, and ports ventilating the after cabin. Baugean comments that the barques of Naples are of a such a variety, some bizarre, some picturesque, that it would take too long to describe them. Their skippers, in his opinion, were not well trained, and rarely ventured beyond sight of land.

To the right is a lateen rigged Genoese pinque, sailing close by the wind on the starboard tack. The fore and main sails are just touching the rigging. Note the beakhead, transom stern, cargo being carried outboard, brails and vangs on fore and mizzen sails. [*Collection* 18]

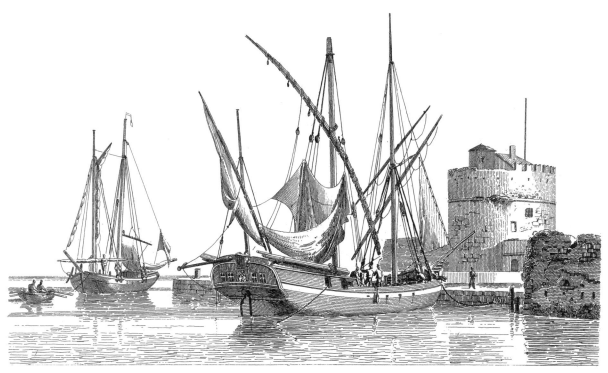

100.

\mathcal{G}ENOESE barque and coasting schooner. The barque is rigged similarly to that shown in Plate 103, that is to say polacre rigged on the fore mast, with two lateen rigged masts besides (compare Plates 101 and 102). The stern details are clearly delineated: cabin lights, with what may be a religious image between them, and long sweeps lashed to the quarters. The schooner is a very small example of vessels rigged that way, and is being towed into port by two men in her dinghy. There are no topmasts, but a square fore sail can be seen. [*Petites Marines* 110]

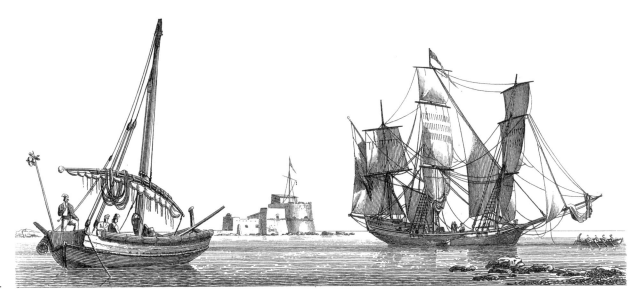

101.

\mathcal{G}ENOESE barque being towed by its boat. These are speedy vessels and can be used for privateering; they carry about 22 guns (see Plates 99 and 102). The hull is rather similar to that of the pinque. Fore and main are polacre rigged masts, and a mizzen carries a square topsail and a lateen mizzen sail. The fore mast is raked markedly forward, suggesting that the vessel originally set a lateen sail on this mast.

To the left is a Spanish bateau. *Bateau* in French is a generic word, which could be translated as 'boat' or 'barge'. The example shown here has a single lateen rigged mast, which is raked forward. Baugean says they are sometimes rigged with a small fore mast. [*Collection* 10]

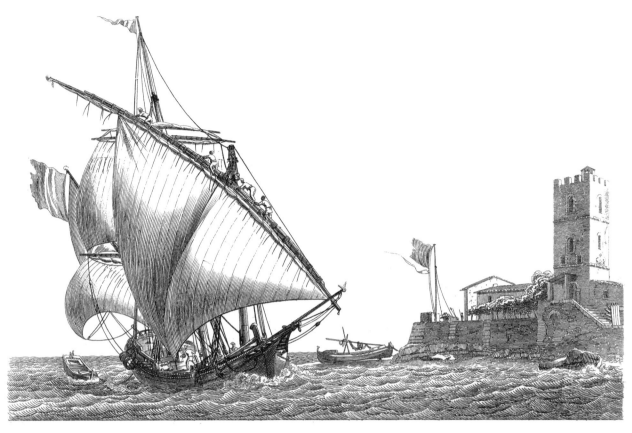

102.

\mathcal{P}ROVENÇAL barque running into to her anchoring berth, with a lively quartering wind, and ship's boat in tow. Fore and mizzen masts are lateen rigged, with the main polacre rigged (compare Plate 173). Casks are carried outboard; the main topgallant has been hauled down on the main topsail yard; main topsail and main course have reefs taken in. Note the square stern; the open beakhead platform (*éperon*), and the men scrambling up the yard to furl the reefed fore sail. Some deck detail is also visible, including the carriage guns at the break of the quarterdeck.

A fishing boat, with its mast lowered on crutches, rides to her mooring in the background. [*Collection* 12]

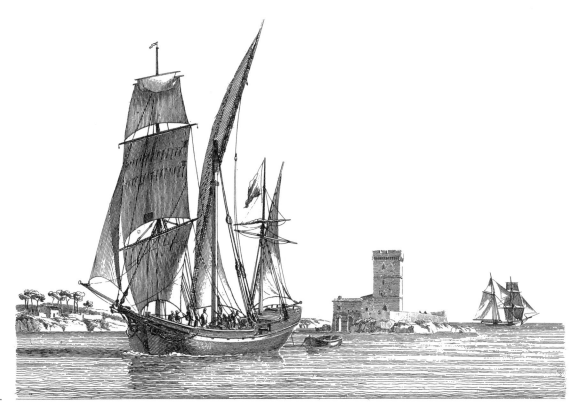

103.

\mathcal{S}PANISH barque in a calm (compare previous two Plates and 99). This vessel has a polacre rigged fore mast with considerable forward rake, similar to that shown in 101. Baugean notes that this vessel would originally have had a lateen sail on the fore mast, and the configuration of fore and main is the reverse of that seen in 102. The mizzen sets a lateen sail and square topsail. The halliards are hauled taut, and the blocks can be seen at the foot of the main mast. Note the characteristic beakhead and transom stern (compare the *cul-de-poule* of the Neapolitan barque shown in Plate 99).

In the background is a brig-schooner. [*Petites Marines* 1]

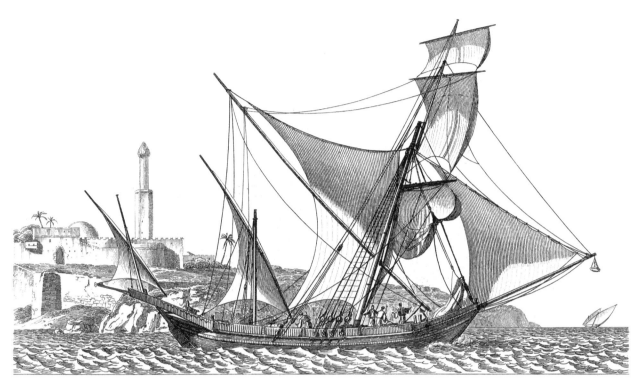

104.

\mathcal{G}REEK sacoleva, with the wind on the quarter.
These vessels exhibit a lot of sheer, markedly raked stem, and *cul-de-poule*. The main mast is heavily raked forward, and this example rigged with a topmast, setting course, topsail and top-gallant. The large spritsail is characteristic of these levantine vessels. Two small lateen sails, plus a fore staysail and jib are also seen. The significance of the wreath, or basket at the bowsprit end, is unknown. [*Collection 22*]

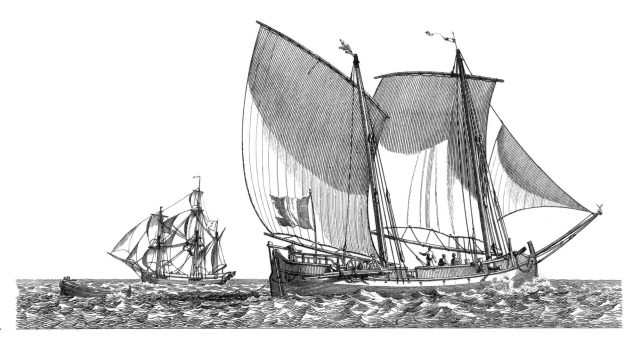

105.

𝒯RABACCOLO. Baugean says the trabaccolo was the favoured coastal vessel in the Adriatic, but because of the shoal waters found there, they tended to be of shallow draught. Some had a third mast, with a lateen sail, but the two-masted example shown here, with its lugsails and a jib, is more typical. John Leather (in *Spritsails and Lug-sails*) says that it was usual to set the main yard to port of the mast, and the fore yard to starboard, although this is not how it is shown in the engraving. The boom of the fore sail extended well forward of the mast, and was held down by a tack-tackle secured on deck well clear of the mast, so that upon going about the forward part of the sail would not catch aback. The boom of the main sail did not extend much ahead of the mast, and the yard was peaked up more, so that there was little backwinding when on the 'wrong' tack. Although, not evident here, two features of the trabacco are worth mentioning: carved or painted *oculi* at the bow, and a cap on the stem, carved to represent a sheep's fleece.

In most lugsailed vessels, the sails were loose footed – for instance, the Cornish fishing luggers,' or the French chasse-marée. John Leather says the boom was disliked for various reasons, particularly the danger of a boomed lug getting overboard and filling with water. In other Adriatic craft, the foot of the sail was laced firmly to the boom, but it is possible that, as shown here, the lacing was slackened off to allow the sail to set better, when not sailing close-hauled.

In the background is a barque rigged vessel, with her fore topgallant missing. [*Collection 4*]

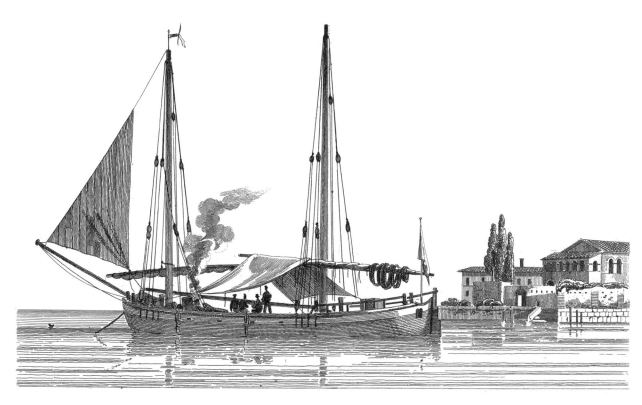

106.

\mathcal{T}RABACCOLO at anchor. This peaceful evening scene shows an Adriatic coaster at anchor. The fore sail is being aired, a meal is being cooked, and an extempore awning lies across the spars. The yards are lowered, but the boom to which the foot of the sail is laced is not in evidence. The hull shown here does not have the same picturesque characteristics as that shown in the previous Plate, being altogether more utilitarian in appearance. [*Petites Marines* 80]

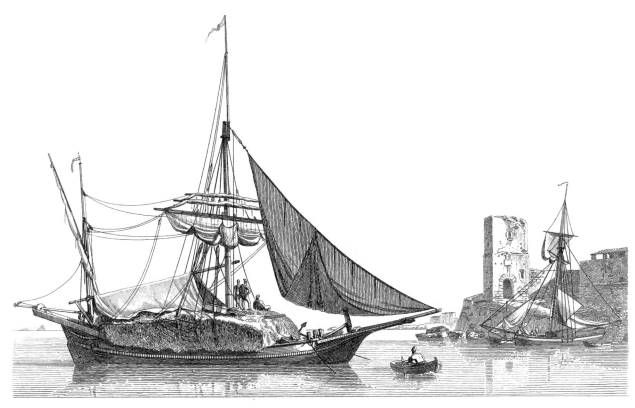

107.

Neapolitan tartane, with two anchors down, and its deck-load of hay (fodder) confined by netting. As in so many traditional Mediterranean types, the beakhead, decorated recurved stemhead and *cul-de-poule* are characteristic. Its very large jib is being aired, and the furling-gaskets can be seen on the forward leech. Some tartanes set a flying jib as well. Commonly, the main mast was rigged with a lateen sail, sometimes with a square topsail above it, but his one has a polacre rig consisting of course, topsail and topgallant, with a fidded topgallant mast. The ringtail is lateen rigged with the sheet extended by a outrigger. The tartane in the background of Plate 184, has a gaff ringtail. Compare the tartane in the background of Plate 69.

In the background is a sloop with a very lofty rig. [*Collection* 21]

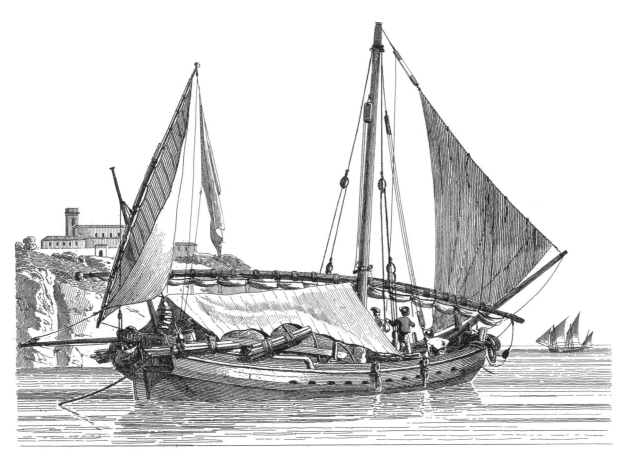

108.

SPANISH vessel from Valencia, moored head and
stern. Baugean uses the word *bateau* to describe it (compare Plate 101), but in some respects,
while the rig is similar to a tartane, the transom stern is quite different. The wealth of details
includes the way the deck load of hay is protected and secured; the rope boat-fenders; the pro-
visions stored on the transom; the broad-brimmed hat of one of the men, which was typical of
the Valencian sailor; the way the head of the main sail is loosely secured to the yard; the rig-
ging of the main mast. The oars on the quarters are too short for sweeps for the vessel itself,
so presumably belong to a ship's boat. [*Petites Marines* 102]

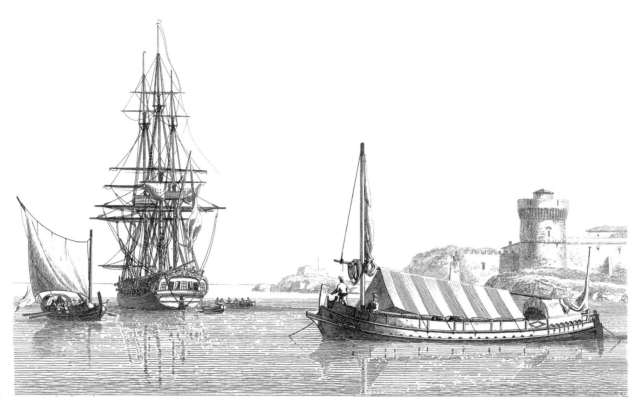

109.

\mathcal{I}N the foreground is a Maltese speronare, a relatively flat-bottomed craft that could take the ground, and the examples shown here exhibit a short beakhead, and a tall recurving stemhead decorated with a Maltese cross. Propelled by sail or oar, they usually stepped a single mast with a spritsail, although a variety of rigs was known. The word is related to French *éperon*, in the sense of beakhead. To the left is another speronare, under sail and oar.

In the background is a nice view of a British warship at anchor in this Maltese or Sicilian port. Judging by the layout and a full set of stern windows, she is a post ship or quarterdecked ship sloop. [*Collection* 27]

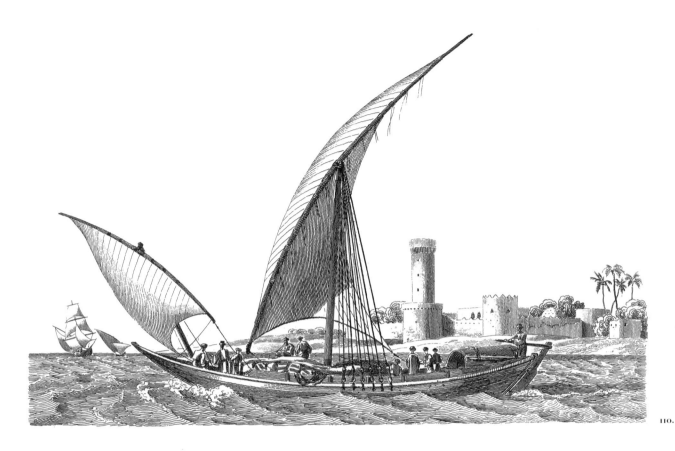

110.

\mathcal{A} Turkish djerme of Alexandria. The fore sail is much smaller than the main, but both yards are fixed to the head of the mast, and when the craft goes about the yard swings around, outside the shrouds. Because the yard is never lowered, Baugean says the sail was liable to get torn in the least squall. Craft similar to this were found from the Nile cataracts to the Black Sea. [*Petites Marines* 86]

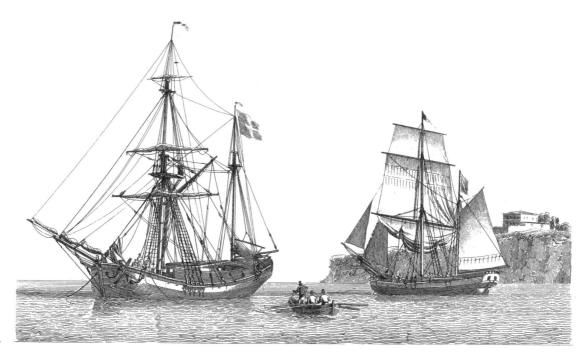

III.

\mathcal{B}ESIDES the Mediterranean, the other sea with its own characteristic ship-types was the Baltic. These were mostly defined as a galiot or galeass, both words existing in a variety of spellings, and very easily confused, as here – Baugean's 'Swedish galiot' is more properly a galeass, given the transom stern. The fore mast has fidded topmast and topgallant mast, and a trysail is furled abaft the mast. The crew are preparing to warp the vessel. A warp is being paid out from the sternsheets of the ship's boat, and a bight can be seen abreast the main mast. This will be secured to a bollard or dolphin, and allow the vessel to haul itself in the desired direction by heaving in on the warp.

The square rigged tartane in the background is discussed with Plate 132. [*Petites Marines* 39]

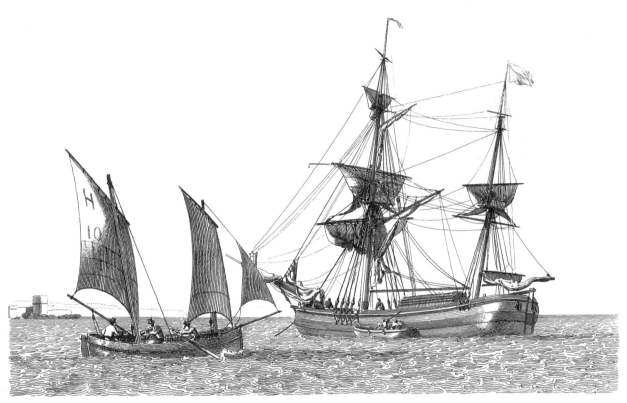

112.

\mathcal{G}ALIOT, at anchor. Note the round stern (with tiller brought in over the taffrail), *roef* or cabin amidships, and relatively elaborate rigging. The fore mast is square rigged to royal, and there is a gaff topsail. The projecting studding sail boom confirms that it had been setting a weather topmast studding sail when coming in to anchor. The main gaff sail has a standing gaff, furled by brailing up and in, while the corresponding sail on the mizzen is furled by lowering peak and throat halliards.

To the left is a small lug rigged fisherman of the type found in the Seine estuary. [*Petites Marines* 84]

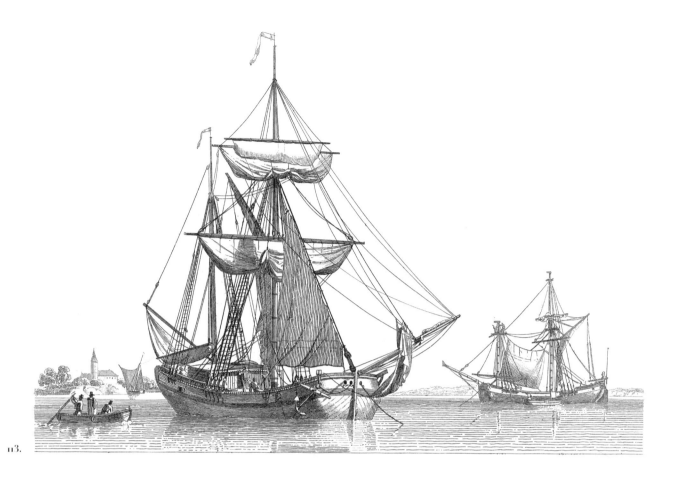

113.

Swedish galiot at anchor. As explained in the Introduction, the transom stern indicates that the vessel shown is actually a galeass. The main mast is placed relatively far aft, and is square rigged besides a large gaff sail. The mizzen sets a gaff sail. Comparing this example with those shown in Plates 111, 112 and 115, we see that the shrouds are attached to the mast much higher up, and indeed we may be dealing with a pole mast. A galiot rigged in this way is shown in Abbildung 96 in Hans Szymanski's *Deutsche Segelschiffe* (1934).

The de-rigged vessel in the background has the hull of a galiot, but if we can judge by the configuration of the mizzen, appears to be a snow. The tiller, with its decorated rudderhead, is Dutch-looking and resembles the stern of the flute in Plate 63. [*Collection 53*]

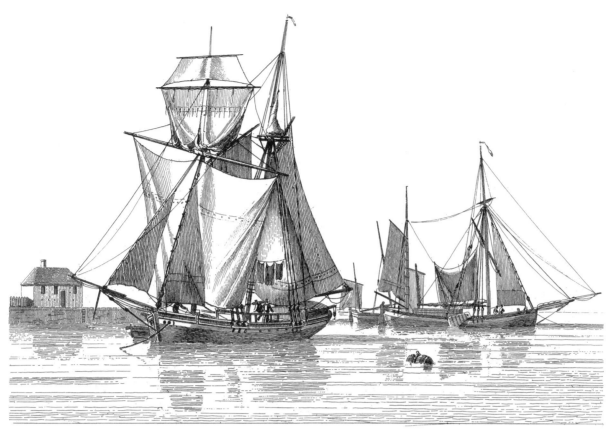

114.

\mathcal{A}N anchored Dutch galiot and a schooner drying their sails. The schooner has spread her immense square main sail (*voile de fortune*), and the main gaff topsail is furled. Hammocks are hung to dry between fore and main shrouds. In the background is a galiot (note the round stern), partially obscuring a lugger. The galiot's leeboards indicate she sails the inshore waters, and would not venture far from land. [*Petites Marines* 105]

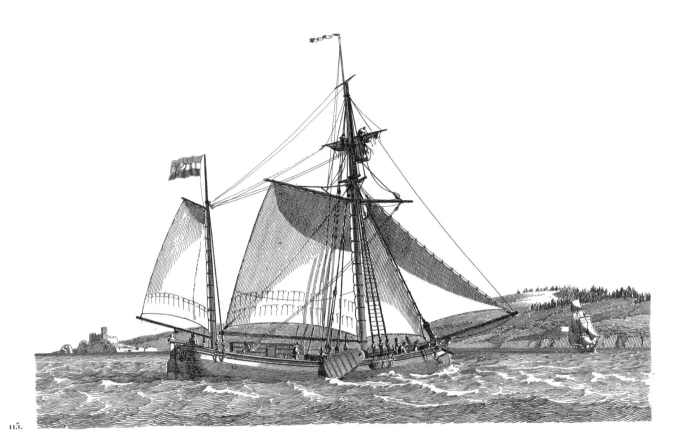

115.

\mathcal{B}ELGIAN galiot, sailing by the wind. This is a little smaller than that represented in Plate 112. Baugean notes that these vessels ran between 60 and 300 tons capacity. Shallow-draught vessels such as this were primarily intended for sailing the protected waters of the Netherlands, such as the Scheldt estuary. The leeboard on the down-wind side is dropped to help prevent this vessel making excessive leeway. Larger examples, venturing into more distant waters, would have dispensed with their leeboards. Note the deckhouse or *roef* forward of the mizzen mast. A small topgallant mast is fidded abaft the topmast, and the topsail is being furled. The round stern makes it a galiot rather than a galeass.

In the background a brig. [*Petites Marines* 66]

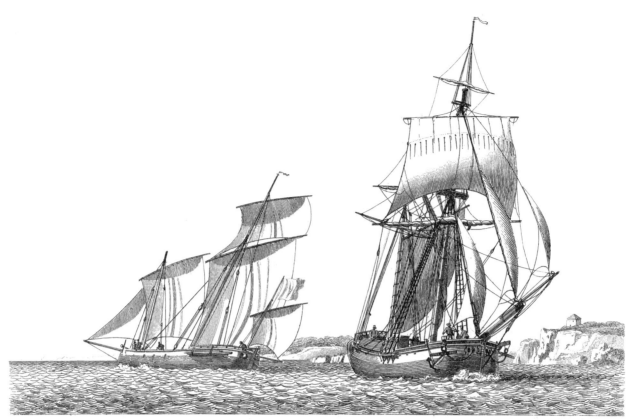

116.

\mathcal{B}ow view of a dogre (or dogger), so-called because they were employed in the herring and mackerel fishery on the Dogger Bank. These were similar to the galiot, so appropriate to be included at this point. Baugean says that galiots differ in not having a one-piece main mast (which is not the case with those in Plates III and 112). The main mast is stepped almost amidships, and has a topmast and topgallant, and the mizzen is stepped relatively closely abaft it. Staysail, jib and flying jib are set forward. A gaff mizzen and square mizzen topsail can be seen. These craft have a capacity of 80 to 250 tons, and Baugean says that those used in the North Sea have round sterns, while those found on the Atlantic coast have transom sterns (which might be the case here). Bonnefoux et Paris say they are fitted with a live-tank (wet well) to keep the fish fresh.

To the left is a chasse-marée on port tack. This example has a round stern, and the mizzen sheet is secured to an outrigger. [*Collection* 63]

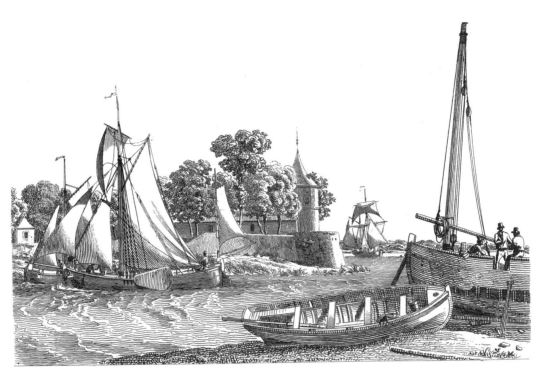

117.

𝒟 UTCH barque or smack coming into port at high tide. Baugean says these vessels are heavily built with flat bottoms, designed to sail in waters where there are many shallows, and weather which is often stormy. He describes it as a *barque*, but the Dutch term *smak* or French *semaque* would be a better fit (compare Plate 118). This one has square topsail, gaff main sail and gaff mizzen. This last is perched right aft, so to modern eyes the vessel is rigged as a yawl. The somewhat bigger kuffs and galiots would be described as ketch rigged, since their mizzens were proportionately bigger and stepped further forward. The shape of the rudderhead, and the leeboard are very typical of craft from the Netherlands. In the foreground is a nicely rendered ship's boat, and a vessel with a few strakes of planking removed for maintenance. [*Petites Marines* II]

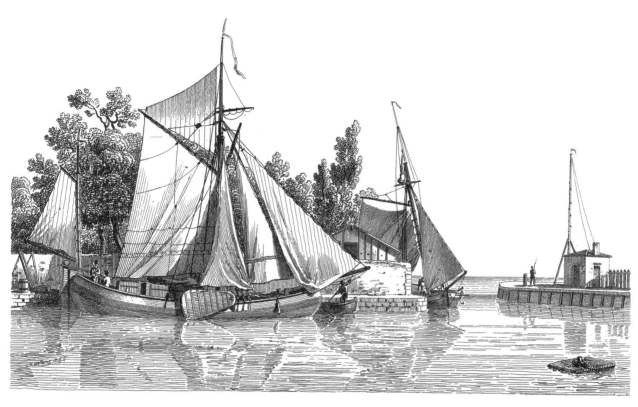

118.

*D*UTCH smack drying its sails. The hull form, with its extreme tumblehome and exaggerated sheer, is typically Dutch. Note the *roef* or cabin aft and the leeboard. It sets, a gaff main sail, triangular gaff topsail, square topsail, staysail and jib, plus a small gaff mizzen. When in use, this latter sheets to an outrigger pushed out on one side.

In the background right, a sloop. [*Petites Marines* 91]

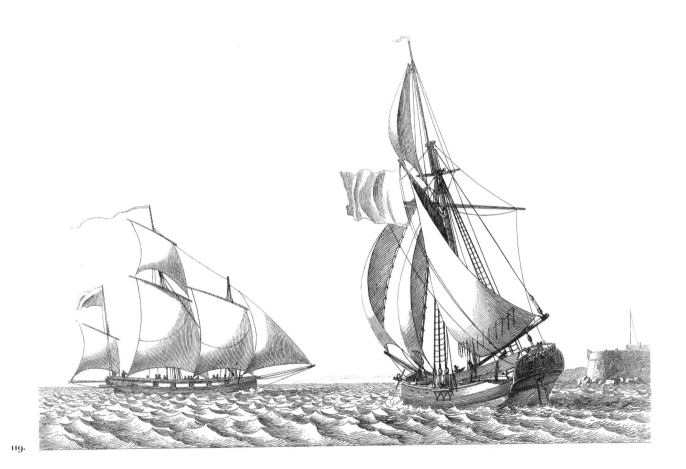

119.

\mathscr{T}HE sloop on the right is very similar to the vessel in Plate 53, but seen from astern. Unlike cutters, which were flush-decked and low-lying, this sloop has a quarterdeck, beneath which is a cabin grand enough to warrant a row of windows. What appear to be sweeps, long oars for use in a calm, are lashed below the gunwale, but it is hard to guess the purpose of the net hung over the taffrail, although it may have been used for the stowage of fresh vegetables or fruit. Just above it is the crutch for boom.

To the left is an armed lugger: Baugean describes it as a lougre rather than a chasse-marée, a term he tends to confine to coasting craft. [*Collection* 66]

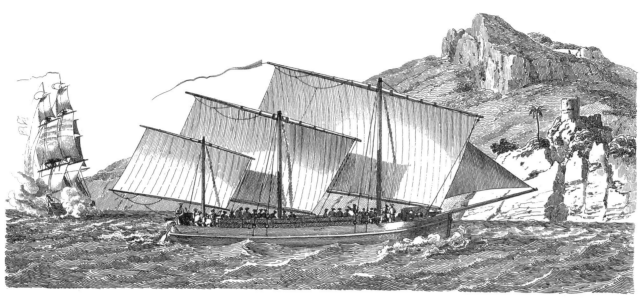

120.

𝒜 PIRATE vessel of the Indies, chased by a frigate. It is difficult to know what to make of this engraving. Virtually all the other vessels illustrated by Baugean were craft he might have seen for himself. This plate seems to offer an exception, perhaps representing something of which he had only heard a description. The hull of the pirate, the one-piece masts, and the cloths of the sails running vertically, all have a suspiciously European look. The sails are of a typical Indo-Malay shape, and twin rudders were used, but the deadeyes and laniards, and vertical sailcloths are suspect. [*Petites Marines* 85]

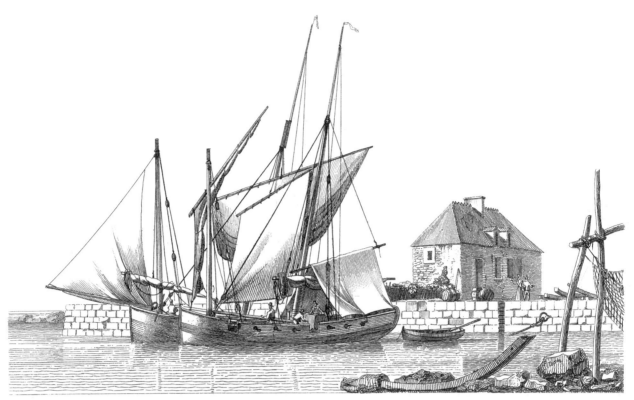

121.

\mathcal{A} PAIR of two-masted chasse-marées alongside a quay at high tide. Baugean says that the 'chasse-marée' has the same rig as the 'lugger', but is less finely built, being destined for coasting. The oarports are cut with a vent at the rear, to accommodate the blade of the oar, which was rowed by men standing on the deck (see Plate 122). The fore yard is at the masthead; the running bowsprit is in; the main yard is lowered. The vessel in the rear is airing its jib, main sail, and main topsail; the fore yard is lowered. At first sight it looks as if the near vessel is mounting a cannon forward, but similar cutaways are seen in the bulwarks of the vessels in Plates 122 and 126, so it probably served some other purpose. [*Collection* 68]

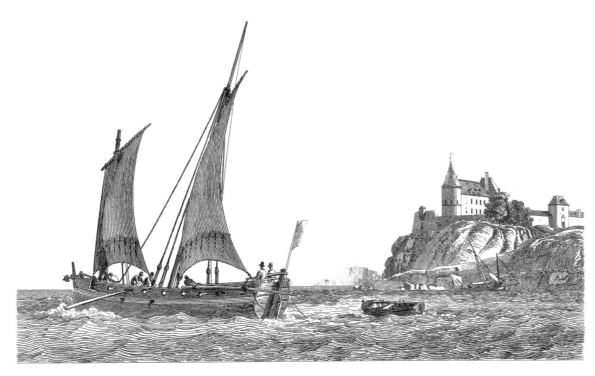

122.

\mathscr{A} SMALL transom-sterned chasse-marée sailing by the wind. The main mast is supported by a pair of shrouds on each side, set up inboard with deadeyes and laniards. François Beaudouin, in *Bâteaux des Côtes de France*, concluded that the main is rigged *en flambart*, that is to say, with a gaff rather than a yard; there seems no way of deciding for certain. Two men standing on deck forward aid progress by pulling on long sweeps or oars like those lashed to the quarters; the boat is towing astern (it has only one thwart but two sets of thole pins). [*Petites Marines* 45]

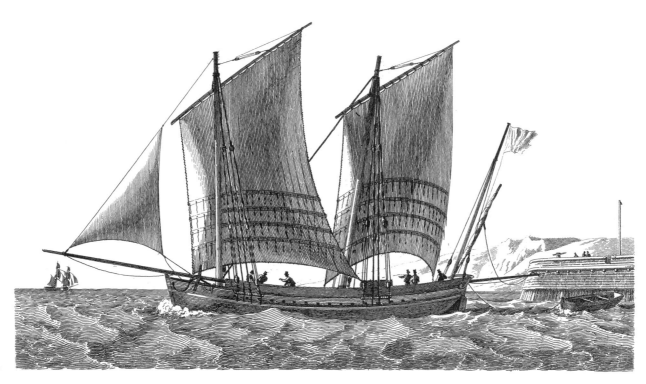

123.

\mathscr{A} LARGE chasse-marée sailing by the wind; this
example has a transom stern, no oarports, and a running bowsprit. The fore and main masts
are almost the same size and the main has a fair degree of rake aft. Note the four rows of reef-
points and the peak halliards, something unusual with lugsails. The mizzen is not set, the sail
being still furled to the spar. A small boat with two thwarts is towing astern.

On the horizon is a brig. [*Petites Marines* 67]

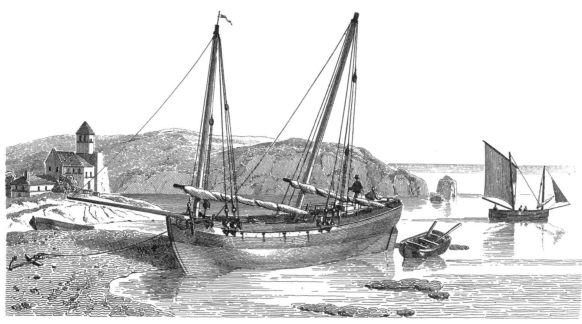

124.

SMALL chasse-marée on the ground at low tide. This sets two lugsails and a jib, and the hull is designed for getting aground and lifting off again without straining the construction. Channels, deadeyes and laniards are used to set up the masts. The starboard anchor can be seen in the ground ahead of the vessel, and her boat is also aground on her quarter. A similar vessel can be seen in the background, with main and jib set. [*Petites Marines* 92]

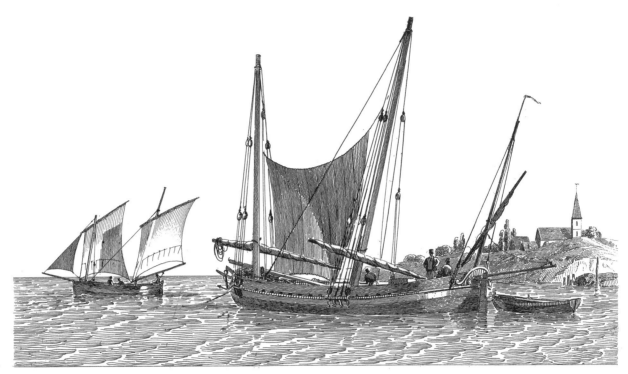

125.

A CHASSE-MARÉE at anchor. The main mast is only slightly longer than the fore, which is raked forward, the other two masts raking aft somewhat. Stern configuration with its decorative work differs somewhat from the chasse-marée in Plate 122, and that in the background of Plate 116. There are scuppers but no oar ports. There are channels, but no deadeyes are obvious (compare Plates 122 and 124). Baugean says the canvas airing between the masts is a square sail, set when running before the wind (see background of Plate 182).

In the background is a smaller fishing lugger. [*Petites Marines* 74]

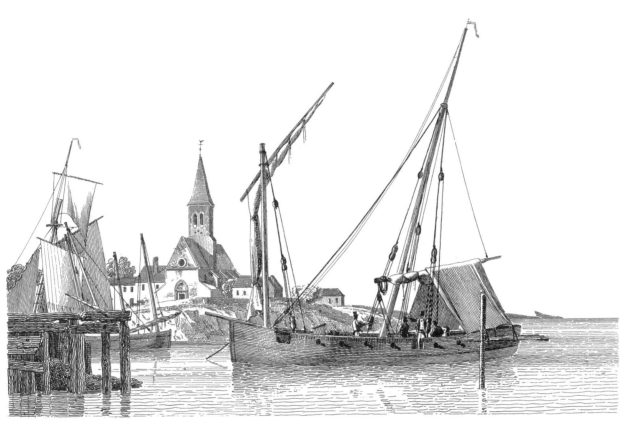

126.

FLAMBARD at anchor. Baugean says that these craft were typical of Cherbourg, and ventured quite far afield to fish. Other sources (Fig 5, Plate B, Willaumez (1831); and pages 147, 216, 222, 280 of Beaudouin, *Bateaux des Côtes de France*) make it plain that one distinguishing feature of the flambard from other luggers of the Channel coast was that the main mast was gaff rigged. The vessel shown here is remarkably similar to that in Plate 121, but in both cases Baugean shows lugsails rather than a gaff on the main.

Baugean's accuracy was not confined to ships, but he was also meticulous in his depiction of location. His Mediterranean scenes abound with decaying antique stone harbour works and very little greenery; this contrasts noticeably with the timber pile piers and heavily wooded backdrops of the northern ports – and the romanesque church of this view is typical of Normandy. [*Petites Marines* 115]

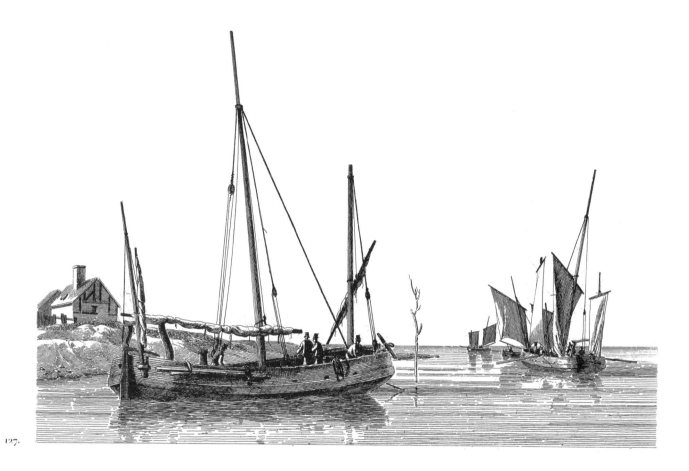

127.

\mathcal{B}ISQUINES. These were the Normandy version of a fishing lugger, built up to about 5o tons or so. The bisquine was still in use in the Bay of St Malo region well into the twentieth century, but the later versions had square sterns. Note the heavy wale; the disproportion between fore and main mast (compare Plate 46); the way the mizzen mast is stepped off to one side; oars stowed outside the gunwale; fishing gallows at the stern; and the fashion the oars work in rowlocks placed on the gunwale, rather than being worked through oar ports as in the chasse-marée (compare Plates 121 and 122). [*Petites Marines* 64]

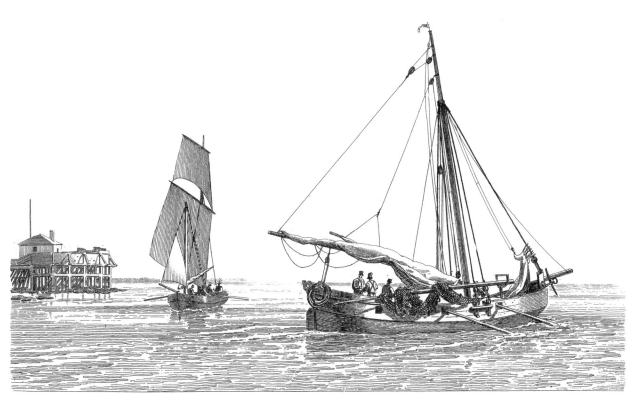

128.

Fishing boats of the Normandy coast, under oar and sail. The vessel to the right is gaff rigged, or as they would have said rigged *à cotre* (cutter-fashion). Note the extended stemhead, square oarports; the net; and what may be part of a beam trawl resting on the gunwale.

The vessel in the background is similar to the bisquines shown in the previous Plate. The pile gun battery to the left is typical of many built at the low-water line during the Napoleonic Wars to protect French anchorages from the ravages of the British navy. [*Petites Marines* 104]

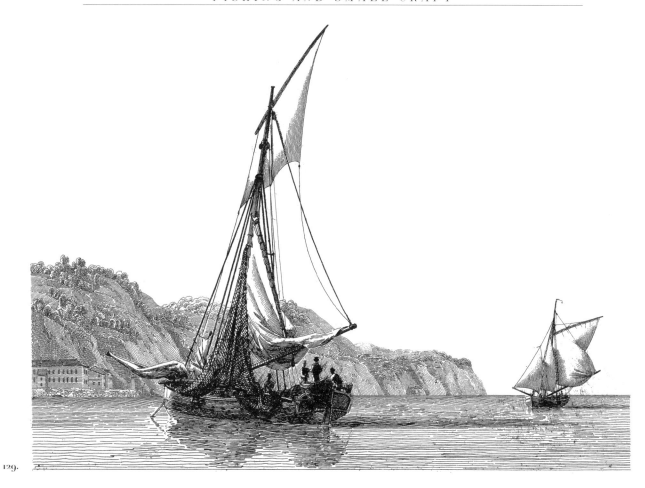

129.

\mathscr{H}ONFLEUR fishermen. These were rigged like sloops, but did not set a square fore sail. The craft at anchor in the foreground has hauled the net up to dry, and scandalised the main sail, dropping the peak, while leaving the throat halliard left fast, and keeping the topsail aloft. This sail was not a jackyard topsail, but was set independently of the gaff, and sheeted to the deck (see vessel in the background of Plate 130). The vessel behind has topped up the boom, causing the sail to billow out under the topping-lift. Vessels similar to these were in use on the northwestern coasts of France into the twentieth century, but were usually referred to as *cotres*, 'cutters' rather than 'sloops' (François Beaudouin, *Bateaux des Côtes de France*). [*Petites Marines* 65]

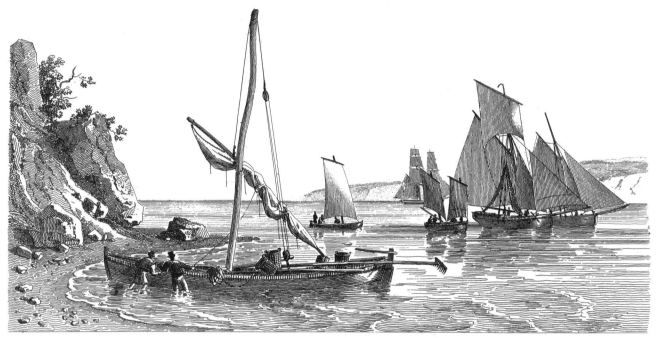

130.

ℋONFLEUR picoteux. These clinker-built craft were used in the mussel and shrimp fishery, as indicated by the shellfish rake at the stern. The name may relate to the process of stirring up ground-feeding flatfish, so they could more readily be taken. This one is rigged with a single lugsail.

In the background are fishing cutters, similar to those shown in the previous Plate. [*Petites Marines* 76]

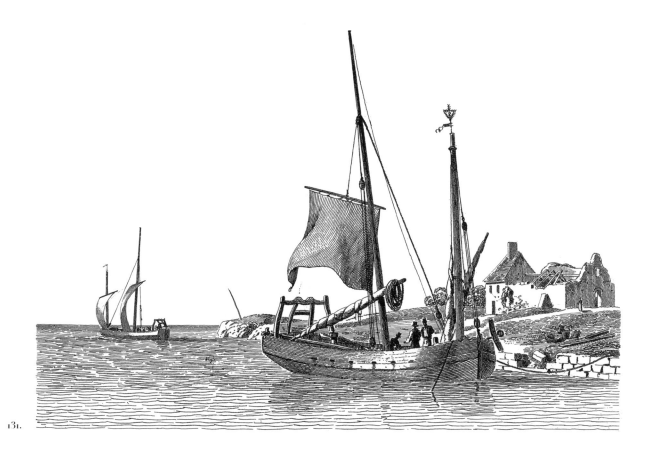

131.

\mathcal{O}ury or houari of Honfleur (the word is related to English 'wherry'). This was the name given to the fishing lugger in Channel ports like Honfleur and Dieppe. Note the cross on the fore mast, which following the fishermen's custom, was formed of mackerel tails. Note also the relative heights of the masts, the capstan, and gallows aft (compare Plate 127). These vessels fished for mackerel off the northern coasts of England. The catch was salted, and at this time was an important branch of business in Honfleur. Those illustrated here appear to be luggers. However, the word *houri* also applied to a leg-of-mutton sail, in fact an early form of gunter rig. [*Petites Marines* 90]

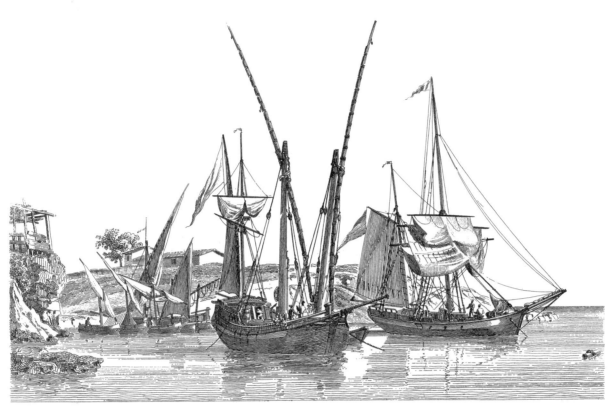

132.

*V*ARIOUS Mediterranean coasters and fishing craft. Nearest is a Genoese pinque. Note the beakhead, and the way the fore and main yards are placed on opposite sides of the very sturdy masts. It can be seen that the tye is secured to the yard forward of the masts. The lateen mizzen sets a square topsail above it, which, as is commonly the case with anchored vessels, has been deployed. The bunt has been hauled up a little.

To the right is a square rigged tartane, with gaff mizzen. This, and the similar vessels seen in Plates 98 and 111, have much more in common with ketch rigged vessels like the bombarde (Plate 55), and the dogre of Plate 116, than they do with other tartanes illustrated by Baugean (for example, Plate 69). Except for historical precedent, one is hard pressed to see why they should be called tartanes at all – the bow and stern are quite different from the *cul-de-poule* and beakhead of the tartane shown in Plate 107.

In the background are various small lateen rigged fishing craft. [*Petites Marines* 37]

133.

CATALAN fishermen in traditional costume. Baugean says their boats were very picturesque. They set a large lateen sail on a mast with marked forward rake. The example here is seen from the stern, with the high curving stem-head just visible; unfortunately, the awning hides most of the internal detail. Compare Plate 135. [*Petites Marines* 3]

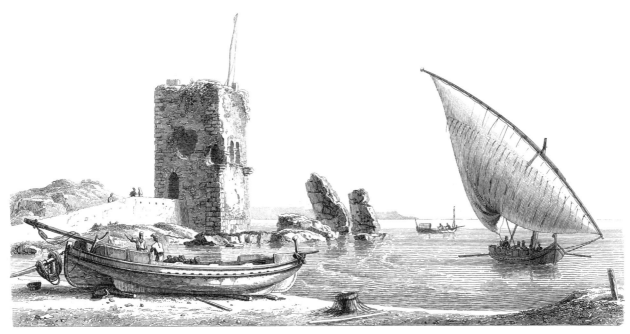

134.

\mathcal{C}ATALAN fishing boats. Baugean says that these half-decked vessels were capable of sailing coastwise for long distances, and being very comfortable at sea. They were rigged with a single mast, markedly raked forward, and a relatively large lateen sail, and were designed for hauling out on shore. Note the decorated stemhead, bilge-keels and the similarity of the configuration of bow and stern to those of the Sicilian felucca in Plate 92. [*Collection* 28]

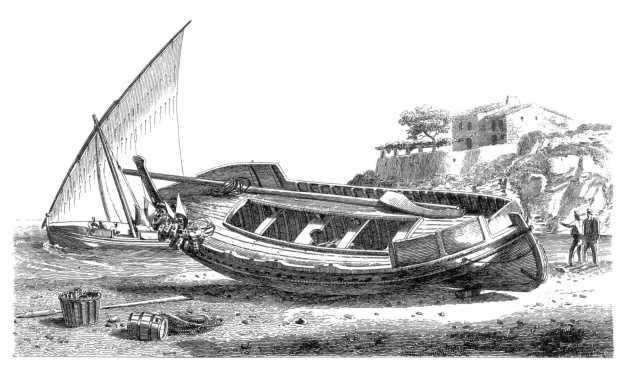

135.

\mathcal{C}ATALAN fishing boat, hauled up on the beach stern-first, showing the deck layout of these craft. These were used in a type of long-line fishery, up to five or six leagues from the coast, the main catch being whiting. They used a *palangre*, a line secured at either end by weights, and supported along its length with buoys. These can be seen on the port bulwark forward. As demonstrated by the vessel in the background, they were rigged with a large lateen sail, carried on a mast with marked forward rake. [*Petites Marines* 20]

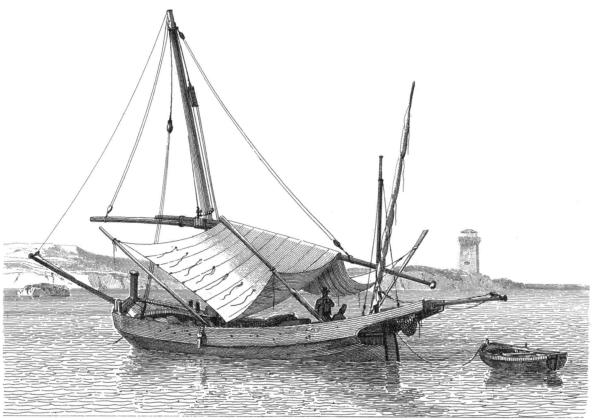

136.

SMALL Spanish bateau, typical of a great variety
of generally similar craft to be found on the Mediterranean coast of Spain. Note the *cul-de-
poule*, *capian*, and fore sail rigged as an awning. The word *capion* or *capian* was applied by
Mediterranean sailors to a stemhead which, as demonstrated in this Plate, is prolonged upwards
and terminates in a decoration of some kind. It was sometimes applied to a similarly extended
sternpost as well. [*Petites Marines* 95]

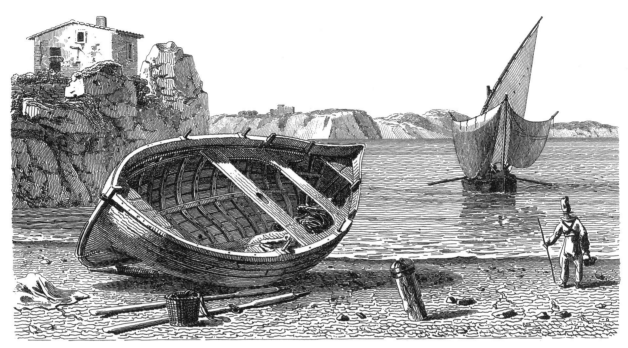

137.

\mathcal{A} DOUBLE-ENDED undecked Provençal fishing boat dragged ashore. Since the Mediterranean was tideless, vessels had to be designed so they could be beached for cleaning, repair, and to keep them safe in bad weather. An iron-bound post is set into the foreshore presumably to facilitate hauling the boats up the beach. The craft approaching the shore under sail and oar has set two extempore spritsails. [*Petites Marines* 93]

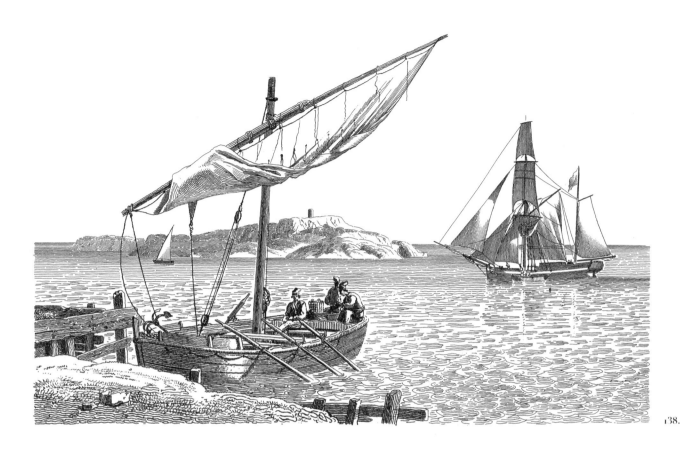

138.

P̶ROVENÇAL fishing boat (compare Plate 137).
Baugean comments on the way the sail is secured very loosely to the yard; although not very
long, this spar is formed of two overlapping pieces in the lateen tradition. The oars are lashed
to the thole pins with rope beckets. The anchor is a grapnel, which was the common ground-
tackle in Mediterranean small craft.

In the background is a Scandinavian galeass. [*Petites Marines* 96]

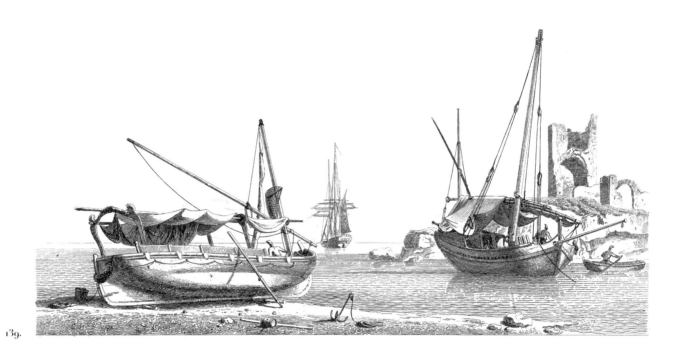

139.

\mathcal{G}ENOESE boat pulled up on the beach. This shares some of the features of the felucca, notably the configuration of bow and stern, which facilitate beaching. They were propelled by oar or by a spritsail. The Corsican vessel to the right, with its high stemhead, is considerably bigger, and served as a packet-boat between Corsica and the mainland. It set a lateen sail on the main mast, and a large triangular fore sail (*polacre*) extended by the long bowsprit, and a lateen ringtail aft.

In the background is a polacre rigged vessel, perhaps a barque. [*Collection* 37]

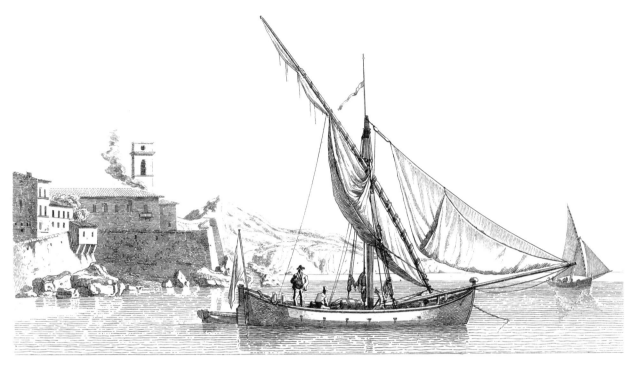

140.

\mathcal{B}ATEAU boeuf. These were used for coasting and fishing, and were rigged tartane-fashion with a lateen main sail and large fore sail (*polacre*). A similar vessel is seen under sail in the background. The Italian word was *bovo* and the *bovi* illustrated in Flavio Serafini's *Vela nella Leggenda*, which date from around 1850, are somewhat bigger, setting a lateen mizzen, and commonly having a *cul-de-poule*. According to Bonnefoux et Paris, the name arose because for one type of fishing, sometimes referred to as *la pêche de vache*, they worked in pairs, reminding the observer of oxen yoked to a plough. [*Collection 44*]

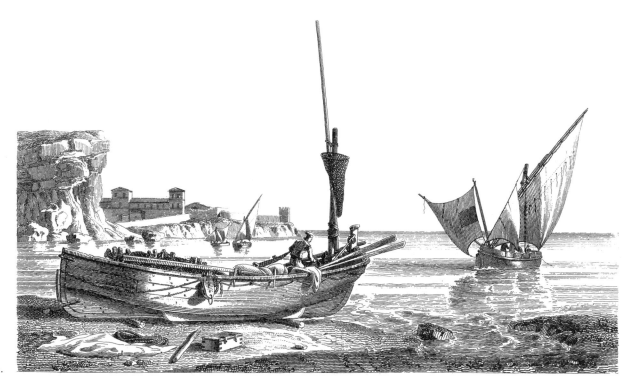

141.

Neapolitan fishing boat to left; a Provençal craft to the right. The design of the hull facilitates the beaching of these craft. Note the buoy and other fishing gear. When drifting before the wind, they set a small spritsail forward (similar to that seen on the right-hand boat). To reach the sardine fishing grounds, they set a single lateen sail on a short mast, and a small fore sail. [*Petites Marines* 48]

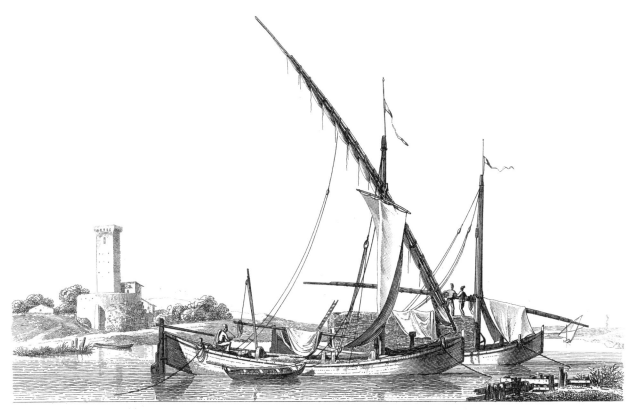

142.

ℛOMAN barques going up the Tiber. The bow and stern of these craft exhibit marked cut-up, to make it easier to beach them. The single lateen sail gives them the capacity to sail along the coast at the mouth of the river. The nearside vessel has a bulk cargo, possibly grain, while the other carries a high deck cargo of hay. [*Collection* 14]

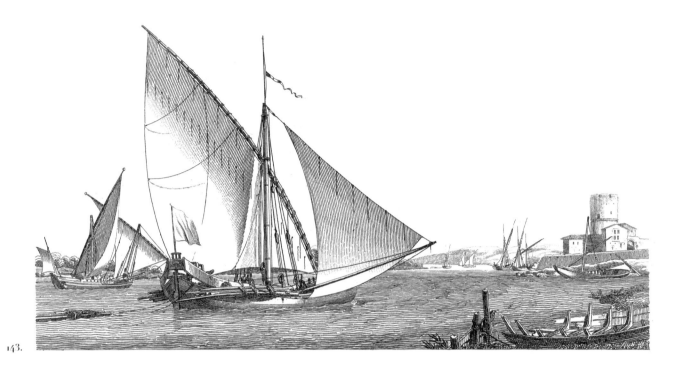

143.

ALLÈGE OF ARLES, descending the Rhône with a timber-raft in tow. These lighters, really a form of tartane, were flat-bottomed and very suitable for the transporting of spars. They sometimes traversed the Gulf du Lion to reach Marseilles, but might lose the raft of spars while doing this. Note the *cul-de-poule*; spars lashed on the sides; single lateen sail; and the way the very large fore sail (*polacre*) is boomed out to starboard, to balance the main sail.

Background left: a pinque running before the wind; right, a riverine craft of some kind, with spoon bow and steering oar. [*Collection 54*]

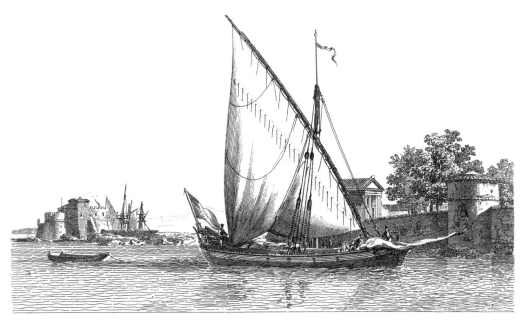

144.

\mathcal{A}RLESIAN allège, towing its boat, and taking in its fore sail or *polacre*. The resemblance to a tartane is more evident in this side-on view than in the previous Plate. They are flat-bottomed, and very much used for the transportation of timber for spars. The centre brail has been partially hauled up. [*Petites Marines* 15]

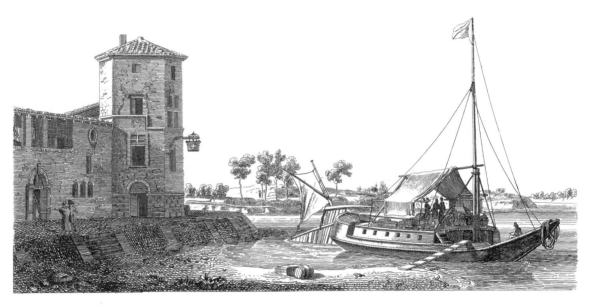

145.

𝒜 PASSAGE BOAT [*coche d'eau*] from Lyons, at Châlons-sur-Saône. These riverine vessels were used for transporting passengers, comparable to travelling by coach on land. The large saloon amidships suggests that travellers experienced some degree of comfort. It is not clear what type of sail was used on the main mast, but note the little spritsail ringtail, stepped on the immense rudder. [*Petites Marines* 30]

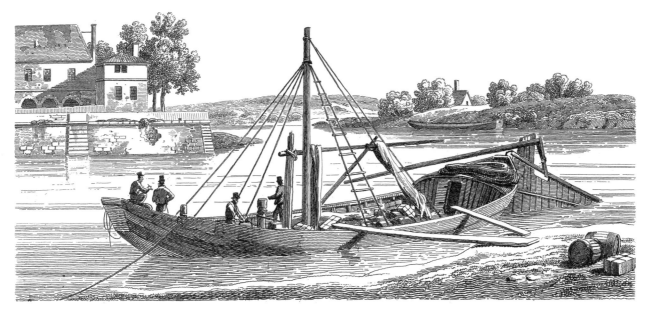

146.

\mathcal{B}ATEAU-COCHE on the Saône. This type of riverine barge was used between Lyons and Châlon. Note the huge rudder and very long tiller. The hull form is not very different from the passage boat in the previous Plate, but this is an undecked cargo carrier. It shows the same horizontal lashed spar, whose only function seems to be as a ridge for an awning. The stump mast sets no obvious sail, and a very solid towing bollard forward suggests that the barge was warped or pulled by horses. [*Petites Marines* 99]

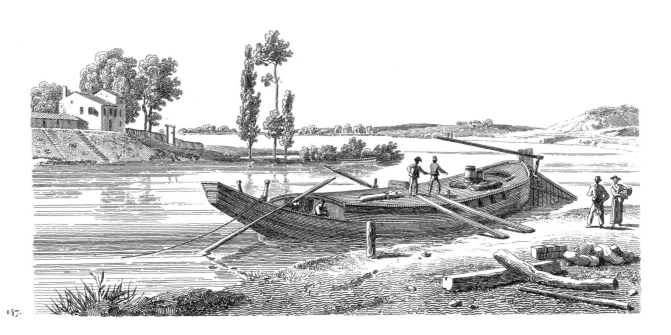

147.

𝓡ʜôɴᴇ ᴄᴏᴄʜᴇ. Baugean says that these solidly built barges were used to transport goods from Lyons to Avignon and even as far as Beaucaire. There is no top-hamper whatever and the craft was probably steered downstream with the aid of long sweeps, and towed in the opposite direction using the large staghorn bollards forward. [*Petites Marines* 100]

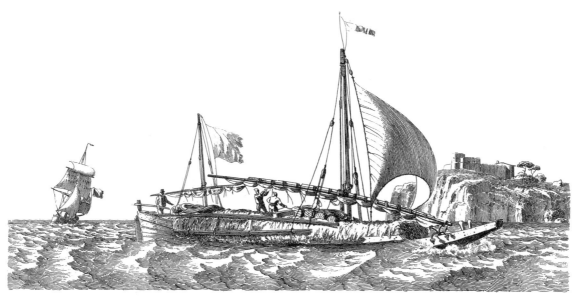

148.

𝒯HE PENELLE (*pénèle*) was a flat-boat or barge used on the Rhône. The one shown here is running before the wind, using its fore sail or *polacre*. Features to note include: the spoon bow, and grapnel; load of hay, which is steadied by baulks of timber lashed together with rope. The rudders, of which there are two, are much smaller than those seen on other Rhône craft (Plates 145, 149). There is a good photo of a penelle, showing its transom stern and twin rudders on page 43 of François Beaudouin's *Bateaux des Côtes de France*. [*Petites Marines 2*]

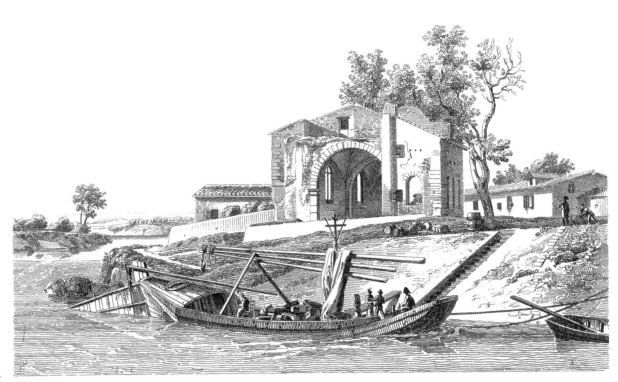

149.

Barque ascending the Rhône. Baugean comments that these vessels are not built for looks, but have evolved to meet the demands imposed on them by local conditions. Going downstream, the vessel was kept under control with sweeps and the huge rudder and long tiller. The Rhône was a fast-flowing river, and using the sweeps on the return journey was out of the question. They were stowed as shown here, and served to support the awning which protected the freight. The sailors were very religious, and have erected a cross above the sweeps. [*Petites Marines* 40]

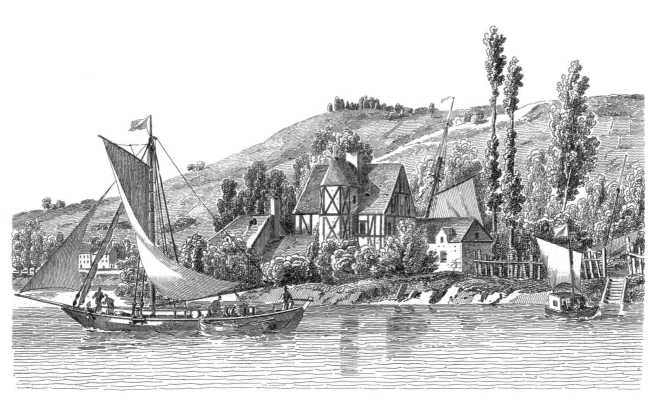

150.

SMALL river barge, or *gribane*, trading from Rouen to Havre. The descriptions of the gribane in Bonnefoux and Willaumez do not entirely agree with what we see here. They were of shallow draft, and it is likely that the one shown here would have been clinker built. Note the rake of stem- and sternpost.

The craft under sail in the background is a ferry, described as a *batelet de passage*: a *batelier* was a 'waterman', or 'boatman'. The house appears to be on an island since there is a mast and large gaff sail appearing beyond the roof. [*Petites Marines* 89]

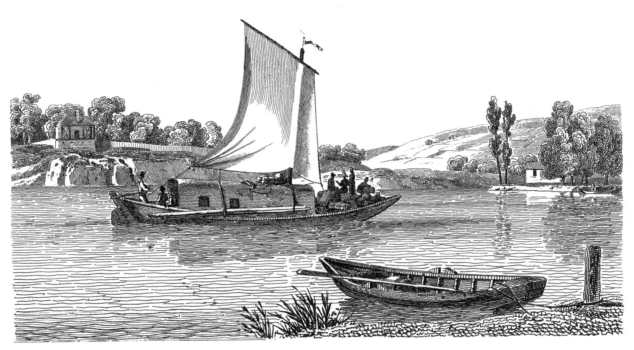

151.

\mathcal{P}ASSAGE-BOAT hailing from Rouen, seen at Elbeuf.
Baugean notes that these were often of a bizarre and clumsy construction, but felt that they
were a great subject for the artist. The River Seine is quite slow moving so it was possible to
proceed upstream under sail. [*Petites Marines* 94]

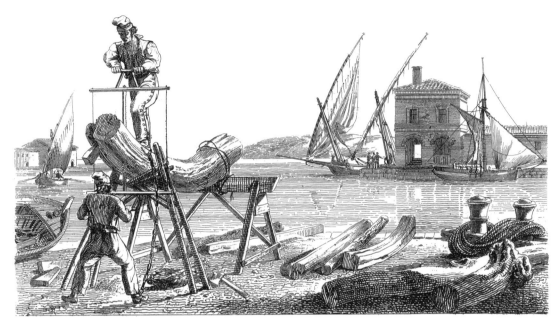

152.

S HIPBUILDING I: *Galériens* or *forçats* ('galley slaves') sawing a curved timber with a frame-saw. The timber is supported on horses of different patterns, and the men are chained together by the ankles. By the time of the French Revolution *galériens* were not slaves but condemned criminals; with the abolition of the galley service, they were no longer sent to sea but were employed as forced labour in the dockyards.

In the background is a sloop and a lateen rigged vessel. [*Petites Marines* 24]

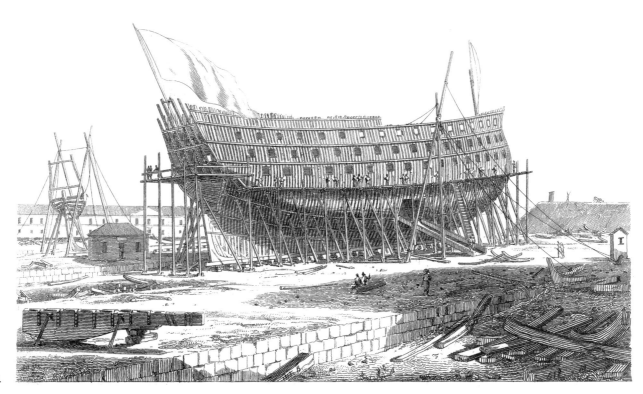

153.

SHIPBUILDING II: French 120-gun ship in frame on the stocks. These were the largest ships – indeed the largest moving structures – of their day, and yet were constructed with the minimum of industrial infrastructure: the only machinery visible is a set of sheer legs amidships. It was common to let large warships stand to season for a year or more in frame, as shown here. A large opening has been left by omitting the lower framing amidships, to allow heavy items to be brought inboard. Later, this will be closed up, when the wales are bolted on. In the foreground a rudder, and various curved timbers can be seen; in the background a stern frame is being raised. [*Collection* 61]

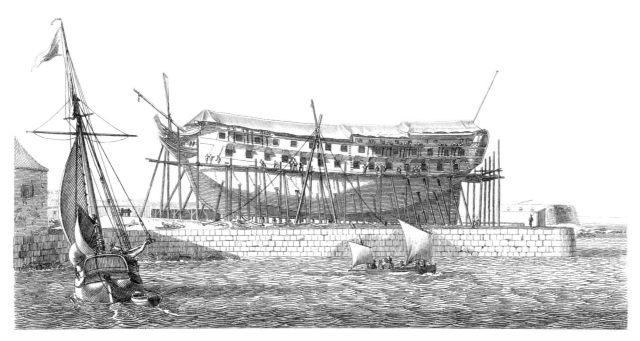

154.

\mathcal{S}HIPBUILDING III: A 74-gun ship in the final stages of construction. The caulkers are working on the staging at the level of the wales, and an awning shelters the upper deck from the heat of the sun. As yet the figurehead has not been fitted, but channels, chain-plates and lower deadeyes are in place. A sentry and his box can be seen at the end of the mole. In the foreground is a lug rigged ship's boat, and to the left a sloop approaching the shore on the starboard tack has dropped its main sail abruptly, so the fore sail will force the head round more quickly. [*Collection 62*]

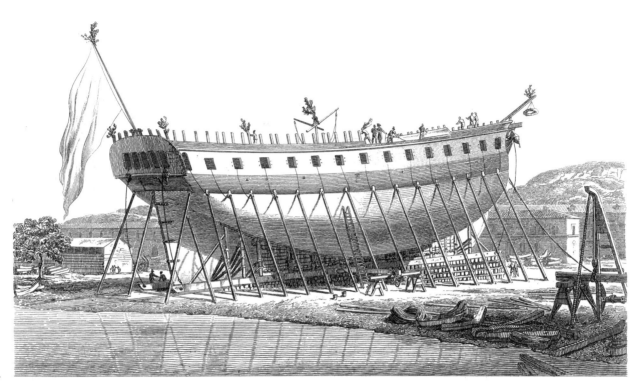

155.

SHIPBUILDING IV: French frigate on the stocks, ready for launch. The fore and aft cradles have been built up on the sliding bilgeways, and the sides of the vessel are supported by pine shores. To launch, the ways are tallowed, and levers applied to them, to start the vessel on its way. A heavy cable leads forward, held by rotten-stops or stoppers which are designed to break in a controlled fashion, preventing the ship entering the water too rapidly. If this happens, the sliding ways and cradles sometimes catch fire from excessive friction. Note the way the ship is decorated with branches and a wreath hung from the bowsprit. In the right foreground are timbers to make knees, and a sort of portable crane. [*Collection 25*]

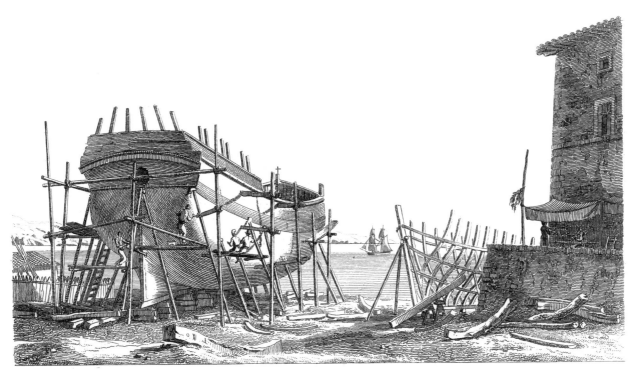

156.

SHIPBUILDING V: A small shipyard, showing a merchantman almost completed to the left, and a tartane in frame to the right. The obvious difference from naval practice is the relatively slight scantling of the frames, and the distance between them. Note the naturally crooked 'grown' timbers for use as knees, frames, etc. The vessel will be launched with the more buoyant bow first, as was commonly done where the water was relatively shallow. The usual practice in Britain and America was launch stern first.

In the background is a true brigantine. [*Collection* 47]

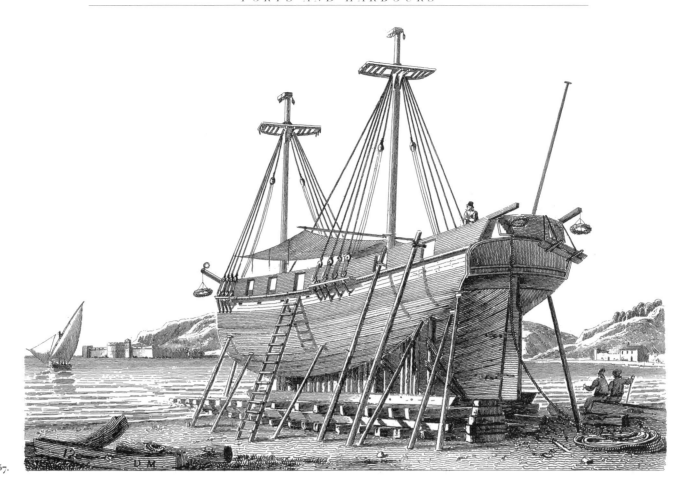

157.

SHIPBUILDING VI: Small Spanish brig on the stocks, ready for launching; the run of the planking is beautifully depicted. It is to enter the water bow first, indicating that the water is shallow (compare the two previous Plates). The lower masts and their shrouds are in place, which implies that the brig is expected to enter the water gently. The cradle has been erected on the sliding ways, celebratory wreathes decorate bowsprit and stern davits, and a drag-rope has been payed down from the stern.

In the background is a tartane. [*Petites Marines* 117]

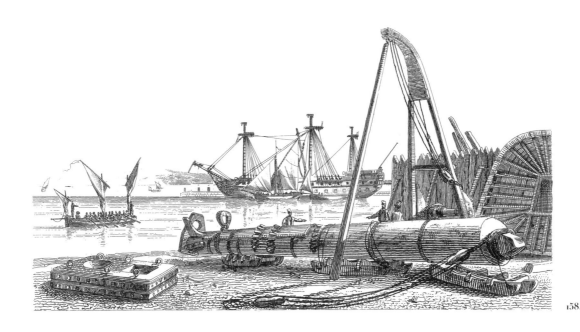

158.

\mathcal{R}EFITTING I: A ship's bowsprit pulled ashore. The sleds which were used to facilitate this can be seen, and a portable crane straddles it. The upper surface of a lower-mast top, and the cap of a bowsprit are also to be seen. The scale of a warship's top-hamper is apparent from these items.

In the background a tartane lies alongside a 74-gun ship which is either laid-up or is fitting out, and a ship's boat approaches under oars. It is dead calm, and the lugsails have been spiralled round the masts, to cut down wind resistance. [*Petites Marines* 5]

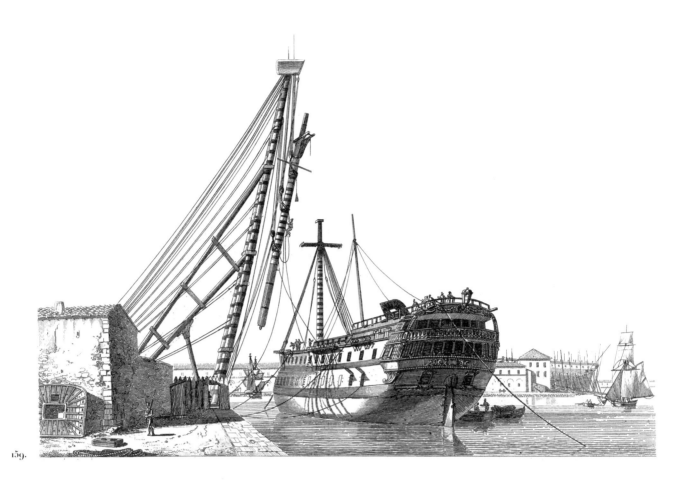

159.

\mathscr{R}EFITTING II: One of the big French 80-gun ships alongside in the Toulon dockyard, having its main mast replaced. Baugean notes that relatively simple masting cranes were preferred in England and France, rather than the more elaborate masting tower at Copenhagen, which, by the way, stands to this day. In tidal ports sheer hulks were preferred since they floated up and down with the flood and ebb, and so were always in the same relative position to the ship alongside; in enclosed docks cranes were the usual machines. The top and the mast cap can be seen in the lower left corner. Compare Plate 22, which shows a frigate replacing a mast with sheers erected on its own deck. [*Collection* 16]

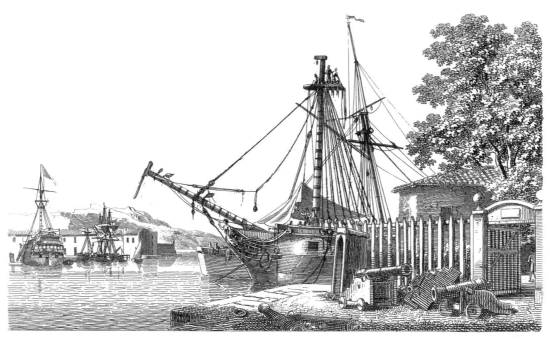

160.

\mathcal{R}EFITTING III: Frigate in the process of being laid up. Baugean says that at the end of a commission the stores from each vessel were taken to a particular warehouse; indeed, in small well-organised navies like Denmark's the fittings and equipment from specific vessels were kept together, and not returned to a common store as was done in the far larger British dockyards. The cheek of the cannon, to the left shows the hole for the breeching. That to the right, is fitted with skids rather than wheels on the rear of the carriage, and would not be for use on board ship. [*Petites Marines* 9]

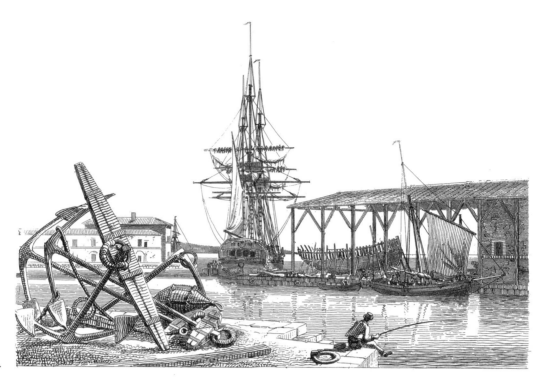

161.

*R*EFITTING IV: Group of anchors, including a single-fluked mooring anchor and an anchor-buoy. The stock of the nearest anchor consists of two side-by-side elements, and this is correct; the stock of the other anchor, is suspect. In the background we can see a frigate, in the process of bending on fore and main topsails. The men on the footropes are hauling the sail up to the yard; a small vessel is under construction under a covered slipway; and a lugger is secured to the quayside. [*Petites Marines* 16]

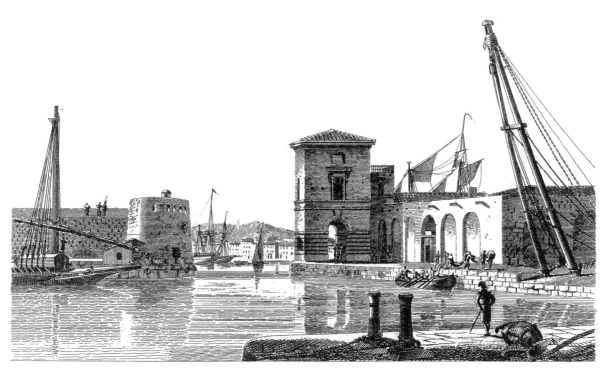

162.

\mathcal{R}EFITTING V: The interior basin of a naval dock-yard or *darse* (a word of Arabic origin related to 'arsenal' and ultimately popularised by the Venetian Arsenale, the greatest industrial facility of the Renaissance). This form of large-scale wet-dock was favoured in areas where minimal tidal movement allowed easy access, as in the Mediterranean and Baltic (both Toulon and Copenhagen had large basins in which ships were laid up or refitted, and in which shipbuilding facilities and storehouses were found). In the foreground are cannon bollards and an anchor-buoy; to the right, a masting machine and to the left, the beakhead and fore mast of one of the last remaining galleys. [*Petites Marines* 58]

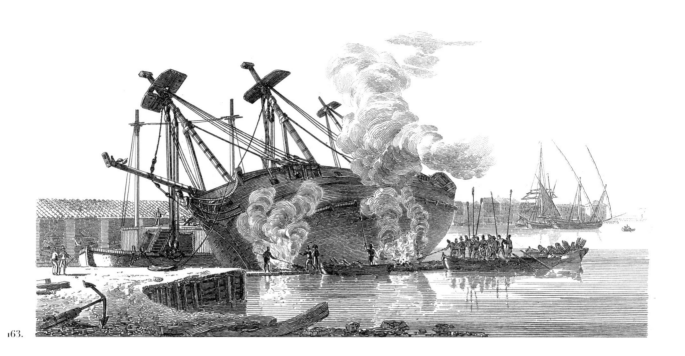

163.

Careening I: French corvette hove down. The fore and main masts have been hauled down by heavy tackles, secured to a pontoon on the starboard side; bundles of reeds, or furze, or faggots of wood, are being set alight, to clean or bream the bottom, ridding it of accumulated sea-grass and barnacles. Men with long poles stand ready to extinguish the flames if they should extend too far up and threaten the lower rigging. Bundles of fuel can be seen in the craft to their right. Next, seams were recaulked with oakum where necessary, and tar, or white stuff, applied over this. 'White stuff', *corroi* in French, was a mixture of tar, sulphur, fish-oil and tallow, and was used prior to the introduction of coppering, and in small merchantmen, to 'pay' the bottom (the verb *corroyer* can mean to curry a horse, weld metal or trim wood). Baugean underlines that the careening operation commences early in the morning, and must be executed expeditiously, being completed within twenty-four hours. It would be extremely dangerous for the vessel to find itself in the situation shown in these plates, particularly at night, in a relatively exposed anchorage, should the wind come up unexpectedly. It is only undertaken in a calm, and using only bundles of reeds or broom (seen the boat in the background) which will burn with relatively little smoke.

This is presumably a Mediterranean harbour given the pinque in the background. [*Collection 24*]

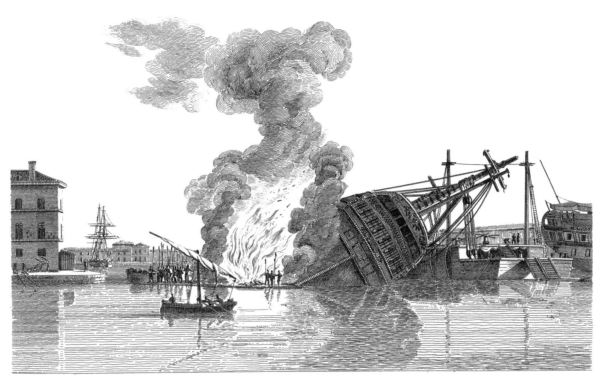

164.

CAREENING II: This is a similar situation to that in the previous Plate, but here we have a ship of the line, and the preparations have been more elaborate – two heaving-down tackles and a bigger careening pontoon. Men stand by, armed with long poles and scoops to extinguish the fire if it should endanger the rigging. The calm weather is evidenced by slow dispersal of the smoke and the small boat in the foreground being rowed with its sail furled. [*Petites Marines* 51]

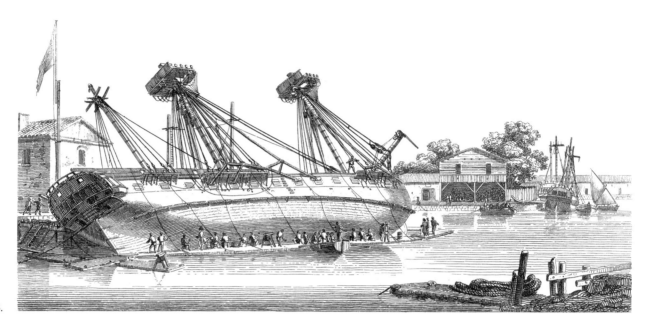

165.

\mathcal{C}AREENING III: A copper-sheathed frigate hove down. Although copper required less frequent attention than earlier forms of anti-fouling, it still benefited from occasional cleaning, but especially the replacement of damaged or torn-off sheets where fouling occurred. Stout outriggers or heaving-down spars project from the gunports under the channels of fore and main masts, and are secured to the masts just below the tops. Heaving-down tackles are secured to the top of the masts and to the pontoon. Work-men on rafts are cleaning and repairing the vessel's copper. [*Collection* 70]

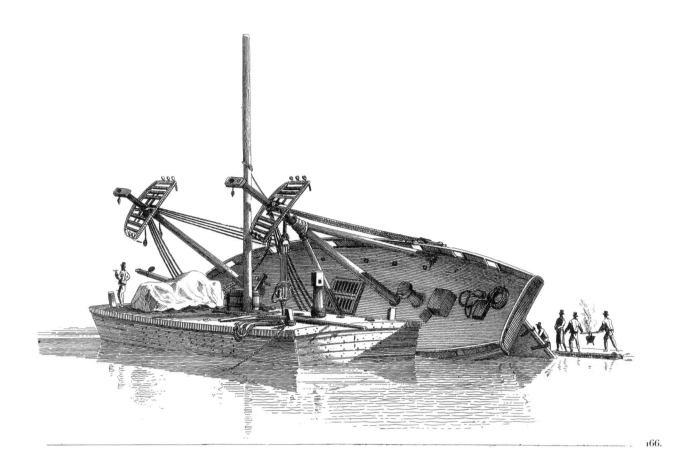

166.

CAREENING IV: Merchant brig hove down against the careening pontoon. Being a relatively small vessel, one heaving-down tackle has sufficed. Note the capstan, and the men on the raft carrying a tar-bucket. [*Petites Marines* 50]

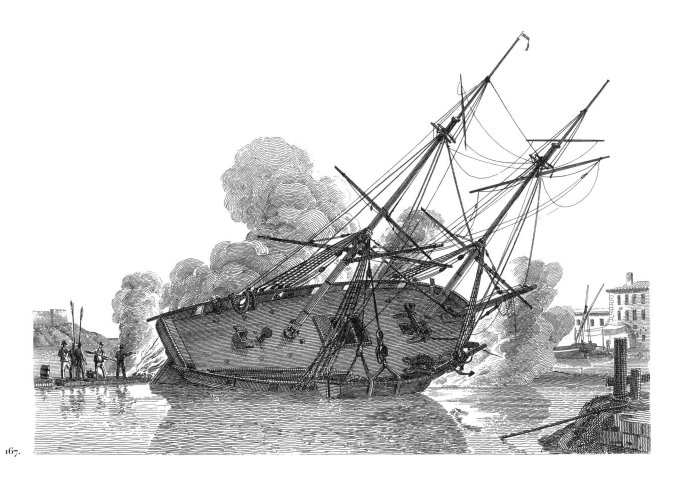

167.

*C*AREENING V: Polacre brig careening. In this case, the ship's boat has been pressed into service as a counterweight. It has been loaded with ballast or other heavy objects, and a runner and tackle secured to the main mast has been used to heave the vessel down; all the topmasts and spars have been left in place. Baugean says this method was only used in the Mediterranean. [*Petites Marines* 52]

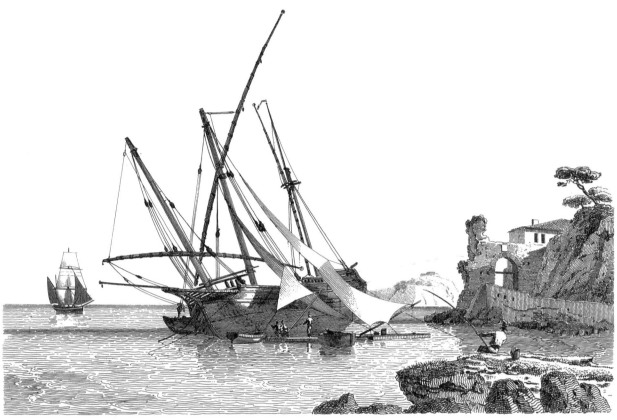

168.

CAREENING VI: Genoese pinque careening. The underside of the beakhead is clearly shown. The vessel is moored, head and stern, and the ship's boat is weighted and used to haul down on the main mast, as in the previous Plate. The weight of the main yard helps to accomplish this. Awnings protect the workers from the power of the sun. [*Petites Marines* 83]

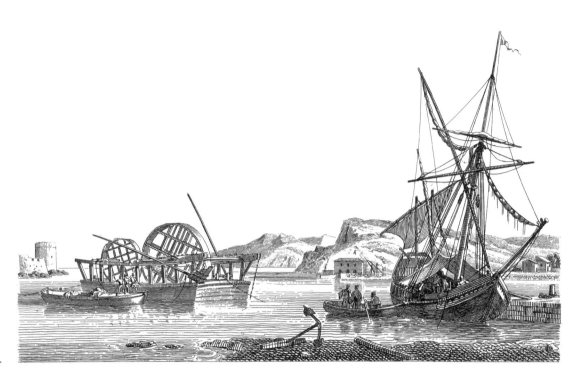

169.

\mathcal{P}ORT FACILITIES I: Keeping harbours free of silt and open for navigation was a constant problem and various forms of mechanical dredger were employed for the task. In the background of this Plate is one such machine. Mounted on a pontoon, this was operated treadmill-fashion and used long scoops to deposit the sand or silt into a lighter like that alongside.

To the right is a Greek sacoleva (see Plate 104). At this time Greece was still part of the Ottoman Empire, and Baugean notes that the Turks tended to be very conservative in their practices and reluctant to change. He notes that their Greek subjects had started to build elegant vessels, more like the standard forms in use in other Mediterranean countries. [*Petites Marines 22*]

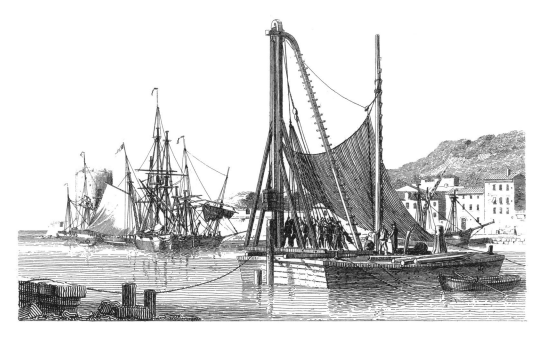

170.

\mathcal{P}ORT FACILITIES II: Wharfs, quays, dolphins and other harbour works were usually based on wooden piling, for which a pile-driver like this was required. The heavy weight used to pound in the piling was hauled aloft by a whip fitted with many tails. The pontoon on which the device is mounted, is fitted with a small capstan, and the men are protected from the sun by an improvised awning.

Various types of Mediterranean small craft are moored in a trot behind. [*Petites Marines* 23]

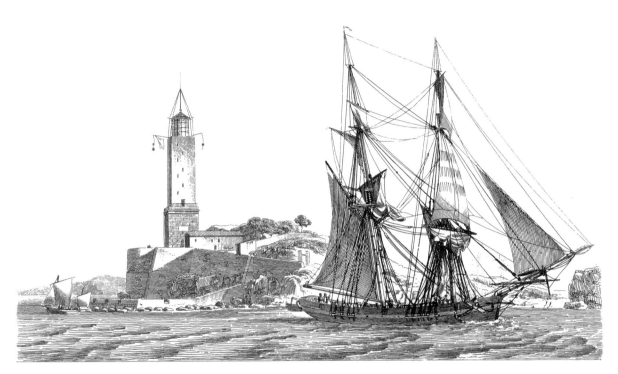

171.

\mathcal{P}ORT FACILITIES III: The prime requirement of a harbour was security, a place where ships could take shelter when necessary, even if they were not bound there to load or unload cargoes. Vessels had to be able to locate the port and enter safely in all weathers for which a prominently placed lighthouse was a huge advantage. Even before the days of electricity, a well-sited oil- or coal-fired beacon could be seen for miles. Towards the end of Baugean's career, the French Fresnel brothers were hard at work on the lenses that would become the basis of nineteenth-century lighthouse optics.

A loftily rigged brig is running in under easy sail, ready to come to anchor. Note the top-gallant crosstrees, furled main course gaff topsail and relatively prominent dolphin striker. [*Petites Marines* 8]

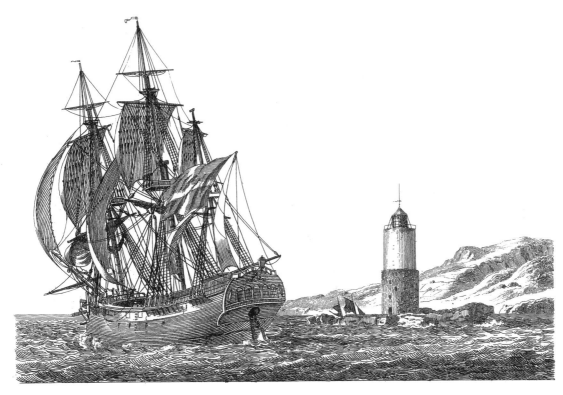

172.

𝒫ORT FACILITIES IV: Lighthouses were also used to mark rocks on the approaches to harbours or in much-frequented channels. In this case the top of the tower is whitewashed so it can be more readily seen at a distance. This form of squat, concentric tubes was fine for relatively sheltered locations, but for more exposed positions the familiar tapering tower of hyperbolic form – ultimately all derived from Smeaton's Eddystone light of 1759 – was to become the nineteenth-century norm.

A lightly armed Scandinavian merchantman sailing under topsails with the wind large on the starboard quarter is seen from astern. The mizzen topgallant mast has been sent down. [*Petites Marines* 7]

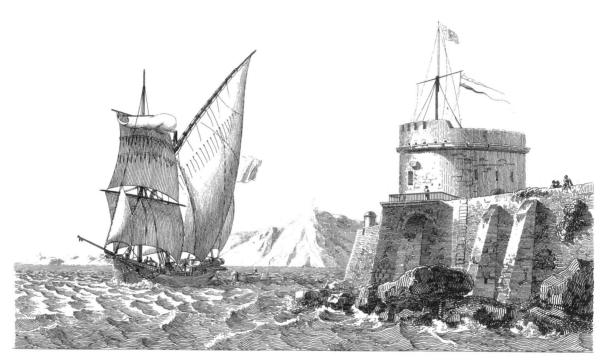

173.

*P*ORT FACILITIES VI: The security of shipping, especially during wartime, could be improved by keeping a vigilant coastal watch. The French coasting trade was a prime target for British attack during the Napoleonic Wars, and France responded with a chain of signal stations which could pass information quickly by means of flags, pennants and, eventually, a mechanical semaphore mounted on watch-towers like that to the right. Many of these were ancient defensive towers reused.

The vessel is a Genoese barque, sailing large. This example has a polacre rigged fore mast, with main and mizzen lateen rigged (compare Plates 99, 101 and 102. [*Petites Marines* 44]

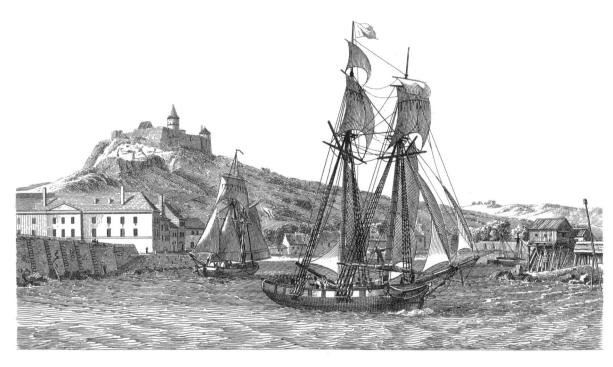

174.

*P*ORT FACILITIES VII: Harbours needed to provide security in the military sense during wartime and most continental European ports had some defences; many could rely on major fortifications like the one shown here on the hilltop. During the wars of 1793-1815 they rarely prevented British cutting-out attacks on the shipping within, but they usually ensured that the port itself could not be occupied for more than a few hours.

A topsail schooner, upper and lower topsails on both masts, and a ketch rigged vessel are shown making sail, as they leave this small tidal port, something which could only be accomplished at high tide. The schooner's running fore sail, furled to its yard, is visible just forward of the fore mast. [*Petites Marines* 56]

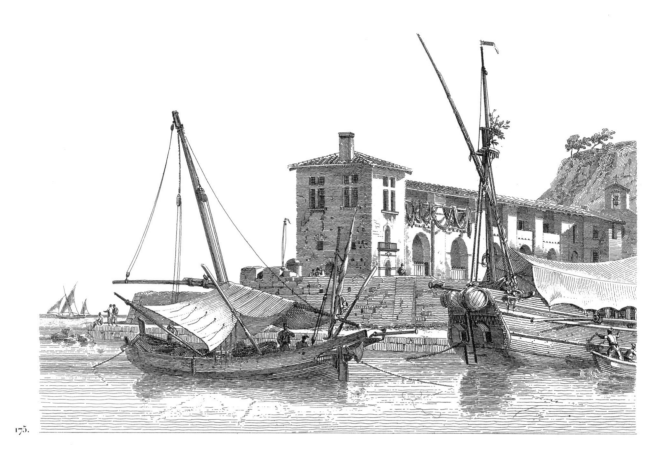

175.

*I*N PORT I: In the tideless Mediterranean mooring practice was different from the north, since vessels did not need to rise and fall with a tide when against a quay, nor to swing with ebb and flood when at anchor. Here a Spanish *bateau* (which might be described as a small tartane) is moored bow and stern, and appears to be rigged with a lateen main sail, small lateen mizzen or ringtail and fore sail, similar to the vessel in the far background, left. Note the *capian*, open stern and outrigger. The fore sail or *polacre* is spread as an awning, supported by sweeps, and the sprit (*tangon*) extends the fore sail. The fore sail halliard is hooked to the forward end of the lateen yard, and the tye-block is visible on the after side of the mast.

The stern of the a Genoese pinque to the right is somewhat less elaborately decorated than that shown in Plate 96. The lateen mizzen has a small topmast, and a tree-branch decorates the cap. [*Petites Marines* 33]

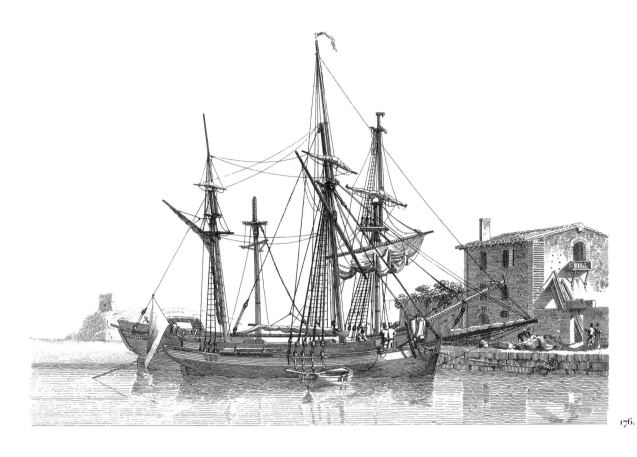

176.

*I*n port II: Merchant vessels moored to a quay. Mooring bow- or stern-on to the quay was common in the Mediterranean. The vessel in the foreground is a galeass. The gaff main sail has been lowered; by contrast, on the mizzen the sail is furled to the hoisted gaff. The mizzen boom is almost invisible against the hull behind, but its presence is betrayed by the topping lift. The vessel further away may be a brig, but with all except the lower part of the after mast dismantled it is impossible to be certain. [*Petites Marines* 42]

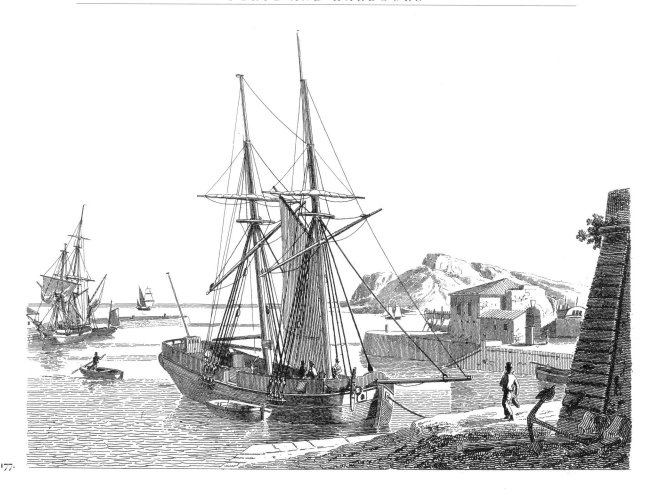

·177·

\mathscr{I}N PORT III: Swedish schooner moored to a quay in a small Mediterranean port. Baugean says that northern vessels like this were rather heavily built, and this bluff-bowed example, with its tall solid bulwarks is a marked contrast to the American pilot schooner in Plate 79.

Astern of the schooner a seaman sculls a dinghy with a single oar over the transom. [*Petites Marines* 114]

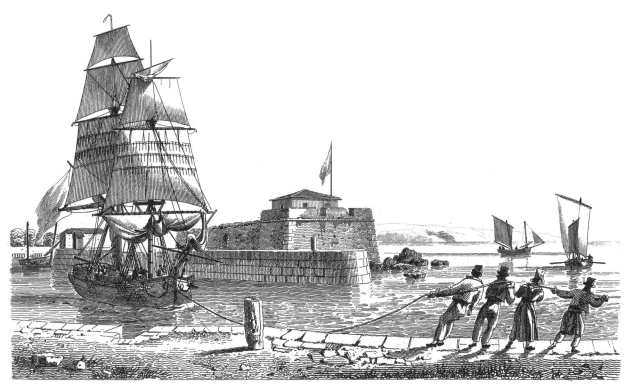

178.

\mathcal{I}N PORT IV: A brig being towed out to sea. Baugean says that in the Channel ports, the poorest of the poor, men, women and children were employed as 'haulers' (*haleurs*), to get the ship to sea when there was no wind, or it was contrary. Judging by the small craft in the background and the flag hanging limply from its staff, there is virtually no wind. In Britain, when a small rowing boat was used for towing, they were known as 'hobblers' or 'hovellers'. The introduction of the steam tug, and later auxiliary engines, did away with this practice. [*Petites Marines* 81]

179.

\mathcal{C}ARGO-HANDLING I: Merchant brig discharging its cargo into a lighter, using one of her spars as a derrick. Note the decorated dummy window above the rudder port, and the crutches for the boom on the taffrail. Baugean notes that brigs, or *brigantins*, vary in capacity from 100 to 400 tons, are widely used in commerce, and as sloops of war they carry 16 to 24 guns. The solid-looking eight-oared boat in the foreground may belong to the brig; it has a wash strake with cutouts for oars.

In the background two sawyers apply a large frame-saw to cutting out a floor timber from a naturally curved log. [*Petites Marines* 14]

180.

\mathcal{C}ARGO-HANDLING II: Tartane loading sizeable blocks of cut stone, which have been brought to the shore from a nearby quarry. The blocks have been largely moved by pure human effort, although there seem to be some wooden rollers near the sitting figure in the foreground. Once on the wooden gang-boards the blocks are winched inboard, guided by two men with handspikes, before being lowered into the hold with the aid of a masthead tackle. The tartane appears to be afloat – they were of very shallow draught – which would have placed less stress on the structure when loading heavy weights like these stones. [*Petites Marines* 12]

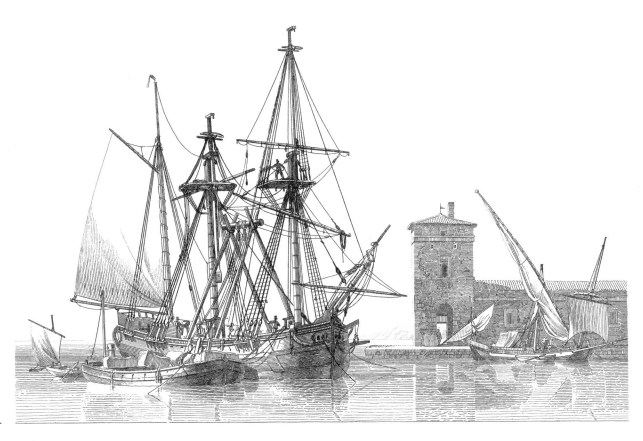

181.

\mathcal{C}ARGO-HANDLING III: Danish vessel embarking blocks of marble; the cargo has been brought alongside in a lighter, and sheers have been rigged to allow the cargo to be hoisted on board. The main topmast has been struck, and the main course and main topsail yards cleared out of the way; the fore topgallant mast has been sent down and the jibboom run in. The vessel is what we would nowadays call barque rigged.

In the background is a small Mediterranean craft of the type that was known locally as a *barque*, although the term was not related to northern usage. This one is lateen rigged on the main; polacre rigged on the fore (compare Plates 99, 101 and 102). [*Collection 55*]

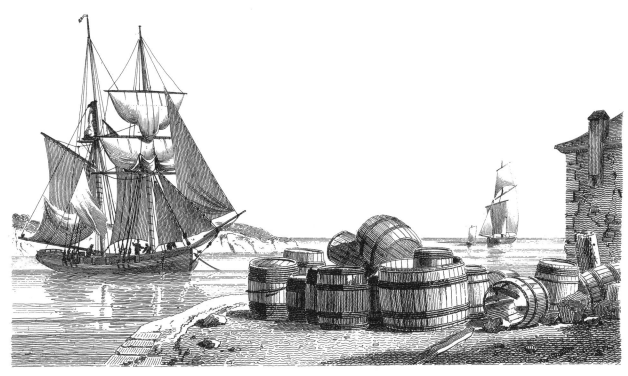

182.

*C*ARGO-HANDLING IV: Before the modern container revolution, the most common unit of carriage was the cask – indeed the medieval wine-barrel, or 'tun', was the basic measure of the capacity of a vessel, from which modern 'tonnage' is derived. One advantage of the wooden barrel not shared by the steel container is that it could be broken down into its constituent staves when not in use, thus saving valuable shipboard space; the ship's cooper would then rebuild the barrels as required. Various sizes and shapes of barrel are shown here. Beyond is a topsail schooner at anchor, airing her canvas. The main gaff topsail is furled at the crosstrees. [*Petites Marines* 82]

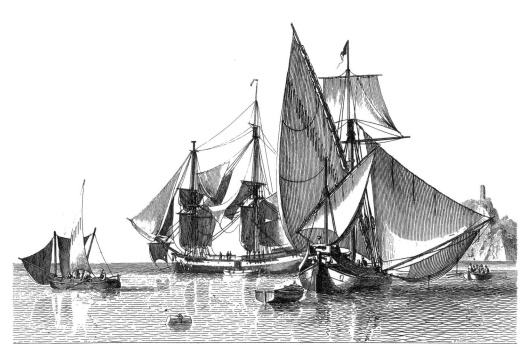

183.

\mathcal{V}ARIOUS vessels in a flat calm. The tartane in the foreground has an open stern and is airing her sails, which include: lateen ringtail with outrigger; square topsail over a lateen main sail; polacre boomed out to starboard with what may be termed a water sail under the boom. Further away a Dutch flute is airing her canvas. To the left, a fishing boat with lateen main sail has two other sails boomed out to the side and from the bow. [*Petites Marines* 25]

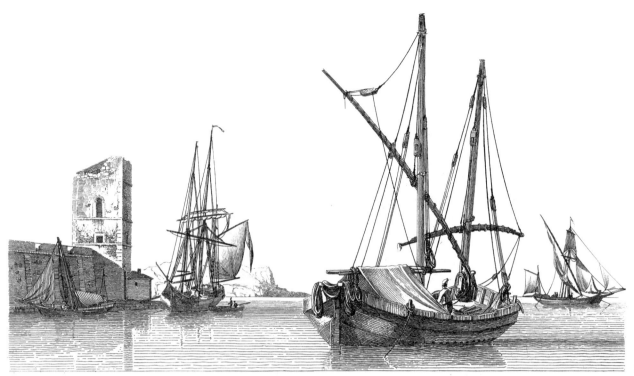

184.

\mathcal{V}ARIOUS Mediterranean coasters at anchor. Furthest left in the shadow of the wall is a Valencian bateau; it is not possible to be certain but this could well be rigged similarly to the Corsican boat, the subject of Plate 139. Next right is a polacre rigged Genoese barque; the main mast is polacre rigged, and is presumably the same on the fore, although the spars are not visible. In the foreground is a Spanish barque seen from the stern. This seems to be quite beamy; has a *cul-de-poule*; and is rigged with lateen sails on both masts. The heavy construction of masts and lateen yards is evident, and we can clearly see the parrels and the tye blocks on the after side of the masts. Far right is a Provençal tartane, with square topsail and gaff rigged ringtail. [*Collection* 38]

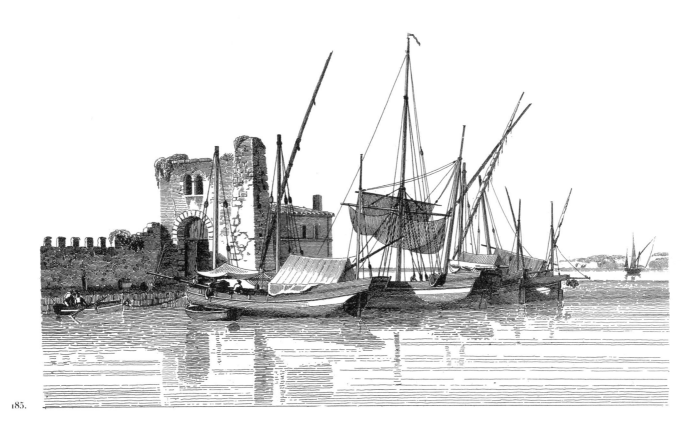

185.

\mathcal{V}ARIOUS small coasters moored in the usual Mediterranean manner to a quay. They exhibit both the variety of Mediterranean small craft, but also some of the consistent features, like the lateen sails, pole masts and overhanging *cul-de-poule* sterns. In the background a tartane is taking advantage of a very light breeze. [*Petites Marines* 120]

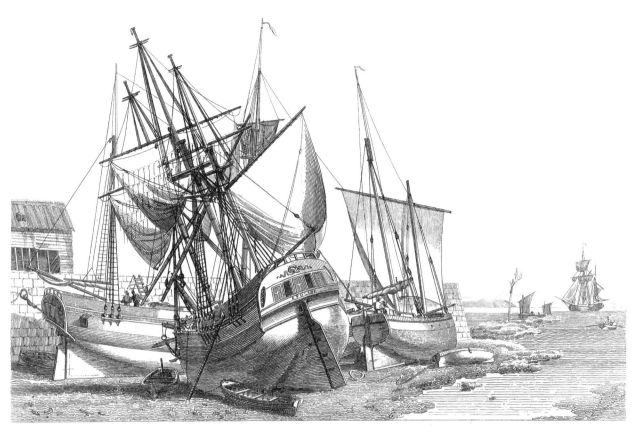

186.

\mathcal{B}Y way of contrast with the previous Plate, a variety of northern merchant vessels is shown beached at low tide. The ability to take the ground safely in drying harbours and anchorages influenced the hull form of vessels operating in a tidal environment. A ship rigged vessel is in the foreground, propped up by a shore against the port quarter, with what Baugean describes as a *dogre* beyond it, and a chasse-marée to the right. In the distance is another dogre. An interesting medley of ship's boats lie around the vessels themselves. [*Collection* 69]

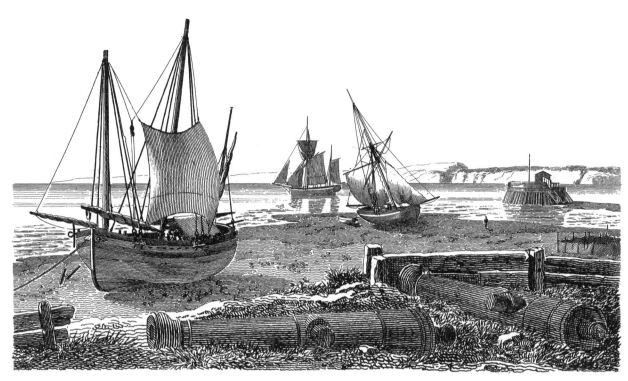

187.

STUDY of cannons and vessels at low tide. The guns seem to be of an outdated pattern, judging by the rather complicated profile of the 'swell', or *tulipe* as the French called it, just behind the muzzle. The swell of English and French naval cannon of Baugean's period, was characterised by a simpler contour. The trunnions are off-centre, so that the centre of mass of the piece was above their axes, and the gun was said to be 'hung by the thirds'. There is no ring at the cascabel for the breeching. This feature was first fitted in British guns of Blomefield's pattern in the 1780s, but in comparable French cannon not until 1820.

In the mid-ground is a chasse-marée; further away, a sloop, and a ketch rigged vessel. In the mud flats and sandbars of the French Channel coast, pile-built wooden structures like that to the right were used as forts, signal stations and pier-heads. [*Petites Marines* 119]

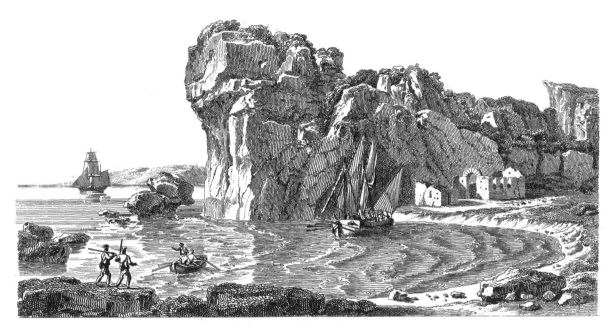

188.

𝒜 ʀᴏᴄᴋʏ bay, with a ruined chapel, where a small three-masted privateering felucca has been lurking. The lookouts, who have seen the ketch in the offing, are being picked up by a boat, and the corsair is getting under way using sail and oar, in preparation for attacking her prey. Note the bow-chasers. Privateering, or *guerre de course* (whence 'corsairs') was a sanctioned form of naval warfare in those days. In some instances, a merchant vessel carrying a regular cargo, obtained 'Letters of Marque and Reprisal', with the notion that she might find a target of opportunity during the voyage. Genuine privateers were fitted out by civilian individuals or firms with the specific purpose of engaging in attack on the enemy's trade. Since licensing was always rather lax, and the behaviour of many privateers even laxer, legitimate traders considered it little more than state-sponsored piracy, especially as practised by the Barbary states of north Africa for whom it was an important fact of economic life. [*Petites Marines* 57]

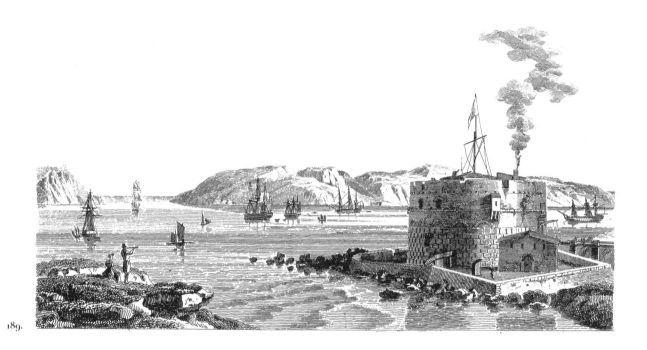

189.

CLOSED roadstead. This was a place, usually heavily defended, where vessels could anchor in relatively protected waters, and often was in proximity to an even more secure dockyard, where vessels could be built, provisioned and repaired. Examples were found at Brest and Toulon in France, and Spithead and Plymouth Sound in England. This one bears a strong resemblance to the outer roads at Toulon. [*Petites Marines* 59]

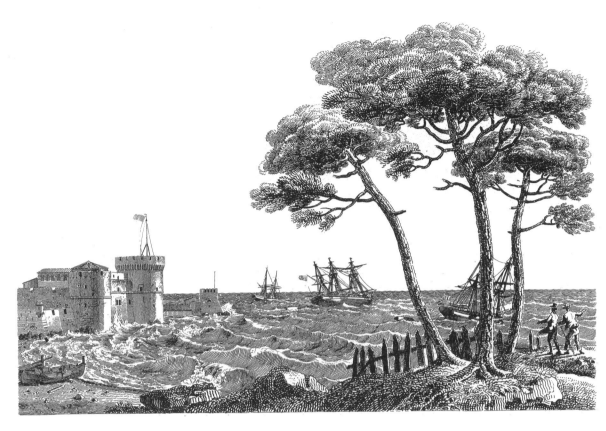

190.

ℰxposed roadstead. This was less sheltered, but
preferred as an anchoring place, because the ground offered particularly good holding while
allowing vessels to get underway in most conditions of wind and weather. Two brigs and a ship
are at anchor in blowing weather, emphasising the disadvantages of an open position. To the
left is an elaborate fortification (a medieval castle with added artillery bastions), and a fishing-
boat hauled up on the beach. [*Petites Marines* 60]

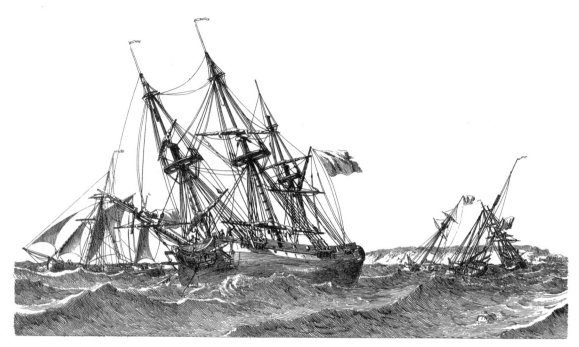

191.

\mathcal{S}EAKEEPING I: Rolling. The merchantman in the foreground has two anchors down, and the sheet anchor at the cathead ready to let go should it be needed. Topgallant masts have been partly struck, fore and main lower yards lowered to decrease topweight. Some of the yards have been braced up as far as possible, in an effort to cut down windage.

In the background to the right a lugger, a cutter and a third unidentifiable vessel are rolling heavily at anchor; to the left, a ketch rigged vessel, perhaps a Dutch kuff, is sailing by the wind. [*Petites Marines* 26]

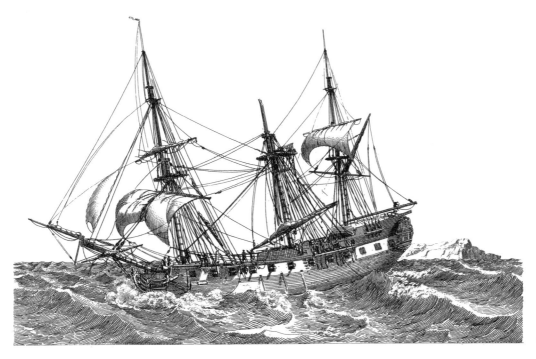

192.

SEAKEEPING II: Pitching. A large armed merchant vessel (possibly an East Indiaman) is running before the wind, under reefed fore course and mizzen topsail. Water pours from the scuppers on the port side, indicating that she had just shipped a big sea. The fore topgallant yard has been sent down, and is stowed in the lower rigging. The main topmast has broken, topsail yard and everything above being lost. The main yard has been lowered to the foot of the mast. This plate is intended to illustrate the effects of heavy pitching. [*Petites Marines* 27]

Concordance of Plates

The running order of the Plates in the original published works is listed below, with their position in this volume cross-referenced. For those wishing to find the original Plate numbers and volume of specific Plates in this book, it will be more convenient to look at the references given at the end of each caption; these list a short version of the title and the original Plate number.

Collection de toutes les Espèces de Bâtiments de Guerre et Bâtiments Marchands, qui naviguent sur l'Océan et dans la Mediterranée (1814)

Title	Original Plate numbers	This volume	Title	Original Plate numbers	This volume	Title	Original Plate numbers	This volume	Title	Original Plate numbers	This volume
Ship of the line, French	1	7	Ship of the line, British	19	3	Bateaux, Corsican/Genoese	37	139	Merchantman, Danish	55	181
Frigate, American	2	25	Sicilian felucca	20	92	Mediterranean coasters	38	184	American pilot schooner	56	79
Mediterranean privateers	3	83	Tartane, Neapolitan	21	107	Ship of the line/ship's boat	39	12	Ship of the line, French	57	6
Trabaccolo	4	105	Sacoleva	22	104	Merchantman, Danish	40	66	Brig/Genoese pinque	58	97
Genoese pinque	5	96	Merchantman, Swedish	23	65	American merchant brig	41	75	Corvette, French	59	28
Schooner, topsail	6	42	Corvette, French, careening	24	163	French brigantine	42	76	Ship of the line, French	60	2
Felucca, Neapolitan	7	91	Frigate, French	25	155	Patache, Portuguese	43	51	120-gun ship in frame	61	153
Dutch flute	8	63	Ship of the line, Spanish	26	13	Bateau boeuf	44	144	74-gun ship on ways	62	154
Dutch cutter/snow	9	44	Corvette/speronare	27	109	Bombardes, French	45	55	Chasse-marée/dogger	63	116
Genoese barque/bateau	10	101	Catalan fishing boats	28	134	Frigate, French	46	17	French corvette	64	27
Brig of war	11	36	Frigate, British	29	21	Merchantman, on stocks	47	156	Sloop/prame	65	53
Barque, Provençal	12	102	Misticou	30	87	Greek merchantman	48	70	Sloop/lugger	66	119
Frigate, American	13	23	Frigate, Swedish	31	26	Half-galley	49	56	Frigate/ship of the line	67	20
Roman barque	14	142	Transport, British	32	48	Ship of the line, Dutch	50	14	Chasse-marées	68	121
British merchantman	15	64	Chebec, Spanish	33	49	Merchantman/liuto	51	71	Merchantmen at low tide	69	186
Ship of the line, French	16	159	Merchant corvette/lugger	34	45	Merchantman /tartane	52	69	Frigate, careening	70	165
Genoese chebec	17	50	Ship of the line, French	35	10	Galiot, Swedish	53	113	Ship of the line's barge	71	59
Barque/pinque	18	99	Ship of the line, British	36	5	Allège of Arles	54	143	British 74-gun ship	72	11

Receuil de Petites Marines (1819)

Title	Original Plate numbers	This volume	Title	Original Plate numbers	This volume	Title	Original Plate numbers	This volume	Title	Original Plate numbers	This volume
Barque, Spanish	1	103	Schooner/brig, Swedish	31	31	Schooner	61	81	Barque, Dutch	91	118
Barque, Rhône	2	148	British three-decker	32	1	Brig-schooner	62	40	Chasse-marée	92	124
Catalan fishermen	3	133	Bateau/pinque	33	175	Brig-schooner, American	63	39	Fishing boat/ Provençal	93	137
Schooners, ballahou	4	80	Frigate, American	34	24	Bisquine	64	127	Passenger boat, Rouen	94	151
Masts and fittings	5	158	Schooner, American	35	38	Honfleur fishing sloop	65	129	Bateau, Spanish	95	136
French frigate	6	19	Gabarre, French	36	47	Galiot, Belgian	66	115	Fishing boat/Provençal	96	138
Lighthouse on rocks	7	172	Mediterranean anchorage	37	132	Chasse-marée	67	123	Corsaire, Spanish	97	88
Brig/lighthouse	8	171	Frigate, British	38	22	Lugger, armed	68	46	Merchantman	98	72
Frigate decommissioning	9	160	Swedish galiot/tartane	39	111	Sloops	69	82	Coche (Saône)	99	146
Pinque	10	98	Barque, Rhône	40	149	Merchantman, American	70	68	Coche (Rhône)	100	147
Barques, Dutch	11	117	Frigate, French	41	16	Cutter	71	43	Felouguone, Genoese	101	93
Tartane	12	180	Merchantmen	42	176	Kirlanghi, Greek	72	89	Bateau, Spanish	102	108
Merchantman, Swedish	13	67	Ship of the line, French	43	9	Chebec privateer	73	90	Brig of war	103	33
Brig	14	179	Barque, Genoese	44	173	Chasse-marée	74	125	Fishing boats, Normandy	104	128
Allège of Arles	15	144	Chasse-marée	45	122	Ship of the line, towing	75	4	Dutch galiot/schooner	105	114
Anchors, dockyard	16	161	Brig/Swedish barque	46	73	Honfleur Picoteux	76	130	Chebec, polacre rig	106	86
Frigate's launch	17	57	Chebec, Spanish	47	84	Brig-schooner	77	78	Schooner	107	41
Battleship's launch	18	58	Neapolitan fishing craft	48	141	Merchant brig	78	77	Brig of war	108	35
British lug rigged boat	19	62	Frigate, French	49	15	Brig of war lowering boat	79	34	Péniche	109	61
Fishing boats, Catalan	20	135	Brig, careening	50	166	Barque, Adriatic	80	106	Barque, Genoese	110	100
Bombarde	21	94	Ship of the line, careening	51	164	Brig being towed from port	81	178	Balancelles, Spanish	111	54
Sacoleva/dredger	22	169	Merchant brig, careening	52	167	Schooner/casks	82	182	Whaler	112	74
Pile-driver	23	170	Brig of war, British	53	32	Genoese pinque careening	83	168	Aviso, Spanish	113	52
Saw-horse	24	152	Ship of the line, French	54	8	Galiot/Havre fishing boat	84	112	Schooner, Swedish	114	177
Vessels in a calm	25	183	Frigate, cockbilled yards	55	18	Pirate, Indian	85	120	Flambard	115	126
Rolling merchantmen	26	191	Schooner leaving port	56	174	Turkish djerme	86	110	Ship's boats	116	60
Pitching merchantman	27	192	Corsaire	57	188	Greek brig and corvette	87	37	Brig, on stocks	117	157
Mediterranean anchorage	28	95	Darse (dockyard)	58	162	Chebec	88	85	Corvette, British	118	29
Corvette and brig in action	29	30	Roadstead, closed	59	189	Coaster, Rouen	89	150	Low tide, cannons	119	187
Coche of the Saône	30	145	Roadstead, exposed	60	190	Oury, Honfleur	90	131	Mediterranean coasters	120	185